THE HUMAN FORM IN CLAY

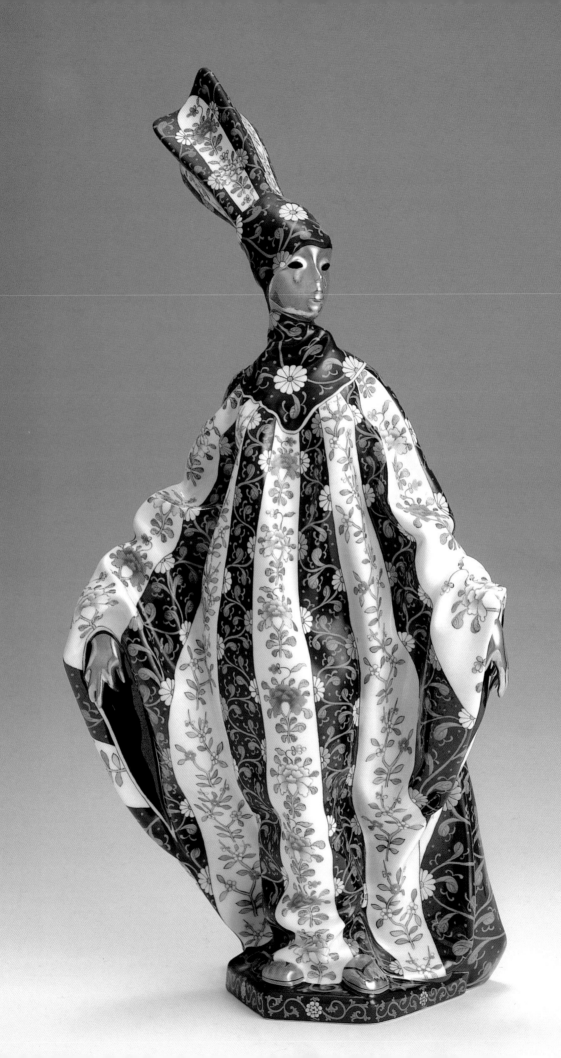

The Human Form in Clay

Jane Waller

The Crowood Press

First published in 2001 by
The Crowood Press Ltd
Ramsbury, Marlborough
Wiltshire SN8 2HR

www.crowood.com

This impression 2007

© Jane Waller 2001

British Library Cataloguing-in-Publication Data
A catalogue record for this book is available from the British Library.

ISBN 978 1 86126 413 8

Dedication
To all the ceramic journals which help to spread an awareness of what the
artists create around the world – and to the artists themselves.

Acknowledgements
Thanks to the many people who helped me to locate the artists from
abroad, especially Janet Mansfield, of *Ceramics: Art and Perception*, Renée
Fairchild, of *Ceramics Monthly*, Garth Clark of the Garth Clark Gallery, in
the USA, and Gustav Weiss of *Neue Keramik*.

 To all the translators, especially to Melissa Muys; and to Barry
McDaniel and Gunnar Jakobsen who each translated more than one
entry.

 To the following libraries in particular: those of the Crafts Council of
Great Britain, The Central and St Martin's Art College and the Tate
Gallery, and to the Westminster Reference Library.

 To all the people who kindly lent or helped me to find the
inspirational pictures; but particularly to The British Museum, The Tate
Gallery, and to Julian Sofaer, Desmond Morris, Linda Lasater, Anne
Daniels and Judy Gilbert. To those who gave pictures for the
Introduction: Alexander Götz, of London, the Franklin Parrasch Gallery,
of New York, *Alphabet & Image*, of Somerset, and to Georg Kolbe Museum
and the Museum für Völkerkunde, both of Berlin.

 And to my husband, Michael Vaughan-Rees, who, although writing a
book of his own, took time to help and advise me.

Photograph previous page: Imre Schrammel, *Carnival*; porcelain; 1998;
42cm; fired to 1,380°C. Kornèl Kovacs

Designed and typeset by Annette Findlay

Printed and bound in Singapore by Craft Print International

Contents

Preface

I felt strongly that there needed to be a fine art book to celebrate the increasing number of artists who were choosing the human form in clay as a vehicle for expression, an interest that has been growing steadily over the last twenty-five years or so. I decided to choose fifty contemporary sculptors – some well-known, some relatively unknown – all of whose work showed depth of meaning.

Thinking that it might be interesting to discover more about the artists themselves by delving deeper into what lies behind their work, I decided to ask them all to choose one person or thing (not necessarily a work of art) that had inspired them during their careers and to explain why. This gives an extra dimension to the book, since we are able to enjoy the influence pictures too, and learn why they had been chosen. We do learn more about the artists, as well as their technique and reasons for creating their sculpture – though these tend to be fused together, as they should be.

As with my previous book, *Colour in Clay*, I was keen to include newer talent as well as more established artists and was pleased with the mixture which resulted. Most artists gave new information for the first time or reassessed the reasons for making their art. Lorraine Fernie, for example, wrote to say, 'I have enjoyed writing the piece. It provided a great chance to sort out my ideas in relation to my work. Thank you for providing the opportunity.'

The artists from the United Kingdom proved easy to find, thanks to the Craft Council. Those from abroad proved much harder, however. Fortunately, I was helped by a number of people, notably Janet Mansfield, of *Ceramics: Art and Perception*, and Renée Fairchild, of *Ceramics Monthly*. And word of mouth, as well as help from other artists, meant that I eventually managed to locate most of them (I had already decided that I would not discuss the work of any artists without their input).

There are three tributes to be paid: one to an American sculptor, Daniel Rhodes, whom I was delighted to find out about through his being one of Varda Yatom's influences; Louise Bourgeois, who does not work in clay but who has been a great inspiration; and Anna Abakanowicz, the Polish artist – who, it turned out, had made one or two works in clay, which she sent to be included.

It was a tricky business to group the artists each under the umbrella of a single chapter, many could have been in more than one; but doing so has given the book more structure, and I have tried to link each chapter by ending it with an artist who could equally well have been in the next. Also there was a kind of internal linking which occurred naturally when one artist cited another whom I had chosen to be in the book as an influence.

Finally, I also wanted to couch the language in a style that was easy to understand so that anyone could enjoy reading the book, find inspiration in it, or be encouraged to make work of his or her own.

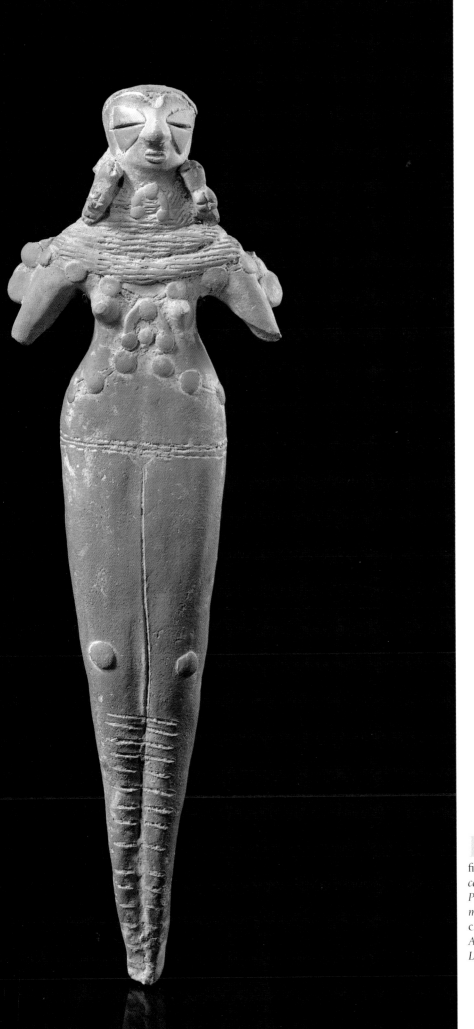

Fertility cult
figurine. *3rd–2nd
century* BC. *Charsadda,
Pakistan; red hand-
modelled terracotta;
c. 32cm. Courtesy of
Alexander Götz,
London*

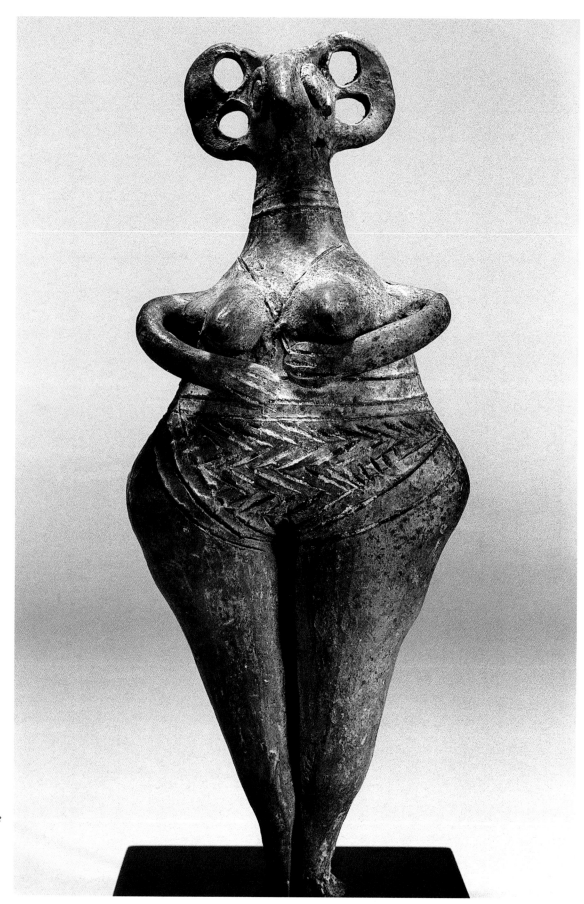

*L*ate Bronze Age Base
Ring Figure, Mother
Goddess, *from Cyprus.*
Terracotta; 20.7cm
high. Courtesy of
Desmond Morris

1 Introduction

Art reveals man's mental response to his environment, for with it he attempts to interpret and subdue reality, to rationalize nature and give visual expression to his mythologizing explanatory concepts.

Marija Gimbutas, *The Goddesses and Gods of Old Europe* (Thames & Hudson,1982)

Representation

For thousands of years the earliest representations of ourselves were fashioned out of clay. These were used, almost certainly, as votive offerings to the gods: as devices to help to produce order in the midst of nature's irregularities, at a time when creation, cyclical change, death and resurrection were all ascribed to supernatural intervention.

Nowadays, figurative sculpture in clay is more likely to be an explorative vehicle in which to communicate thoughts, perceptions and feelings about ourselves and our contemporary situation. In other words, to establish a critical interest in the human condition. But our approach is more subjective than objective; we all seem to be working from the inside out, showing what it feels like to be on the receiving side of our body, looking inquiringly from the back of our own minds and eyes. Antony Gormley says, for instance, 'Man is relating to his inner space and physical space ... giving the image from the other side of appearance ... I want to produce a generic human being with which we can all identify ... I want to use my own existence, in a sense, as the raw material ... The body has its own energy and way of making apparent what was always hidden.'

With this new freedom of expression comes a new language, something that is harder and more profound. A few of us still make figures that, for example, convey anger or love or pity; but it is far more likely that our new clay sculptures display ambiguities, questions, prognoses and probings. Many of us are finding that our work is just a series of enquiries, with the answers seeming to be always further away. Christie Brown, for example, says, 'If clay possesses an ancient, archaic, timeless quality, can we use this in a contemporary context to create a new language?' And in her notebooks she asks, 'What makes a figure speak? Is it form, stance, scale? The surface, texture, line, expression. I want to capture their potency ... in my search for a personal identity and an identity in the contemporary art world.'

For a long time the obligation to depict the human form in a traditional, representative way had been replaced by an equally conventional tradition of non-realistic abstraction. Recently, however, we have been moving towards a successful synthesis of both approaches. Now Anthony Caro speaks for us all when he says, 'The language of abstraction is so well established that it doesn't have to be defended in the same way. In the past, it seemed that if a sculpture was to be alive, to be "real", it couldn't look like anything else. I used to worry that my sculpture might remind you of something. Now I don't mind if they do.'

Nor is it necessary to sculpt the entire figure. Small pockets of information can say as much as a 'complete' work; a part can represent the whole. 'Usually the head is missing,' as Henk Kuizenga says, 'representation of the head would turn the warrior into an individual again, while I want to express the universal and timeless.' And Christie Brown says, 'As soon as you put a head, a pair of eyes, a mouth and

Jane Waller, Reclining Fertility Goddess. *1981. Mixed stoneware and earthenware, unglazed; 7.5 × 10.5 × 5cm. Photo: Alphabet & Image Ltd*

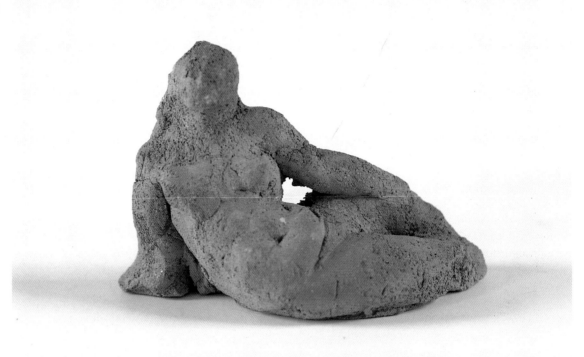

nose on something it becomes a figure in that iconographic godlike way. [...] If you leave the head and features off, you do not have to give it a name because it automatically becomes a universal symbol of humanity and could also belong to any age.'

Another change in style is that many of us celebrate fragmentation in our work (Chapter 6 shows strong evidence of this). We have probably learned to do this directly from the way that fired clay has the habit of lasting for centuries while still looking amazing – even in fragments of itself. Despite the erosion of time, these fragments carry the beauty of the whole, or they can add to and bring their historic romance and resonance to modern assemblages (*see* Gertraud Möhwald's wonderful shard sculptures).

We are also multi-firing our pieces (*see* Xavier Toubes and Carmen Dionyse). If cracks or distortions appear or joining seams are left, they are simply considered as part of the process (*see* Christie Brown and Luo Xiaoping). You do not have to disguise the marks and means of making in the search for a more polished finish. For many sculptors it is now the process of making that is as important as the end result. Evidence of process is celebrated in itself. Jean-Pierre Larocque says, 'The work is largely about its own making. It is preoccupied with language, this ordering device outside which no meaning is attainable ... A piece in progress is a likely place for a crisis to occur. It has the fertility of chaos. There, an unpredictable situation may build up that has to be dealt with. In the end what you get to see is the measure of resolution brought to the crisis. The outcome is the piece itself.'

Content

And the content of our work has changed. Figurative ceramics now carry new messages. Increasingly we see our role as sculptor as one of shared responsibility. Sculpture still does, of course, fulfil its traditional role as a direct and significant conveyor of human emotions and as pure justification for our own existence; but it is more likely to express our fear for the future of the world, our uncertainties about the way our planet is being spoiled; or it can comment on war and politics (notably in the work of Varda Yatom). We share universal concerns which are drawn from every place and race and are swiftly disseminated by global media and cultural intercourse.

We can celebrate both the differences and the similarities that exist between us, since we all share one human form. We can exchange common values and realize personal convictions.

Interesting questions also arise as male and female roles alter according to the changing social, political, sexual (and spiritual?) climate. It is reassuring, for example, to many of us female sculptors, that so many of those early cultures worshipped earth mothers. Female goddesses (who, incidentally, were thought of as destructive as well as constructive) were revered for more than 20,000 years from the palaeolithic through the chalcolithic (5,500–3,500BC) to the neolithic and beyond to the pre-Minoan. In fact, between 4,500 and 2,500BC they were considered more important than any male gods. Today, more women are making figurative ceramics about how it feels to be a woman (*see* Sandy Brown) and have finished 'being angry' about the time when so much figurative sculpture was male-oriented. (Louise Bourgeois has been standing up for feminist ideals throughout her inspiring career and so it is not surprising that three of the artists in this book pay tribute to her).

Men, too, have broken away from the traditional representation of themselves as hero (Doug Jeck states that he is 'offering a replacement for the idealized male hero with an introspective, self-examining male countenance'). Nor do they attempt to depict the female 'nude' as representing a thing of 'fragile' beauty.

Most of us, in fact, want to go beyond the idea of pure gender in our art, and this is the way, I think, the future is set to go. In 1990 Christie Brown was already saying, 'I do not call myself a specifically feminist artist since I do not agree with some basic tenets of feminist theory, but I do think that artists who are women need to keep their eyes open for and ask a lot of questions since our historical visual language is male-orientated.' And in 1997 Claire Curneen said that she was beginning 'to eliminate the idea of gender. I want to talk about the human condition rather than the female condition.' Today, much of our work in sculpture is noticeably androgynous and speaks for both male and female – and the male and the female that are in all of us (*see* the work of Stephen De Staebler and Herman Muys, as well as that of Claire Curneen).

Stephen De Staebler, Untitled. *1993. Charcoal, pastel on paper; 11in × 9in. Courtesy of The Franklin Parrasch Gallery, New York*

Stephen De Staebler, Untitled. *1993. Ink and wash on paper; 8¾in × 6¾in. Courtesy of The Franklin Parrasch Gallery, New York*

Sources of Learning

Something that is still going strong, however, is the continual urgency to understand the structure, architecture and biology of these male and female bodies. By looking more closely and deeply at ourselves we can inspire new forms, new moods and new ideas of representation. Through the discipline of life-drawing we can learn to think accurately and analytically, to appreciate how light and shade will alter form through an infinite variety of poses (*see* Babette Martini and Stephen De Staebler). Eileen Newell says, 'It is only when we draw that we really look at something very, very intensely and there is always so much to discover.'

When life-drawing, I always try to keep an old Chinese saying in mind which instructs us that 'art comes when the hand, the eye and the heart meet together – the three not the two'. Life-drawing goes hand-in-hand with figurative sculpture, quickening an awareness of different sensual and emotional qualities, helping us to learn more about the science of stretch and slump, of movement or repose. It has always been so, and we are still a constant source of inspiration to ourselves.

A further inspiration – one that is as strong today as ever – is that of history and ancient mythologies (*see* Gudrun Klix). But we tend to use these potent myths as carriers: to incorporate them or reuse them to illustrate a different context. Anthony Caro said, when he made his *Trojan War* series, 'The clay itself reminded me of warriors. I could use mythology to say something about the present.' Or we are more likely to create our own dream world (*see* Patricia Rieger and Graciela Olio), producing a cast of personal heroes and modern mythologies. However, many ideas that are understood as archetypal still hold true. And if the inspiration pictures chosen in this book are anything to go by, we are still learning from many familiar sources.

With such a long archive of figurative forms to admire and be influenced by, we are moved as much as ever by painters and sculptors such as Moore, Picasso, Brancusi, Miro, Degas, Marini, Maillol and Rodin. We acknowledge strong cultural and spiritual links with even earlier sources of inspiration: Michelangelo and the Renaissance; Gothic and early church carvings; the classical Greek tradition; right back to the ancient Vinča civilization in Middle Europe, the Indus Valley civilization or the Chinese tomb figures.

With many really ancient figurative ceramics we may now be inspired not so much by the content as we are by the form. Fertility

Georg Kolbe,
Reclining Figure.
1916. Courtesy of V. G. Bildkunst Georg-Kolbe Museum, Berlin

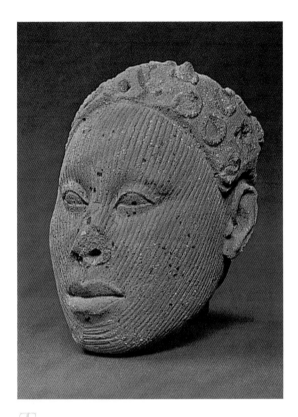

*T*erracotta head from Ife, Nigeria. 12–14th century. 17cm. Courtesy of Museum für Völkerkunde, Berlin

goddesses are no longer thought of as showing 'primitive' modelling. We keep returning to the way they demonstrate essence of form, simplification, abstract design, a paring down to the essential by cutting out fussy extras that could only delay or distort the message. There is as much respect as ever for really ancient representations, such as the Willendorf Venus (*see* Wayne Fischer and Sandy Brown), as there is for the later schematic geometricization of the Cycladic figurines (*see* Susan Low-Beer), the basic, powerful forms of African art (*see* Gabriele Schnitzenbaumer and Sally Mac-Donell) and ancient Mexican cultures (*see* Maribel Portela), or the straightforward quality of the Romanesque (*see* Lorraine Fernie).

The Material

Clay is one of the most fundamental of all materials, one of the most poetic substances in which to sculpt our modern forms. In Greek mythology it is Prometheus who shapes the first

human being into clay and Athena who breathes life into it. In the Old Testament (*Genesis* 2:7) we read that 'the Lord God formed man of the dust of the ground and breathed into his nostrils the breath of life; and man became a living soul.' Working with clay today, we still symbolically take on the responsibilities of creator, invoking the help of all four elements. We refine clay from the earth; we breathe into it new life, creating figures in our own likeness by making it malleable with water and allowing the air to dry it out. Then we set it in permanence for a while, subjecting it to a baking through fire and smoke. And we give it away three times: at first from ourselves, then to the kiln, and finally out into the world into a hopeful eternity.

As a modern medium for sculpture, clay still offers a wonderful range of possibilities; and the variety in our treatment of it is as diverse. This is undoubtedly because it is the most responsive of materials in its plastic state. The feel of clay is like that of no other substance, responding to the lightest touch of fingertip markings; or it can take an energetic pounding and stretching. Even after drying and firing, it will accept further treatments and alterations in patination with glazes (*see* Tove Anderberg), smokings (*see* Sally MacDonell), sandings (Wayne Fischer or Henk Kuizenga) or blastings (*see* Sándor Kecskeméti and his blow-lamp). Not only can it be altered easily at practically every stage, but it also blends well with other materials such as iron, wood, stone or steel (*see* Charles Bound, Anthony Caro and John Maltby). Stephen De Staebler says, 'We ought to have at least as many words for clay as the Eskimos have for snow.'

Clay also acts as an accommodating carrier. We can alter its consistency, opening it up with grogs, making it tougher with fibres and giving it flexibility with paper-clay (*see* Gill Bliss); we have new high-firing colours that do not burn away. Clay, it seems, is growing more and more versatile; we can choose from a veritable palette of possibilities, and we have new mixes of clay that are reliable, giving malleability as well as structural strength, and offering the exact consistency needed to convey surface, texture and form. Because we no longer feel the need to glaze everything after it has been bisque-fired, glaze nowadays, if used at all, is a means to an end rather than an obligatory clothing to clay. Interesting barium or lithium glazes, for example, will produce striking surfaces and bubbly

*L*orraine Fernie, Homage to Louise Bourgeois. *1999. 50 per cent T Material, 50 per cent porcelain with paper pulp and plaster of Paris wash; black stain is fired on and acrylic colour is painted on after firing.*

A complex pattern of limbs turned in on themselves supports this sensuous female body in a sexually-presenting pose. The darker half of each form is highlighted with a clear, untroubled, blue. The thin red lines keep the movement flowing in full curves while linking the darker to the light halves.

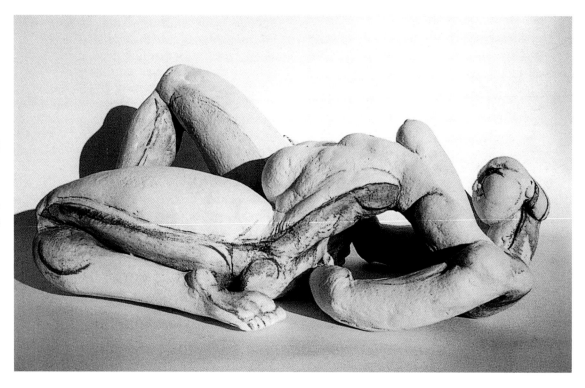

textures which are matt (*see* Varda Yatom); and vitreous slips combine and hold together well, acting as vehicles for texture and colour. We look to modern technology to give us yet more improvements – and we shall surely get them – because clay is usually somewhere in the fore-front of modern scientific technology in, for example, ceramic conductors, heat storage and tough coverings and we are party to its research spin-offs.[1] 'Modern technology is on clay's side', the celebrated artist Magdalena Abakanowicz says, 'Each scientific discovery opens doors behind which we are confronted with new closed doors.' (Although this celebrated artist hardly ever used the material herself, she has been such a great influence that there is a trib-ute to her on p. 97.)

How do we show our finished work? It was Auguste Rodin who displayed his sculptures on the top of classical columns, not only to forge links with antiquity but to isolate them in space in both a surprising and a dramatic way. And we still like our work to shock or surprise, challenge, or just look good wherever it is placed. Nowadays, installations are one of the most favoured choices (Varda Yatom or Gra-ciela Olio), and our figurative sculpture may be minute or monumental (Viola Frey), architec-tural (Imre Schrammel or Gwen Heeney), afloat in water (Antony Gormley), grouped together (Claire Curneen or Akio Takamori) or

suspended in air (Susan Low-Beer). Or they can be lost in the landscape, like Mo Jupp's forms, eroding away with weather and time.

Spiritual Content

But in the end, like us, our representations are just a borrowing and, as rock is worn to sand, clay will return to the earth as dust, eventually to be borne away on the winds of time. A few of us, like Carmen Dionyse, believe in the Resurrection – a reassurance that is displayed in her work, cen-tred through image, symbol and myth. Although most of us are without the prop and succour of religion today, more are investing in the possibil-ity that man consists of both a body and a soul – but sacral rather than religious. Varda Yatom, for instance, says that, 'The connection between the physical and spiritual components both in man and in artistic creation is an open question that I try to delve into again and again. When does anything material transform into something of spiritual value, whether man, or language, or expressed idea, and take on exalted qualities far beyond its material being? These are the ques-tions that guide me in my work.'

The need for a more spiritual content to our work has run like a thread through much of the sculpture chosen for this book; but the recovery

of universal values is told today through the profoundly personal (and with our inner voice, with what some give as the expression 'other', inherent in the body). Gerard Manley Hopkins's idea of inscape is what I think comes nearest to explaining this concept:

Each mortal thing does one thing and the same:
Deals out that being indoors each one dwells;
Selves – goes itself; *myself* it speaks and spells;
Crying *what I do is me: for that I came.*

With the recognition of spirit within our own selves comes the power of its use. Answers that have surfaced from the artists in this book have touched on such wish-fulfilments – call them modern votives if you like – as reasons for providing a protection for our inner lives; an appeasement against evil, loneliness and loss, loss of religion; a need for justification of life and of being here; or a political comment on injustice and inequality.

Sometimes what we find to express is painful – but one answer to this is to look at ourselves through humour (*see*, in particular, Gabriele Schnitzenbaumer). At other times it is just plain hard – Jean-Pierre Larocque says that 'being an artist is like jumping off a plane and making a parachute on the way down'.

Despite these difficulties, we continually need to pit ourselves against the difficulties of being and existing in the outer world. Socrates said, 'The unexamined life is not worth living', and clay is a wonderful medium in which to examine, explain and represent ourselves, acting as it does so well as a membrane or skin covering our inner thoughts and inner space. It is a material that lends itself easily to an expression of human warmth, and what emerges from the work of many of these artists is that what they do is in order to celebrate the quality of life so as to add to the quality of this life.

There is always magic in ourselves to reveal, always magic in the outside world to enjoy and learn from; ways of looking at things that are just around the corner, just out of sight. Only the other day, for example, I learnt that traditionally the Aborigines refer to stars as 'holes in the sky'.[2]

We are forever trying to throw out bridges – between our art and ourselves, our own work and other people's perception and understanding of it, from past cultures to the present and from present predicaments to concerns for the future. Creating bridges is an idiom that occurs more than once in this book in the artist's philosophy. The sculptor Anthony Caro has designed a real bridge – the first new bridge to cross the Thames for 126 years. And despite its initial wobbles (or maybe even because of them) I end with the image of this new bridge to the future and what it might hold.

The Millennium Bridge, London, 2000. Courtesy of Foster Partners. Photo: Jeremy Young/GMJ

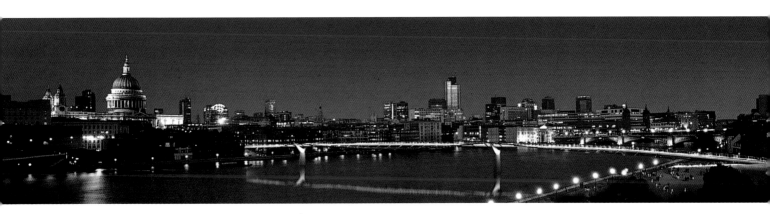

[1] I have read (in *New Scientist*, 1 July 2000) that a recent study of the giant pink queen conch (*Strombus gigas*) reveals that layers of tiny platelets are arranged at right angles to each other and held together by a protein 'glue'. The scientist, Arthur Heuer, says that, 'The platelets dissipate stress into numerous tiny cracks instead of one. This arrangement makes shells over a thousand times tougher than pure aragonite crystals. This could be the inspiration for new lightweight and tough ceramic composites.'

[2] Edna O'Brien, *Wild Decembers.*

2 The Sexy and the Sensual

This is an optimistic chapter which concentrates on the human, and particularly the female form. The work is both honest and sensual. There is an obvious revitalizing of earlier civilizations. *Sandy Brown*, for example, brings to her sculpture features that were in existence thousands of years ago: 'Those early figures show how revered the female was: they express the essence of female, and bigness. Big breasts, big bellies, big vulvas'. The ordinary, real qualities of women are expressed by both *Helen Ridehalgh*, who shows the female body as it is, and *Vanessa Pooley* who actively looks for the kind of honest approach that Marino Marini liked to portray in his work: 'the dumpy solidity so many woman have'. *Kathy Venter*'s work reflects 'values of quiet, contained emotion which draw the viewer in and bring about a willing participation', while *Lorraine Fernie* chooses to 'balance violence and fear with geometry and movement in order to create as positive and sensuous an image as possible'. *Tove Anderberg*'s approach is poetic; it is 'the drama, the illusionism and the sensual feeling arising from the effects of light and shadow' that interest her. Two female sculptors who celebrate the male torso are *Helen Ridehalgh*, who hopes to bring to her work such Renaissance qualities as 'delicacy of detail but also a remarkable grandeur' and *Maribel Portela*, who endows her male figures with anthropological camouflage, giving us stripy penises and spotted body-patterning. Two men represent the female form: *Wayne Fischer* says that the sexuality that people find in his work is unconscious and 'just a connection between sensuality and the new life that's been there forever'. *Mo Jupp* (*see* Chapter 8) delights in the female torso, and drew from one spectator the comment: 'Your pieces make me feel good to be a woman.'

Maribel Portela [Mexico]

Through my work I want to recover the universal values attached to the human race. The reason for portraying free, worthy, brave, affectionate and creative characters is because all these values are the cohesive strength that join and represent the human being.

Maribel Portela's sculpture holds a direct link with her past Mexican culture. Her inspiration comes from the source itself and her figures instantly incorporate those same spiritual values and mythological content. It is as though she was just the latest contributor in a long, unbroken tradition. Her brave, long-legged hunters and gods wear their souls on their outer skin which is decorated in direct, attractive body marking and handsome, highly potent, mythological symbols.

But Portela's work is not just concerned with what her figures may suggest in the way of ethnic camouflage or tribal identification, she has a universal message to send – one of unification, and what is infinitely valuable – to save the content and the message from past cultures throughout the whole world. She has chosen the power that good sculpture can bring, and goes for impact. Portela revels in the pleasure that this act of creation brings. She says, 'I have been working with ceramics for fourteen years and during this time it has been a pleasure for me creating sculpture with my own hands. I face life and art with quality and intensity. I enjoy playing with reality because it can be altered.'

With her natural gift and talent for putting her message across, Maribel Portela's work can

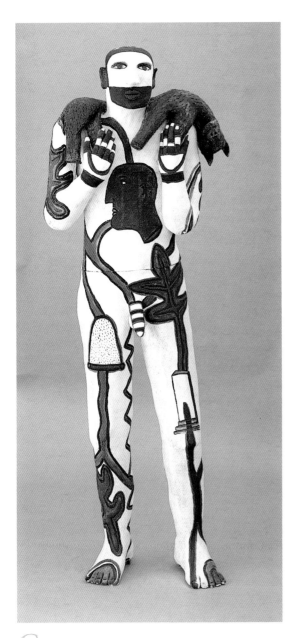

*C*azador De Perros. *2000. Zacatecas clay and engobes; 147cm × 46cm × 31cm. Carlos Alarcon*

describes her training: 'I was born in Mexico City on 7 March 1960. My father was a Spaniard, arriving in Mexico after the Civil War. My mother is a wonderful Mexican woman. I grew up in a common neighbourhood of Mexico City. As a child, my family and I used to travel around Mexico; that is why I know very well the Mexican culture. When I finished college I got a job in a photographic archive. In that place I usually classified material from the pre-Hispanic cultures which caused my insides to sing.'

Although Maribel Portela has sent a picture of a priest of the God of Death (AD1325–1521), she states that various images from different cultures throughout the world form a perpetual inspiration for her work, because what she is really interested in is looking for 'the essential thing, in our remotest and mysterious primitive link with the universe. I am concerned with searching out the internal and external reality in each piece I create. In order to achieve this, I deal with myth, magic and rituals which, in my opinion, are part of a spiritual condition that is related to the cosmogony of ancient cultures that still remain.'

Clay as a material is very much part of the history of Maribel Portela's land. She reminds us 'that Mexico is a country with a tradition and culture in which *barro* (clay) has been an important element for all the different and ancient peoples that evolved from here.' For her technique today, the artist gets her *barro* from Zacatecas, a region in the north of the country, although she does mix this with other clays. She coils her figures, shaping the walls of each piece little by little, but without their getting thinner than 2cm. She uses the slabbing technique to make reliefs. Her work is not too refined as she says, 'I like to keep in each sculpture the traces of a rough and bumpy texture that occurs while I make it because I do believe that this gives to the sculpture a kind of strength.'

One of the things that makes Portela's work so distinctive is her use of engobes, or slips, all of which she makes herself. In decorating her pieces, she shows a free, instinctive way of working, a brave spontaneity that creates character and charm. It is her approach, so unafraid and untentative, that sets it apart in a class of its own. Her strong signature is the application of coloured engobes which are applied over a body engobe which has the purpose of drawing the whole figure together to make a canvas for her all-over symbolic decoration. This is at once

be an inspiration to all artists working today. Her human forms in clay contain the essence of what many of us are constantly seeking to aspire to in our work – a deep, spiritual essence and clarity of vision. Picasso would have recognized instantly what they stood for and smiled at the reasons for their creation.

Portela's whole existence has undergone a close relationship with her past culture so that she is able to employ the language of its ancestral symbolization to speak for her today. She

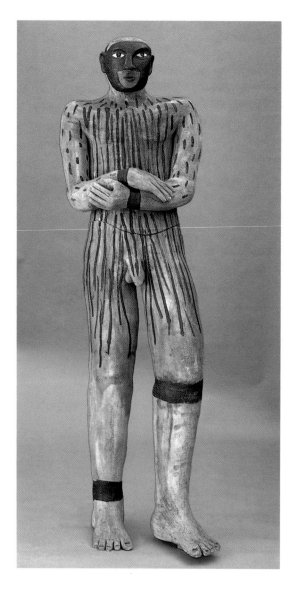

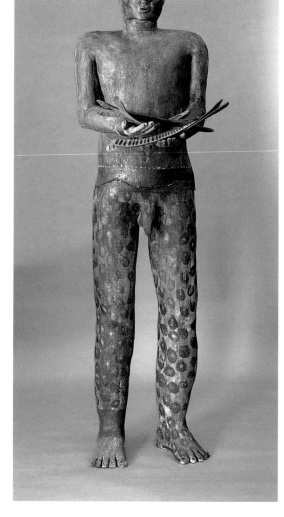

Recolector De Lluvia. *2000. Zacatecas clay and engobes; 146cm × 55cm × 31cm. Carlos Alarcon*

Recolector De Vainas. *1999. Zacatecas clay and engobes; 161cm × 51cm × 52cm. Carlos Alarcon*

delightful and profound. (I love the striped penis and the spotted camouflage.)

Maribel Portela does not use glaze very much, but she describes how she 'sets the pieces in a 1,060°C kiln, and sometimes', she explains, 'I blacken them with wood out of the kiln, and finally I polish them. In some cases I combine ceramics with metal, wood or stone. The purpose of using these varied elements is to … satisfy myself. But, much more than focusing on techniques, I'm interested in the shape and the impact that produces the finished work. Basically, my work is focused on the sculpture

itself and the materials I use are different kinds of stone, bronze and wood – but actually my favourite material is ceramic. Nevertheless, I am still interested in searching for new techniques and materials. That is why my encounter with materials hasn't finished yet.'

Portela has exhibited every year in discerning galleries in Mexico and throughout the world. Because her work is so much steeped in her own culture, as well as showing so much of her own original personality, it is a privilege and certainly a joy for us to see and share it whenever we can.

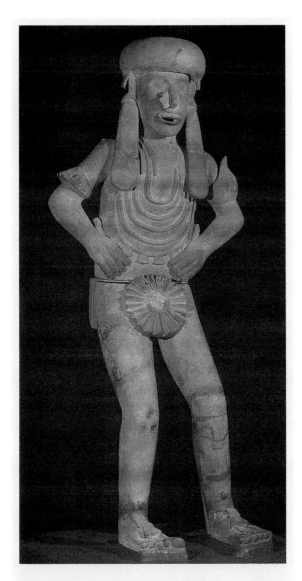

*I*NFLUENCE
Sacerdote Del Dios De La Muerte. 1325–1521;
156cm × 65cm. Courtesy of The Department of
Anthropology, Mexico City and the Mexican government

Sandy Brown [England]

I do not want to know in advance, I want it to be a journey of discovery, that is part of the reason to make it, to find out what it is going to be … It is like the language of dreams, reading one's own art. Sometimes the meaning is embarrassingly obvious, sometimes obscure until maybe a few years have gone by.

Sandy Brown's sculptures are a series of smiles and electricity. She works direct from the heart, the mind and the spirit, while her hands deploy the clay to create a expression of an intellect truly liberated. She acts like a power bolt from the mains and becomes suddenly the artist of 'Whoosh, in one go.'

Brown uses only a limited palette, and this, with a single clay and a white slip, is enough for her to build great Earth mothers and striking celebrations of femininity, whose surfaces are tactile and patterning sensual. Her 'play' always flows seemingly without hindrance. If there is a hindrance, then it is wrong and needs a bypass.

Although she is a free spirit and appears to go at everything with uninhibited abandon, it is not exactly like that. The concentration is intense and exhausting. The artist has first to set herself right and ready, centred and in control, poised like a lioness on the hunt … it is then that she can direct the energy in a straight line to where she wants. She has learned this discipline in Japan; but there was a big wait before Japan happened.

Sandy Brown was born in 1946 and did not have much of a start in life. In 1989 she wrote, 'I didn't have a happy childhood so I'm having it now. I am an adult with the joy of playing […] My father influenced me most by loving me for a short time then leaving me as a young child, which changed my personality to that of an angry, hurt child. It sealed up the creative flow for nearly thirty years. It is now bursting open with all the force of an angry bull. My mother influenced me by letting me go. She likes wild flowers which grow free.'

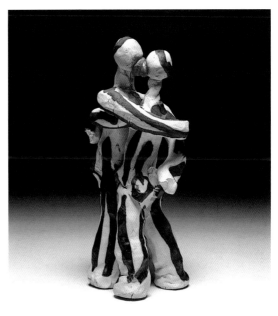

*L*overs. 1998; 6cm × 6cm × 37.5cm. Russell Baader

Kara and Ulana.
2000; 79in. Photo:
Takeshi Yasuda

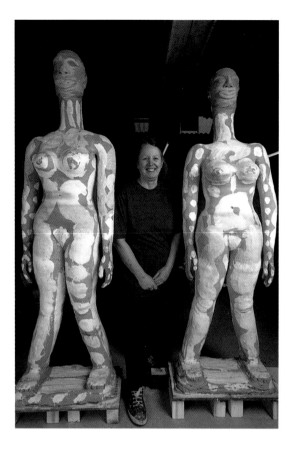

In 1969 Sandy Brown set off to go to Australia overland. Three years later she arrived in Japan with five dollars and the address of the youth hostel in Tokyo. Before long she had discovered the Daisei Pottery in Mashiko and fallen under its spell with its eastern methods of instruction. There she received her training and also met her future husband, Takeshi Yasuda, returning with him in 1973 to England to set up a studio, first in Hampshire, then Devon. Since then Brown has lectured, given workshops and exhibited throughout the world. Now, amicably divorced from Takeshi Yasuda (in 1994), she lives in a Georgian house in north Devon and everything is centred happily around her work.

Today, she has become an artist of maturity and wisdom, with much more control and understanding of life. Japan is still her second country because it gave her the ability to get back to basics and new ways of thinking. It was the Japanese magic which allowed her to grow into the free spirit of today. Because she is now so fused with the art, Brown has become a personal performance artist, needing to be intensely involved with herself and her work while the process is going on. Every time a new

group appears it is like a celebration. Sandy Brown is a national treasure.

Her way of working, as she describes it, reminds one of a magical fairy story: 'I was having nightmares about being in planes which crashed, and others about never being able to get off the ground. A psychotherapist friend said that the dreams were about my life. So I made my first figure, a Bird God, to help me. He is a small, stick figure with big wings, flying. I still have him, he sits on top of the kiln, and is Kiln God now.

'I was influenced, if anything, by the teachings of Carl Jung. I thought, mistakenly actually, that it would be possible to resolve my crashing life by making these flying figures. (I see now that I was attempting to fly away from the crash. The healing did not occur until I went into the crash some years later.)

'I made more figures, and they were also flying, each one getting bigger, with stronger wings. They looked childlike, fresh and free, like my painterly ceramics. I made one every month or so. I feel wonderfully free and joyous when I'm making art, as if I'm playing, totally free, able to do anything I want.

'At first I wasn't thinking of exhibiting them. I just showed them to people who came to the

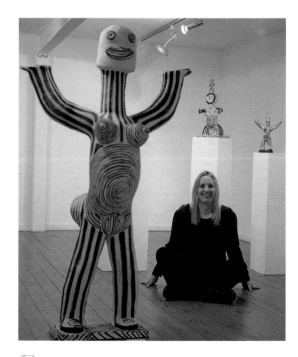

Full Moon Goddess. *1990; 6cm × 6cm ×*
175cm. Takeshi Yasuda

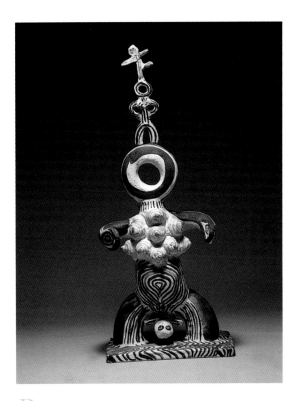

Birthing Goddess. *1990. Height 32in; Takeshi Yasuda*

studio; I could see that they were also touched by my figures and could see things about their own lives in them. Quite often what is the most personal is also universal. I then realized it was important to exhibit them. I first showed them successfully in the solo touring show, 'Sandy Brown: the Complete Picture' of 1986–89, and have been exhibiting them ever since.

'I didn't need to see or know about figurative art to make my figures. I just did it, without thinking or planning. In fact I didn't start looking at figurative art at all until one day in the late 1980s when I saw a figure in the Museum of Mankind in London which was identical to one I had made six months earlier. That was one which came after the flying figures; it was a simple figure with a circle for head, semi-circle for arms and legs and two pointy breasts. The one I saw had been made in wood, in Africa. I got goose pimples on the back of my neck when I saw it. In a way I felt that seeing a primitive figure was an affirmation of something. Obviously I can't say that that wooden figure influenced me, but it did make me curious about what was going on in the rest of the world.

'Since then I have read and loved Marija Gimbutas's book *The Language of the Goddess*

which has illustrations of the first figures found many thousands of years ago, which are in clay and are nearly all female. The piece that has moved me most is the *Venus of Willendorf* together with those early figures. I felt at home with them. I love that celebration, adoration even, of the female as goddess. Our culture does not have female deities. Those early figures show how revered the female was: they express the essence of female, and bigness. Big breasts, big bellies, big vulvas. When I see those figures now I love that confident simplicity. I have chosen for my influence picture an early Japanese Jomon clay figure. I love, too, its simplicity; also its warmth and its direct tactile sensitivity, and its breasts and its pubic triangle.

'During the past twenty years I have made figures every so often, and each one is an indicator of where I am, if I can read the language. From the start, there is narrative all through the figures: some are very painfully personal which I couldn't bear when I first made them: although most are strong, earthy and very female.

'I did make some male figures a few years ago when I did a series of lovers, and then pairs. Over the years my figures have gradually got bigger, and are nearly always female, with big bottoms, breasts, bellies and vulvas. I seem to need to celebrate being female. I remember as a child being puzzled as to why my dolls had no vulvas. Why are they wiped out? So those parts are always celebrated in my figures.

'Recently as the figures grew bigger they outgrew my kiln. I had to dismantle them to fire them, and then reassemble them after firing. I wasn't completely happy with this so I have just finished building a new kiln large enough to fire seven-feet-tall figures in one piece. The two most recent figures were the first ones fired in the new kiln.

'I make all the figures from the base upward; smaller ones under four feet tall are usually made solid. Solid clay, when it is allowed to dry out completely and is fired very slowly, fires well. Now the taller figures are still made by starting with the base, and are coiled, like a big pot. I just make the base, then the feet and go up and see what happens. I resist all attempts to second guess what it will turn out to be, as I do not want to be in control. That is why I am so pleased with the two most recent figures, *Kara* and *Ulana*. I didn't try to make them calm and monumental and meditative, they just are that way. And in so being they are, I believe,

representative of all women now, at a time when we are stronger than ever before. Strong simply just to be. I believe *Kara* and *Ulana* show us as we actually are. By that I mean women who are strong, proud of their curves and their roundness including bellies and buttocks. This is unfortunately not as we are represented in popular culture because of the influence of gay fashion designers who would have us deny our curves and conform to their erotic fantasy of a prepubescent, boyish silhouette. I think part of my unconscious motivation must be to redress that balance, to show us as we actually are. I find it a very exciting time to be making female figures, for a female artist to show what it is like to be female, after many centuries of the female in art being represented by males.

'I want the clay handling to be as it is all throughout my ceramic work, that is, direct, bold, not fussy, and with fingermarks every-where. I use a coarsely-grogged stoneware clay, which fires to a light brown colour. I brush on a white slip. I do that loosely, freely. At this stage I am relaxed, doodling, going *tum te ta*. Then, when they are drier, I paint them with the same coloured glazes as I use on my pots. It is basically one simple transparent glaze coloured with oxides such as those of cobalt and manganese, and with glaze stains to make several coloured glazes.

'Then, when they are completely dry, I get to use my new toy, my Christmas present, which is a yellow pallet truck to carry them gently into the kiln. So they are seven feet tall, and fired in one piece. I raw-fire them to 1,230°C or so. The secret of firing big pieces safely is to be absolutely sure they are bone dry, and to allow 24 hours or so pre-heating before going above 200°C. I have fired life-sized pieces which were solid successfully by observing that.'

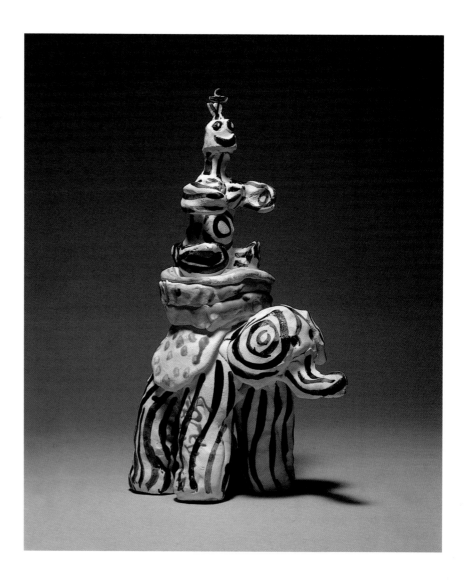

Goddess on Her Elephant. *1991. 6cm × 6cm × 45cm.* Stephen Brayne

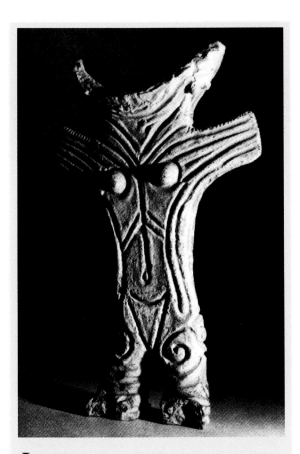

*I*NFLUENCE
Jomon figure. Early Japanese clay figure.

Helen Ridehalgh
[England]

The human figure, its character and pose, has always fascinated me, and, recognizing this, I am trying to interpret the essential whole that constitutes the person from the many complexities observed. The surface colour I strive for comes largely from my interest and experience in metalworking techniques, particularly bronze casting and its patination as well as a general fascination with the natural ageing process of metals.

Helen Ridehalgh's sculptures are like modern archaeological finds, very sumptuous in appearance and recapturing an aesthetic classical tradition in the beauty of their form. The artist delights in the clayness of clay modelling, and then bringing to her torsos exactly the right patination to celebrate that form, giving it a deep chiaroscuro effect of the kind you can get with bronze. This she learned while being

allowed a sabbatical from fourteen years of teaching at Ripon Art College. Ridehalgh wisely chose Camberwell in 1979, where she was part-time lecturer in drawing and the history of ceramics, within a lively department led by Ian Auld. She describes how she 'took advantage while in London to attend three courses of bronze casting, two of which used the ceramic shell process. It was a wonderful experience combining the skills of modelling, pouring, "archaeologically" revealing the cast and experimenting with exciting patinas. The experience of bronze casting has deeply influenced my ceramics.'

The artist's work does have that particular quality and also seemingly the 'weight' of a bronze. The fragmented edges of her torsos approach the nobility of a piece of bronze dug up from the earth, and when you see that the ceramic 'skin' is not very thick, you realize that Helen Ridehalgh exhibits great skill and control in the masterly way she creates the feeling of density and realism in her work.

The secret that she uses to get this depth of realism is revealed through her honesty of approach and in her experience of looking. This is achieved through drawing. With drawing, the pose can be properly clarified.

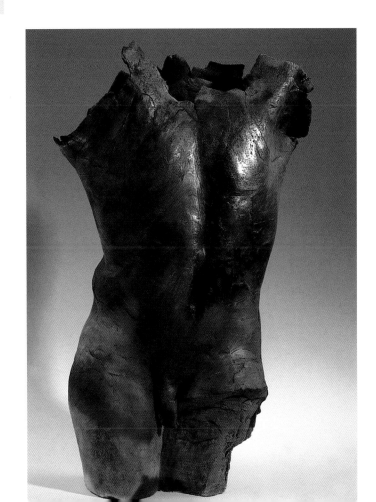

*T*orso VIII. *Smoked T Material; 56cm. Tim Long*

Drawing, in my estimation [says the artist], is very important as its spontaneity captures that immediate observation and also accommodates the 'line' of one's imagination, that important subjective and yet allusive quality. As I draw I search for an understanding of these forms that inspire me, for instance, archaeological fragments which even as relics convey a vital piece within the human jigsaw; rock strata, their powerful structural forms which also rely on a rich palette of colours; the form and patina of aged bronze sculptures, the shell of which may often be no more than millimetres thick but yet exude a presence – a thumbprint of mankind's understanding. It is through the medium of fired clay that I am able to interpret all of these observed qualities.

Helen Ridehalgh explains her own working process thus:

Torso VII.
T Material, oxidized glaze-fired to 1,250°C; 60cm. Tim Long

I begin by modelling a maquette of the life figure. With none of the restrictions of ceramic technology I am able to work with uninhibited speed, trying to capture the essence of the pose. From this maquette I then work the

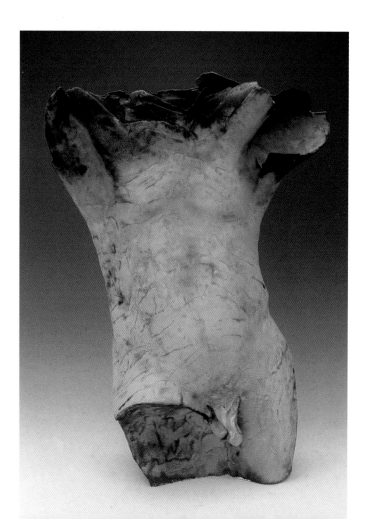

ceramic sculpture adjusting the scale accordingly. I use T Material, which is an incredibly resilient clay and provides a white 'canvas' for delicate colour interpretation. Each torso is individually hand-built, 'drawing' out the movement of the pose. The resulting ceramic 'shell' torsos are arrived at by the interaction of external and internal modelling that forces the clay to its limits. I use an alkaline glaze (barium carbonate 11.1; lithium carbonate 8.3; whiting 2.8; nepheline-syenite 77.8; and bentonite 2.0), high firing to 1,260°C (after the sculpture has been fired to 1,020°C bisque). This glaze is sprayed on in fine layers and rubbed back until I feel that the strength of colour suits the pose. Sometimes I smoke the bisque piece and then softly polish it.

Ridehalgh has always found a good source of inspiration for her style and an excitement to get a good patination from a delightful tale of Michelangelo's bozzetto of *David*, modelled in 1501.

This exquisite model – or bozzetto – the only true, small-scale, finished model by Michelangelo, 8in in height, was made as a model for the later carving of his great statue of *David* in Florence. These bozzetti were usually made from clay or stucco. They show an extraordinary beauty of form and a delicacy of detail but also a remarkable grandeur. It was in 1690 that the palace storerooms were devastated by fire. The model that survived was severely damaged, battered headless and limbless. This mere torso still conveyed the life and personality of the original pose, the wonderful colouring becoming more alive from the fire that had embraced it – a ceramic torso one might say beautifully modelled and fired by fate.

Ridehalgh was always going to be an artist, having made this decision at quite a young age. She was born in north Yorkshire and brought up in Lancashire, her father's home county. Her parents agreed that she could study art as long as she qualified as a teacher. She was lucky enough to have her art teacher recommend Corsham (the Bath Academy of Fine Art) for her training. This was in the mid 1960s, a time of great change in art education. The artist describes her tutors there and would like to include a short dissertation on her teacher's discussion on the meaning of art:

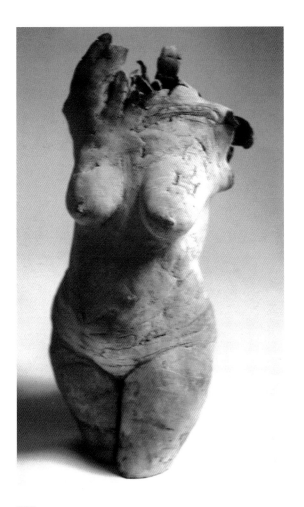

and creations must be measured against all other creations. Real things have life. All other objects stand in the shade of living things, that is, an ashtray presupposes smoking; which presupposes man's wish to smoke. That makes the ashtray a fantasy object. Can you imagine what would be thought of an ashtray by a race who had never heard of smoking?

The reality of the 'donkey' we sit on to draw is the tree. The shape and existence of the 'donkey' owe everything to man's wish to draw sitting down. The donkey is a fantasy object. If you took Michelangelo in front of his *David* and said, 'Look, you have taken a large piece of marble over 16ft high and carved it into a shape, but it had a shape to begin with – what have you done?' The man that made my boots changed the shape of the leather to do it. Is the man that made my boots equal to Michelangelo then? Is it enough then just to change the shape of the media? The coloured mud you spread on a canvas had

Torso III. *T Material, oxidized glaze-fired to 1,250°C; 32cm. Tim Long*

Torso II. *T Material oxidized, glaze-fired to 1,250°C; 32cm. Tim Long*

Bath A.A. was unique in its individuality and its ability to employ some of the best regarded artists of the time as tutors – Robin Denny, Adrian Heath, James Tower and Howard Hodgkin. Abstract art was the 'in' thing. However, it was my introduction to Ray Robinson's class that laid the foundation for my thoughts on figurative art. Ray had been Slade-trained and a pupil of Bomberg in the 1950s when a group of like-minded figurative painters, including Auerbach, Andrews, Bacon, Freud and Kossoff were pursuing the challenge of figurative painting.

In my struggles as a student I once questioned Ray on the meaning of art. Here is an excerpt from his reply:

What is Art, you say. I think Art is man's attempt to make reality. Artists make objects but these objects must be creations

*INFLUENCE
Michelangelo,
Bozzetto for David.
1501. Gesso sculpture.
Courtesy of The
Honegger Foundation,
Geneva and Thames &
Hudson*

yearning to somehow contain it – much as Gerard Manley Hopkins wrote in his poem 'The Leaden Echo and the Golden Echo':

> How to keep – is there any any, is there none
> such, nowhere
> known some, bow or brooch or braid or
> brace, lace, latch
> or catch or key to keep
> Back beauty, keep it, beauty, beauty, beauty,
> …from vanishing
> away?

But Venter's work is also a plea for safety and security. And to that end her super-reality makes a strong foundation for composure in her second life in Canada. She ensures that her pieces are deliberately toughly-made and resilient. Some of her high-fired terracottas have, in fact, survived outdoors for up to twenty years.

Kathy Venter exhibits mainly in Canada but also in South Africa, where she was born and raised. She received her training up to a Master's

a shape and a colour before you touched it. There is, of course, only one thing that can be added and that is 'life'. And 'life' is, as I said, the difference between reality and fantasy. Art is reality.

Kathy Venter [South Africa/Canada]

My life-size clay works are symbolic of the temporal in their material and the divine in their imagery; they examine the phenomena of grace and the inviolability of the human spirit. Above all, they celebrate quiet strength and powerful gentleness, and create a sense of presence within their setting – requiring the viewer to accept them as a measure of his/her own humanity.

Kathy Venter's sculpture, with its touching, gentle authority, is born out of a great need for peace. Her work delights in youth, life and a

F*rom the ground up. Terracotta; 38in × 31in × 16in. David Borrowman. Courtesy of The Vortex Gallery, Salt Spring Island, BC, Canada*

Sleeper. *Terracotta;
72in × 15in × 12in.
David Borrowman.
Courtesy of The Vortex
Gallery, Salt Spring
Island, BC, Canada*

Diploma in Fine Art Sculpture at the Port Elizabeth Technicon in Cape Province. In 1989 she emigrated to Canada, where she now lives and works, still continuing with the special method she developed at college to build life-sized figures out of clay. She says:

'My main interest all through my training years and my career as a ceramic sculptor has been the human figure, both smaller studies and large-scale works. These are complex and often very personal. The earlier pieces were born out of the political turmoil and violence of my homeland, South Africa. The calculated simplicity of the figures expressed a yearned-for sense of permanence and stability, a view of the absolute through the singular, a monumental sense of equanimity founded on the belief in a world governed by divine purpose. This is symbolized by the clearly defined, outer line of the entire work which displaces space and forms a close tension between the figure and the atmosphere.

'The larger works, executed since emigration to Canada, reveal freedom of expression and movement. A sense of reverence for the human form is the filter through which this residue of gratitude passes, collecting and forming an integral part of my vision as it does so. The result of this process is, I hope, the rendition of figures imbued with sensitive perception and intuitive feeling, the sharpened edge of intent being integrity of expression. The work reflects values of quiet, contained emotion which draw the viewer in and bring about a willing participation.

'In my series *Only Person*, shown here, I wish to explore the dual residency within the human form. The girl woman, an adolescent. The child is not yet superseded by the adult, both being visibly present. How these presences reside and reveal themselves without contradicting or overpowering each other is shown by a surprising, subtle and delicate balance. The clothing fits close to the form, creating no hindrance or interruption, stretched tight over the shoulder muscles and elsewhere falling loosely away from the body, creating deep shadows.

'The sleeping figures lie in soft pillows, showing the weight of the arms and head. The traces and residue of mental attitudes and convictions are evident in the posture and movement and shape of each muscle and limb, culminating and summed up especially in the hands and feet. These are articulate and carefully observed.

'The great influence for making my life-sized figures came from a study I made of the exhumed terracotta army of the Emperor Shihuang Di of the Qin Dynasy. These Chinese, life-size terracottas have technically influenced

Sleeper. 2000. Terracotta; 13in × 58in × 21in. David Borrowman. Courtesy of The Vortex Gallery, Salt Spring Island, BC, Canada

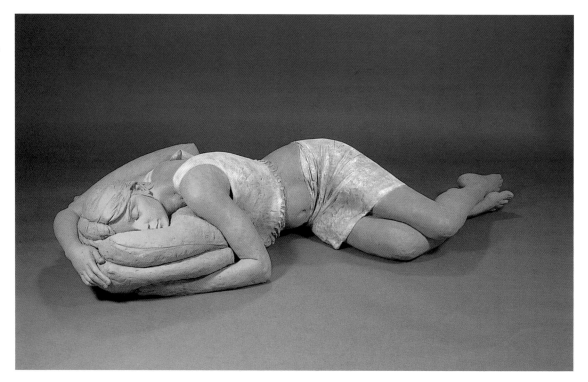

Sleeper. 2000. Terracotta; 13in × 58in × 21in. David Borrowman. Courtesy of The Vortex Gallery, Salt Spring Island, BC, Canada

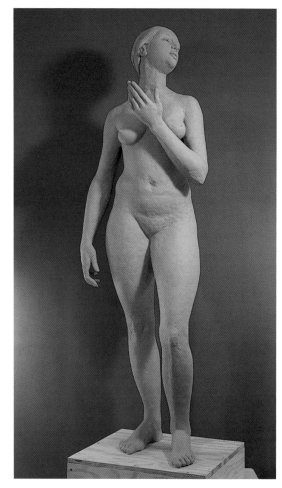

Standing Figure. Terracotta; 65in × 18in × 16in. David Borrowman. Courtesy of The Vortex Gallery, Salt Spring Island, BC, Canada

every work I have made by the breakthrough they led me to in building figures on a life-size scale. Many of these were broken, showing the hollow interiors and even the thickness of the walls and the coil-building method. I experimented with this method, but found that on more complex forms the weight of the coils was difficult to manipulate. I decided to use pellets of clay but still to work in a spiral (as in coil-building). Extending each pellet after application gave the method its versatility to accomplish any form without the need for armatures, interior support structures, moulds or casting.

'The lower sections are shaped and completely resolved and finished before the area above is constructed. Using my pellets of clay I work spirally in the extended pinch method from the base upwards, allowing the walls to dry almost to leather-hard to hold the height and weight of the new construction. This requires a clear vision of the proportions and lines of the yet incomplete parts – and the figures also have to be 12 per cent larger than life-size in order to accommodate the shrinkage.

'Keeping the walls throughout of an even thickness reduces the tension of drying and firing, thus eliminating the possibility of cracking. The shaping of the curved forms takes place by alternating pressure of the hands on the interior

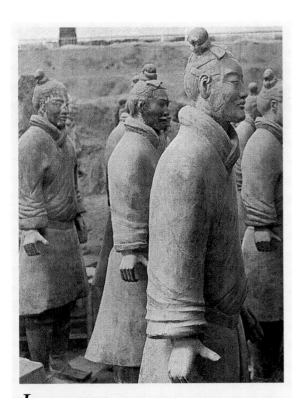

*I*NFLUENCE
Standing Warrior. *Qin Dynasty: Emperor Shihuang Di*

and the exterior of the walls. In the same manner (but much slower) as a pot is formed on the wheel. The wet surface is worked with a rubber kidney in areas to push the grog into the smooth clay and to bring the finer clay to the surface, creating a smooth texture. The clay I use is hand-mixed in equal parts of white stoneware grogged body and red earthenware ungrogged body. The hand-mixing creates a slight variation in hue which enhances the fleshlike quality in the fired pieces.

'The sleeping figures are begun with a coil of clay extended on the base over the full line of the figure and pillow. Building proceeds simultaneously from toe to head, the highest points of shoulders and hips being the highest and final building stages. An acute knowledge of the possible limitations and extensions of clay is necessary. This building process is direct and immediate, up to and including firing. The figures are high-fired in one go (to cone 8) in a large electric kiln or wood-firing kiln. Colour on the surface of the clothing is dry-brushed acrylic paint or engobes.

'Apart from the Chinese terracotta army, Etruscan funerary terracottas through to the

baroque terracottas of the late nineteenth century inspire me. I have been moved, too, by sculpture from the Archaic Greek through to Bernini's *Blessed Ludovico*, the connection being the delectable presence of thought and emotion within the form, the depiction of the human form as the vehicle of mind and soul as well as of blood and bone.'

Vanessa Pooley [England]

My work is an emphatic exploration of the female figure. The starting point is being female and my ambivalence about female shapes. I try to show positive, bold, rounded, solid forms in a sensual way. I make ample, curvy, feminine forms that are beautiful. Since having children recently I feel even more focused on making my sculptures emanate calm, wit and beauty, wherever I can.

Vanessa Pooley is a natural. She is able to work clay how she wants, filling out shapes which are fat in volume, almost succulent. Her sculptures look pleased with their dispositions and are always positive in the way they greet the world, displaying *luxe, calme et volupté*. Much of her own self goes into the work, and in this way it ties in with her everyday family life in Norwich. This was where she was born and educated and, after taking a BA in fine art at the Norwich Art School, she went to London to take her postgraduate diploma in sculpture at the City and Guilds School (and to meet her husband, Tobias), before returning to set up studio, have children and make a home back in Norfolk. There she is completely content.

This contentment is used to create Vanessa Pooley's work. It echoes its maker's enjoyment of the material. She approaches each new idea

*T*ouch Bottom. *1994. Ceramic; 37in × 15in × 15in. Photo: FXP*

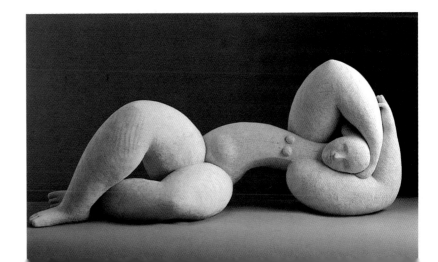

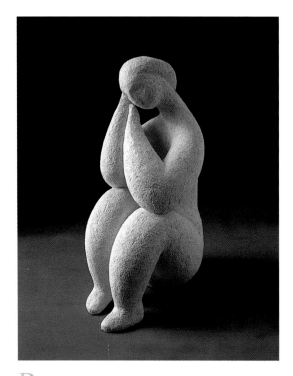

Rachel. *1998. Ceramic; 9½in × 6in × 4in.*
Photo: FXP

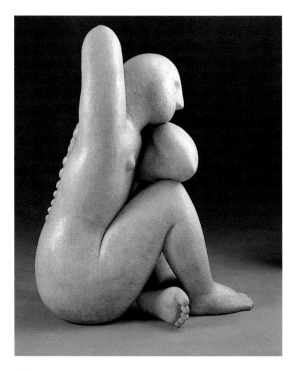

Female Figure with Plait. *1993. Ceramic; 38in*
× 18in × 20in. Photo: FXP

with such an equable energy that you wonder if she has any difficulties to overcome in its making. I know that sometimes the journey to the finish is easy, other times a lot of work is needed until it is as she wants it. If there are occasional rantings, it never shows; it looks easily conceived and carries that feeling over into the finished piece.

Pooley uses a grogged C Material and her figures are modelled solid. It is this that gives them that feeling of weight and the forms that meaty solidity. And, by working without any armature, she can get her sculpture exactly as she wants it without compromise, until it is just right. She can also concentrate more fully on the ability to keep a taut surface over her work, to hold the tension and stop 'negative spaces' from entering a curve or form. It makes her pieces, too, excellent shapes to cast into bronze, which is what Pooley does with many of them.

After the modelling is completed, the forms are hollowed out to about a half-inch thick. This allows them to dry evenly, and be fired to 1,180°C without exploding in the kiln. The finished pieces are coloured with layers of oil paint, building up a patina which also shows agreeably the gentle markings of surface texture that a serrated modelling tool can give.

Her sculptures hold no special, deep meanings. They are what they are: glorious celebrations of the female form – with a touch of fun thrown in. The final pieces are a cohesive collection of simple shapes that relate well to composition and weight. Sometimes a chunky plait will course down the female's back, looking like a chain of wholesome bread rolls. They are reminiscent of the work of several late nineteenth- or early twentieth-century sculptors, namely Henri Laurens, Miro, Arp, Picasso and Brancusi. But it is the sculptor Marino Marini with whom the artist identifies the most, and one work in particular has been her constant inspiration. She says:

I first saw pictures of Marino Marini's work when I was at college; he was recommended to me by a tutor, but I couldn't see the point. They just looked heavy, leaden and lumpy. How wrong can you be! I saw them on and off and gradually realized his immense sensitivity and gentleness. Combined with the frank and honest approach to the female figure, they became fascinating to me. At the same time as portraying the dumpy solidity so many women have, he takes it that strange step further to a simple but quietly dramatic sculptural shape. Walk

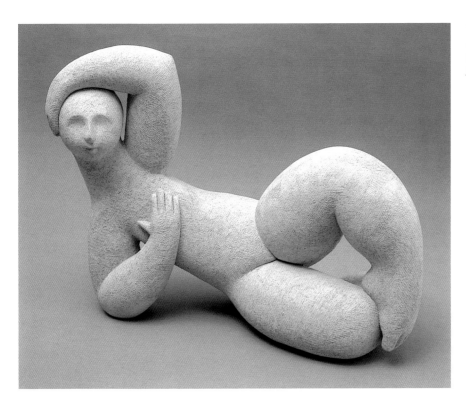

F. F. 1990. *Ceramic;*
18in × 10in × 14in.
Photo: FXP

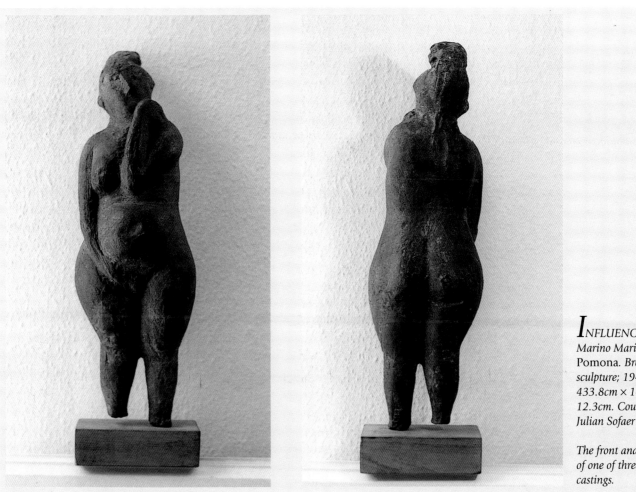

INFLUENCE
Marino Marini,
Pomona. *Bronze*
sculpture; 1944;
433.8cm × 14.1cm ×
12.3cm. Courtesy of
Julian Sofaer

The front and the back
of one of three bronze
castings.

round and you are never disappointed, each viewpoint different and working in its own way. This *Pomona* is well-rounded but elegant; awkward but poised; ugly but beautiful. It takes just a bit of time with her to lose the ambivalence and fall in love with her.

Marini said of his *Pomonas*, 'Probably they should be nameless, as befits the fostermothers of history. They are anonymous images like the statues in a cemetery of people you don't know, but who move you after 2,000 years with their essential humanity, free of any subjective overtones.' In his work you get the sense of the particular, odd, vulnerable model that he is referring to at the same time as it is also being generalized, nameless and ancient. They transcend any fashion, the forms being feminine without overlay. He managed to take the essential female form and serve it pure and unsentimentalized.

Marini's work has so many qualities I wish mine had; it would be easy to be dispirited by the perfection of it. However, when I see his work I always get an impulse to get back to my own work, totally inspired by just how right and wonderful a piece of art can be.

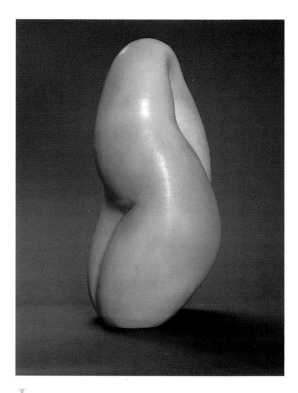

Leda and the Swan. *Porcelain with shadow glaze; 51cm × 27cm. Stine Heger*

Tove Anderberg [Denmark]

I regard my works as bodies and my glazes as the skin, and my continuing effort is to draw these two as near to each other so that they unite naturally in the expression of the final work. At the end of the day it is the drama, the illusionism and the sensual feeling arising from the effects of light and shadow and from the layers of glaze that is the real substance of the work.

Tove Anderberg's sleek sculptural pieces display a special kind of classical elegance and purity of form. They are to be found in most of the Danish art museums as well as embellishing several public places and private buildings. People look forward eagerly to the event of an exhibition from her every four or five years; work which comes out of the middle of a forest in Hammer Bakker, where the artist lives. There, in a large workshop, Anderberg puts enormous energy and feeling into her pieces, making beautiful bowls and torsos. The torsos are a relatively new departure, and further explorations on this

theme will appear. These figures in clay are luxuriously feminine and show a profound fusion of the organic with the abstract.

It takes two processes to form them, of equal importance. Tove Anderberg insists that it is strictly the combination that is important. First, there is the creating of a sensitive form (or body) which is refined until it is as thin as a blown-up balloon. Secondly, the application of a rich glaze (or skin), when up to twelve layers of fine shades may be applied to get a surface which has the right brightness and light. As each veil of glaze is added – like the dressing of Salomé before her dance – the surface becomes more sensual. One by one each layer is absorbed into the body during the firing to fuse with the clay. Afterwards, a deep glow radiates and sings from the skin, celebrating the form it encloses.

Anderberg's forest comes to her aid to bring this about, because she herself uses it for the manufacture of her glazes. 'Most of my glazes are ash-glazes: willow tree, rowan tree, beech, spruce, volcanic ash.' There is also a symbolic fusion of herself with nature, the artist reveals that 'even human hair, burnt to ashes, is part of my glaze'.

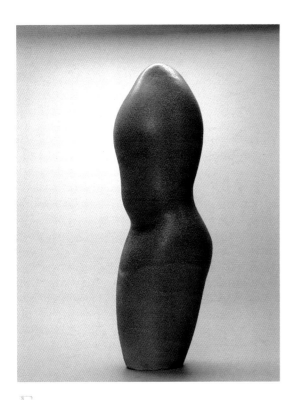

Egg-Woman. *Porcelain with glaze in two textural effects; 50cm × 16cm. Stine Heger*

exactly where I stood and that I was free to be as I was. I knew exactly which way to proceed [...] I especially remember his saying that even if we never saw each other again, he knew that we would be meeting again and again. And that proved to be correct. I continue to take up what he showed me.'

It was during a study-tour both to London and Amsterdam in 1972 that Tove Anderberg fell under the spell of Maillol's sculpture and his forms. And it was later, on a visit to Rome in 1995, that she experienced the work of the Italian sculptor and architect Lorenzo Bernini, who was to remain a constant preoccupation, inspiring her way of working with textural effects. 'One of his works, *La Verita Svelata* in the Galleria Borghese, had an immense impression on me', she says. 'In his marble sculptures Bernini

Anderberg is influenced by every fluctuation of the natural world around her. 'All my colour inspirations come from the colours of nature,' she says, 'especially from the flowers.' The artist acts as if she were a large telescope, receiving subtle nuances communicated to her senses, her mind and her body. It is her response to these stimulations that she channels into her work.

She was born in 1942 and brought up on a farm in Aalborg in the northern part of Denmark. In her early years she was taught painting and drawing by Renal Bache and Carlo Wognsen, and later by Per Gunther and Valdemar Foersom Hegndal. But by 1972 she had moved to Århus and enrolled at the Academy of the Arts. There she learned different methods of throwing and, under Rie Kaae, embarked on her journey of learning about the chemistry of glazing. Her education was completed under the influence of a number of people who were to shape her philosophy and to influence the form her work was to take.

The first of her mentors was Bernard Leach, met during a visit to his studio in St Ives. She describes how her own 'sense of poetry was corroborated. So when I came home, I knew

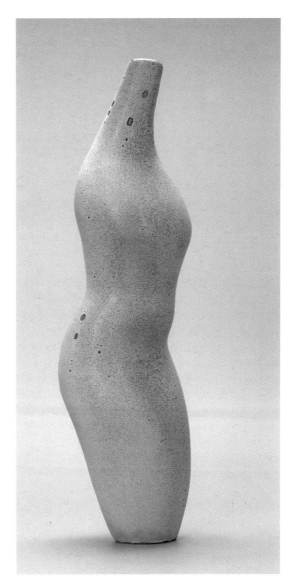

Bottle-Woman. *Porcelain with shrinking glaze; 41cm × 11cm. Stine Heger*

*I*NFLUENCE
Bernini, La Verita
Svelata. *Marble.*
Courtesy of The
Galleria Borghese,
Rome

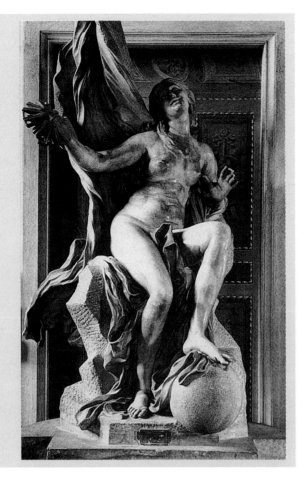

shows an endless number of variations and shades of texture. His style is very impressive; he can transform a hard marble to look like soft skin. This can be seen particularly in *La Verita Svelata*. Here he is a master of contrasts. He can make the surface of the marble cover a wide range: from coarse to finely-shaped stone; from the silk of the skin to the velvet of the curtain; from the finely-shaped ball to the coarsely-shaped rock behind it.'

Finally, she visited an exhibition in London showing the work of Lucie Rie. 'Immediately', she recounts, 'I replaced the stoneware – which had satisfied my need for simplicity in both form and colour – with china clay. This, in combination with transparent glazes, could produce bright and luminous colours and depth.'

Tove Anderberg describes how she works today:

'I use three different types of clay, kneaded together to a smooth unit with a 0,25 chamotte (grog) to stabilize the load capacity: German Odenwälder clay, English Podmore clay and white china clay with grog. The mixing ratio

varies depending on the idiom in question. I work with open and closed forms, small and large forms up to ceramic sculptures weighing 2 tons – which I cannot do in my own workshop. For many years I was convinced that the clay was the boss in our co-operation, that the clay remembers, that the clay leads its own life which you are bound to respect and which sets the limits for the final results. But in later years I have been working with much more deliberation and purpose with my own idiom. The final work is accordingly the result of a combination of the locked-up … and chance.

'My torsos are closed sculptural forms. First, the base is thrown, then the body modelled up from this until the final form is closed over. The closing itself is done by modelling a top piece larger than that required. The clay shrinks into the top, and the trapped air will stretch the form. I always work with very thin clay walls – right up to the bursting point – in order to obtain lightness of form. (This is why I never use plaster moulding techniques, because work made by this method lacks the inner tension I need, and results in looking like a shell and not a torso or a bowl.)

'Final modelling is done against this cushion of compressed air trapped inside. I am able to stretch the skin of the clay where I desire, still keeping the inner volume taut against the outer skin. Now, with a pin, I pierce a hole, letting the air out little by little … until the top-form follows the rest of the surface and does not resemble a hat any more. My greatest challenge, working with very thin clay walls, was to find a suitable glaze for it. Each glaze has its own character. The softness and the hardness of the ashes determine how they can be used. As well as my ash glazes, I also use glazes based on pewter, zinc, barium and feldspar with a melting point of 1,260°C. One of the special ways I have found is to induce a local reduction by having coal-like particles in the glaze. I reduce oxygen at the end of the firing, and, when the coal burns, flecks of changing colours are achieved.

'The process of glazing is very slow, because there are so many interactions possible: the chemical composition of the clay with the glaze, the type of glaze, the lustre and the depth of the glaze, the thickness of the body, and the temperature of the firing – all play a part in the final result. But – on top of this – lies the unforeseeable, the chance element in ceramics: the peculiarity of the clay and the reaction of the glaze with the specific form – elements that

are so important that I almost feel thankful for a successful firing. But the chemistry of the glaze is very exciting, too. At the high temperature I fire with today, I am closing in on the limits of the foreseeable. Just a few degrees, a few minutes difference from a former firing, may result in something quite new and different – and often a result that deserves only one fate: the hammer! But when a glaze lies properly in the grooves and over the ridges, spreading correctly along an edge, or hanging like a fur coat over a rounded form – then the glaze will always be in an intimate relationship with the ceramic form. New glazes inspire new idioms, new idioms inspire new glazes in a continual interaction, keeping the process alive. But at the end of the day, it is the drama, the illusionism and the sensual feeling arising from the effects of light and shadow, and from layers of glaze, that is the real substance of the work.'

their strange, dreamlike forms also remind one variously of Venus fly-traps, our internal organs, of plant germination and inflorescence, of sea-worn beach pebbles, of extruded ice-cream scoops. These forms are created by using an unusual method.

After sketching the initial idea, Fischer prepares variously sized nylon sacks filled with vermiculite which he arranges on a board to act as formers for the kind of curve required. A porcelain slab is flattened, smoothed out and, at a consistency that is not too soft nor too dry, is placed (with a plastic sheet first) over the vermiculite bags. Then the whole thing, board and all, is raised 30 to 40cm above the ground and dropped carefully. The sheet of porcelain now hugs the shape beneath with the approximate form desired. Any alterations (possibly the addition of another bag) are made at this stage.

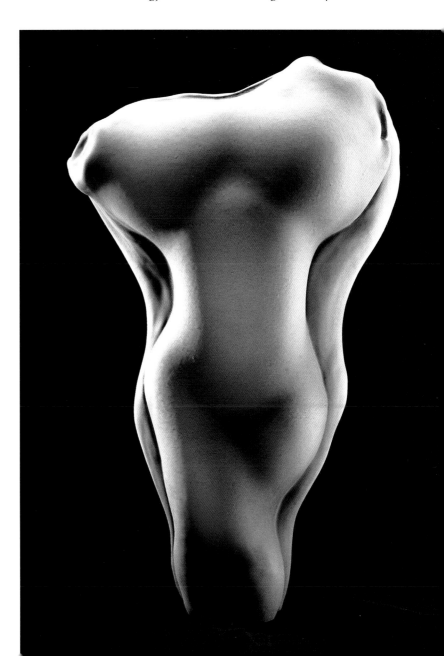

Untitled. *Sand-blasted porcelain; 70cm × 43cm × 27cm. Charly Erwin*

Wayne Fischer [France/USA]

My work tries to show what it is to be human at the turn of a century full of examples of inhumanity. I try to show the power and dignity of the sensual, life-giving form as our ancestors sensed its primordial importance over 20,000 years ago.

Wayne Fischer is the Salvador Dali of figurative ceramics. His surreal, curvingly-sensuous pieces are flower-pods of fecundity whose organic structures are totally suited to the exacting qualities that porcelain can produce. From 1972 to 1978 he studied Fine Arts at the University of Wisconsin in the USA, where he also took classes in physics. In 1986 he went to Paris to enjoy a different culture. He is now settled in the south of France, where, in 1992, he set up his own studio in order to work on his meticulously made pieces. He also tries to keep up with the world of physics and astronomy, incorporating ideas involving natural forms into his own sculpture.

Fischer used to work both in porcelain and other clays which he rakued, but since 1976 he has confined himself to porcelain for his double-walled pieces, allowing him to create a unique expression that integrates form, surface and coloration in a smoothed-over way. These curves have an obvious Marilyn Monroe fullness, but

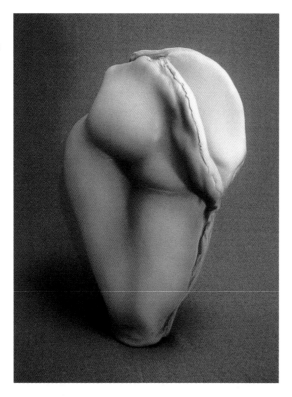

Untitled. *Sand-blasted porcelain; 59cm × 38cm × 22cm. Charly Erwin*

Then the sides of the form are cut to shape, leaving enough seam for it to be joined to another slab formed in the same manner.

When the slabs are dry enough to stand under their own weight, the artist joins them at the seams, pinching, smoothing or adding a coil of clay to help. Finally, to create the mysterious double-walled inner shape, a third piece of porcelain is thrown then joined into the top of an opening left between the two slabs. This moistened piece is smoothed and modelled into place and the final arrangement scraped and refined further.

The finished dried form is bisque-fired before the delicate layering of the glazes is carried out. Wayne Fischer produces an ultra-smooth luminescence by covering his colourants with a transparent glaze which he sprays on almost as if he were stroking the sculpture, building up layer after fine layer with an airbrush, until quite a thick glaze skin is achieved. A gas-kiln firing to 1,250°C completes the process. (Fischer now uses oxidation in a gas kiln, the use of which he shares with his wife; his professor at the University said that living in a city meant that it was bad to use a gas kiln, so he spent six years developing glazes that worked in oxidation.)

Fischer is very much a perfectionist and there is still much to do. Because of the post-firing work, his pieces end up by having an 'almost tone' – resembling a sugar-coated almond in the way that the colour looks sunken into his forms with a dense, velvety softness that echoes the curves. First the sculpture is sandblasted, then finely sanded by hand. It is the sandblasting that produces the matt surface and allows the light to be diffused. This is what brings out, through the depth of glaze, the sugared-almond colours beneath. And it is using a transparent rather than a semi-opaque glaze that reveals this depth (a semi-opaque glaze would stay opaque after the sandblasting and close the window through to the colours that lie beneath). The hand-sanding produces the final, silky surface.

Fischer is an artist of inside-outness and his pieces cordially invite you to enter into an inward space that undulates in much the same way as a venturi tube. This play with space and form is sensually exciting. He is clearly influenced by his study of physics, so he would be well aware of the formation of a black hole which sucks in energy, compresses and stretches into itself the altered surface outside and inside … wherever other dimensions might lead. His are thoughtful pieces, and it is interesting and stimulating to find an artist who allows science to inspire and influence what he makes in clay.

Wayne Fischer explains why he chose porcelain and what inspires him:

> I use the soft, malleable material of clay that is sensitive and responds to the slightest touch in a world full of concrete and steel – clay, and water, the source of all life. I use Limoges porcelain, grog, fine white silica sand and fibreglass fibres mixed into the clay to make it more resistant when working with large slabs. As I work, my feelings flow along with the clay and I don't intellectualize about them. The sexuality, for example, that people say they find in my work, it's not a conscious element really, just a connection between sensuality and new life that's been there forever. The forms I enjoy most in nature are the beginnings. There is a softness to the colours, a subtlety in the form. Beginnings are somehow more essential, so simple and basic. My work ends up being midway between abstraction and figuration. I believe that that is the place

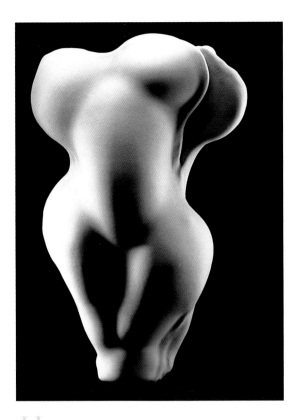

Untitled. *Sand-blasted porcelain; 59cm × 45cm × 25cm.*

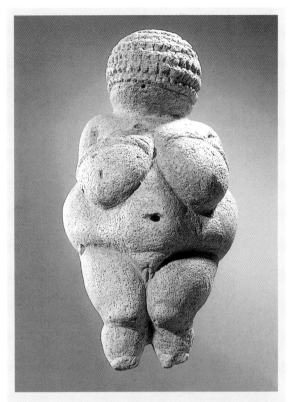

*I*NFLUENCE
Willendorf Venus. *C. 25,000 years old; 11cm.*
Courtesy of The Naturhistorisches Museum, Vienna

where the imagination can create the most powerful dreamlike imagery.

After bisque firing I spray from two to six layers of different colours with an airbrush. Then I spray a transparent crackle glossy glaze and fire to 1,250°C. After the firing I sandblast the piece in a booth with fine sand, then I hand sand. It's a lot of work but it's the only way to get the result I want. The incredible depth from the airbrushing and the transparent glaze and the smooth, satin, matt surface is like highly-polished marble.

I am inspired by the Willendorf Venus and the Venus of Lespugue. And there is also a book, called *Ways of Seeing*, that has inspired me. It is by John Berger and is a most enlightening view on the role of the spectator, audience and the intention of the artist in the history of the nude. I admire and appreciate other artists of today, particularly Carmen Dionyse, the Belgian artist, and Magdalena Abakanowicz, the Polish artist, for their powerful use of the human form; Torbjørn Kuasbø from Norway, for his more abstract use of the life force; Peter Voulkos, Richard Devore, Kvast

O'Barry and Robert Turner from the United States and Claude Champy from France, for their sensitive use of the material – clay. It is dangerous, though, to be too heavily inspired by one artist, and I suppose I am inspired most by life itself.

Lorraine Fernie [South Africa /England]

To me, art is built out of what is happening in my mind, and how those mental concepts interact with the material. The first and obvious challenges are practical things like making a sculpture that stands firmly; but the real interest lies in finding a way to be clear, and also to keep the spectator's eyes engaged, while I create the atmosphere that feels right.

Lorraine Fernie is sculptor, painter and carver. She says that in her work she aims to make 'forms that parallel violence and fear with geometry and movement in order to create as

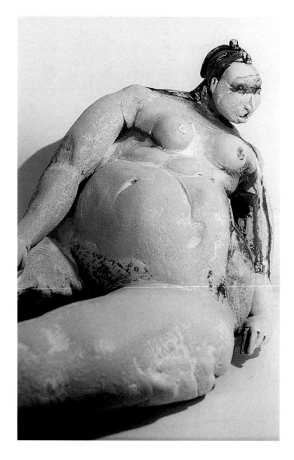

*Angry Female.
2000. 50 per cent T
Material, 50 per cent
porcelain with paper
pulp and wash of
plaster of Paris; black
stain fired on; red
acrylic colour painted
on after firing; 28cm ×
64cm × 37cm.*

*The figure is clearly
divided into a dark
back area and a light
front area. The colour
red is the colour of
anger and of life blood;
it is also used to
emphasize the pull of
the pose.*

positive and sensuous an image as possible'.
Her figures are so expressive with their wonder-
ful moving limbs and torsos on the stretch, or
folding, or delicately touching. They are forever
involved in themselves, as if caught unawares,
engrossed in personal expression or examina-
tion. Sensitive colour and markings continue to
develop the form and movement so that there is
a completed lyrical flow. They never need such a
thing as a plinth – they would be off it and
away in no time at all. Lorraine Fernie has such
a fresh clay language which is emotionally
charged with colour; and her work is so proud
in its celebration of pure existence and poise.

She is also an eloquent and clear writer.

'I come from a rural tradition where, if you
wanted something, you did not go to a shop
and buy it, instead you made it yourself. So
when as children we wanted a span of oxen to
'drive' across the rocks at the river's edge, we
made them. In this way I discovered that creat-
ing things brings me peace. My mother, who
was an inspired teacher, saw to it that our home
contained basic materials that we could use as
and when we wanted.

'I grew up and went to University in Johan-
nesburg to do a BA degree, majoring in paint-
ing. The students there drew and painted from
life models on the one hand, and worked on
design problems like those set for students at
the Bauhaus in the 1920s on the other. The
twentieth-century stress on underlying struc-
tures being the basis of art was exciting and
challenging, but I only really understood what
that meant when I encountered Romanesque
art, in the form of the twelfth-century Lewes
chessmen, which I used as a model for making
a set of my own.

'Later I moved to Britain and travelled in
Europe, where I saw a great deal of Romanesque
carving. I loved the clear structure of the build-
ings that, at given places, bursts into sculptural
life. This sense of life seemed to be enhanced by
the geometry from which it springs, as also hap-
pens with African sculpture. I wanted this sculp-
ture to be part of my life. I bought photographs.
They were not real enough. I wanted to touch
and hold as well as understand. I could have
bought weathered originals, taken down during
restoration, but I did not find the *one* so I
decided to learn to make my own, and there I
was once again back to my rural tradition.

'Constantly referring to Romanesque sculp-
ture, I taught myself to carve figures in wood. I
learnt the value of starting with a good set of
proportions. I learnt the discipline of not get-
ting lost in details at the expense of the overall
composition. But most obviously, during those
years of working slowly by myself, evolved an
instantly recognizable personal style that does
not find a ready-made niche in late twentieth-
century British art.

'Woodcarving was a very slow process for me
as I did not use mechanical tools. So when I
moved to Edinburgh in 1984 I decided to
switch to working in clay. Clay is faster to work
with, is more malleable, and has a long tradi-
tion of having colour added to the forms. I
found a workspace in the established Adam
Pottery and learnt the necessary skills by mak-
ing functional objects. Symmetry is a challenge
when hand-building. I have always based my
work on the human figure, and, after a while, I
turned from making free-standing pots to relief
sculpture in the form of decorative plaques to
hang on walls.

'Since moving to London in 1995 I have
made only female figures in the round. I have
given up glazing them in the traditional way
and I think of them purely as sculpture. I have

never been interested in making sculpture that tries to copy what the artist sees at any one particular time. Instead, I build it out of my mind. I looked for examples of Romanesque sculpture that would be sympathetic to my tendency to make baroque forms but that would at the same time show me a way to rein in the restless movement, complexity and ambiguity. To put this another way: to find a standard by which to balance violence and fear with geometry and movement and in so doing project a positive view of life. I found it in what has become a much loved sculpture of a figure on the main doorway of the small church of St-Julien-de-Jonzy in Burgundy. Christ sits centrally encased in an oval held up on either side by an angel. My figure is the angel on his left. For me the concepts of the piece are centred on support and flight. Support is expressed through the strong triangular geometry of the layout and flight by the movement of the drapery. Support and flight combine where the basic forms of fluted folds and oval cloth encountering the body are played off against the dominant diagonal of the angel's pose. The drapery also responds to the wind created by flying and so lifts its furthest points.

'So what use is analysing drapery to someone who makes figures that have large areas of unadorned flesh and no easily recognizable clothing? From looking at the drapery as a concept I developed the courage to cut across forms at any point where I want a sharp change of tone. From this cut, or line, further cuts and painted areas fall away to one side. I also use colour as the Romanesque sculptor used drapery, to animate the surface and connect different parts of the figure. A more obvious parallel between my sculpture and the Romanesque angel can be seen in the way faces, hands and feet are treated. Each has a larger, simple area that breaks up into a series of closely-packed smaller areas.

'Another influence that continues to work for me is the place at which the main vertical of a human body is seen to change direction in order to create movement. In the twentieth century this is usually at the waist, but I prefer the Romanesque break which occurs at the junction between the torso and the legs. It is closer to halfway down the body and so there is a greater sense of the two halves balancing each other. It allows me to imagine a single unbroken rod running through the centre of the entire torso and in my mind I can measure the

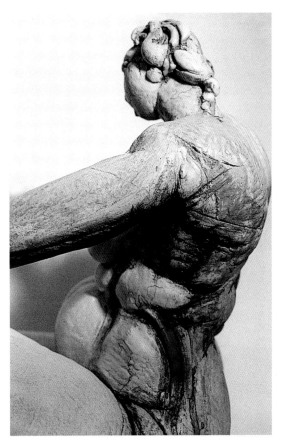

Seated Woman. *2000. 50 per cent T Material, 50 per cent porcelain with paper pulp and wash of plaster of Paris; black stain fired on; acrylic colour painted on after firing; multi-coloured; 32cm × 73cm × 28cm.*

This figure is poised and contentedly full. The colour is used to stress individual three-dimensional forms and by the use of clear sudden flashes also connects parts of the sculpture to each other.

movement of the limbs against this rod, which is, in turn, measured against vertical and horizontal.

'I use 50 per cent T Material for basic strength and 50 per cent porcelain for its greater malleability and fine whiteness. To these I add pulped paper to decrease the amount of cracking that firing produces. Toilet paper pulps most easily. I find that the mixture of clay and paper can be dried and worked exactly as I previously worked pure clay. A squeeze of bleach added to the pulp keeps the dreaded grey mould at bay. My figures are built hollow. To maximize the potential for movement in every part of the figure, I model separate units that are then joined together when the clay has partially dried. To enable me to model the forms from the inside as well as from the outside, I make each unit in two halves (the break running longitudinally). The joins between the pieces often remain visible in the finished figure where they are the basis for colour and tonal variations. I cut into the surface as I clarify the forms. I apply layers of pure porcelain slip. I paint the back half of the figure with a black stain, scouring off parts before firing the figure to 1,260°C. After

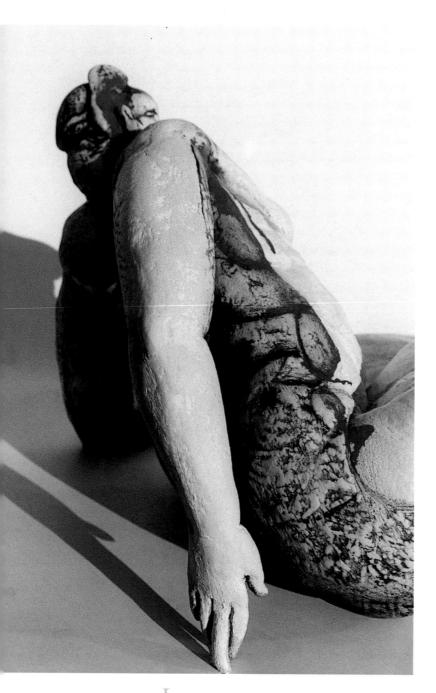

firing I apply a wash of plaster of Paris to vary and enhance the textures on the surface. I then smooth off any sharp edges with a grindstone and work over the surfaces with a flexible pad manufactured for polishing marble. The final stages are painting and varnishing.

'I love to apply colour to three-dimensional forms. I aim for the maximum variation, spontaneity and unpredictability I can obtain while enhancing the original concept and pose. More and more I find that I look at contemporary photographs in connection with my work, but by studying and drawing energy from such consummate artists as the sculptor who made the Burgundian angel, I hope that, when I step back and look at my figures, I will see the dance of life on my worktop.'

Levered Up. 2000. 50 per cent T Material, 50 per cent porcelain with paper pulp and wash of plaster of Paris; black stain fired on; acrylic colour painted on after firing; red, black and cerulean blue; 27cm × 67cm × 34cm.

The arms of this figure function as two props holding up a reluctant torso while she gazes directly outwards. The red flows like life blood. The cerulean blue is simultaneously pretty and associated with bruising; it is also used to tie the stress in the shoulder area to the face.

*I*NFLUENCE
Stone carving of an angel from St-Julien-de-Jonzy, Burgundy. 12th century. Malcolm Thurlby

To embody the concepts of support and flight the sculptor has used a geometrical framework and the drapery. Note that the drapery is sharply cut up the centre of the entire length of the leg; and also that the face, hands and feet consist of a larger, simple form breaking up into a series of closely packed, smaller areas.

3 Movement and Flying Fantasies

This chapter deals with movement in the human form and the way that it gives rise to both physical and emotional energy, often expressed through fantasy. Lorraine Fernie (*see* page 39) finds the place at which the main vertical of a human body is seen to change direction in order to create movement: 'In the twentieth century this is usually at the waist', she says, 'but I prefer the Romanesque break which occurs at the junction between torso and legs.' *Babette Martini*'s work involves a more athletic approach; her physical leaping often occurs through the result of physical suffering: the struggle between gravity and the desire to soar transformed by energy and thus 'lifting the human spirit on to higher levels.' In *Michael Flynn*'s work it is the tension that produces a resonance which can be picked up by the spectator; the flow of movement coming from extremely vivid arrangements inspired by visual, musical and literal connotations – all ideas from the dancing of the mind. *Matthias Ostermann*'s pieces, too, are the result of emotional dramas in which energy comes from 'personalities poised on the brink of movement or caught in a pertinent gesture'. *Kate Thompson*'s sculptures are also full of latent movement like a clock spring held in tension which you know has the power to uncoil. She captures the elastic quality of the clay itself. *Herman Muys*'s fantastic dramas are more severely held in check: he builds up emotions of an immense physical energy to their highest possible level – but then leaves us with these pent-up emotions, 'petrified just one second before the final blast'. *Graciela Olio*'s neobaroque fantasies whirl in energies of power games and social role-playing, all so filled with global cultural references that they form a kind of ever-moving carnival of humanity.

Michael Flynn [Ireland/The World]

The underlying intention in my work is to create a resonance in the eye, in the mind of the spectator.

Michael Flynn's flying figures in clay show poise, balance, lightness and tension. His is the stuff of legend from the other end of the rainbow. His ceramic forms have a quicksilver surface with dabs of the rainbow painted here and there to pinpoint and help the movement elasticate the eye. For his work is perpetually on the move, turning, spinning, dancing the wild

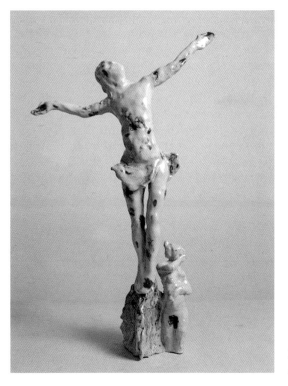

Unbearable Lightness. *1997. Porcelain; 58cm high.*

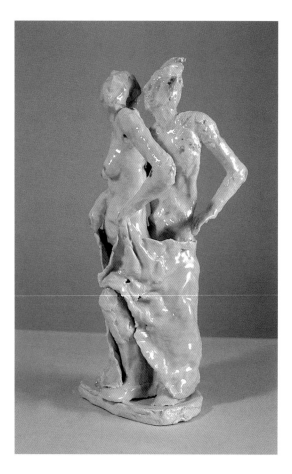

*The Bedspread.
2000. Porcelain; 40cm
high.*

dance of life, interspersed with touches of pain and melancholy, madness and grace. His pieces are multiple with meaning and there is a narrative in every one. His work, in fact, is very Irish in the way it picks up myth and magic, tragedy mitigated by comedy, and all embroidered in a poetry of his own particular style.

Michael Flynn was born in 1947 in the Irish countryside, and he particularly loved visiting his grandparents' farm. But his early Catholic upbringing was changed abruptly when, still as a child, the family took him to Germany, where he was steeped suddenly in the German Gothic. This contrasted upbringing has, I think, formed his work into an extraordinary mixture of Irish-style storytelling in its content, with rakued German Gothic for its surface. He is forever taking liberties with clay and mostly finding that these work. But it was quite a journey before he became a figurative sculptor in clay.

Flynn trained in painting at the Birmingham College of Art and was a painter for ten years; then, in 1975, he did ceramics for a year at the Cardiff College of Art before turning to print-making in his second year there. But, under the

guidance of the ceramist Alan Barrett-Danes, who taught him, he returned finally to clay, as a sculptor. Now he is a global traveller, transversing the world with a kind of restless energy similar to that portrayed in his work. He is to be found teaching, giving exhibitions and workshops everywhere, but most particularly in central and eastern Europe, because he runs a studio in Germany as well as one in Wales.

Today, the artist gathers narrative themes from many sources and also changes his clay to suit the situation. He mostly chooses raku to establish surface vitality. His use of clays, colours, enamels, chlorides, stains, slips and firing methods are merely conjuring tricks performed to create his symbolic allusions. He works quickly, using a kind of coiling/pinching method, encouraging pieces to spring upwards and curl into the surrounding space.

Here is his personal philosophy, captured during a moment in his life:

'To create a resonance in the eye, in the mind of the spectator, needs the bringing together of imagery and materials to create forms which express or comment on those ideas which interest me. By resonance I mean the tangible manifestation of various tensions occurring within a piece, tensions which result from the combination of diverse associations. There is, for example, the tradition to which a material, say European porcelain, or a process, perhaps raku, belongs. How do these traditions relate to the resultant object? There is the image, how it relates to both the idea and to its own historical context. The idea itself, the genesis, may immediately be at variance with its original context. The strength of the resonance created by these tensions is further modulated by associations brought to the piece by each spectator. With figuration in particular the artist has no control whatsoever over what associations a spectator might bring. This is especially the case where the human body is concerned. It is the principal reason for my choosing to work figuratively.

'Basically I am interested in how people have responded to their world at different times in history, in the beliefs and traditions that have developed, how they have originally been presented and how I might express them in contemporary terms. Sebastian Brandt's series of woodcuts *The Ship of Fools* had an enormous currency in the sixteenth century. Can the imagery and ideas contained within them have any relevance at the beginning of

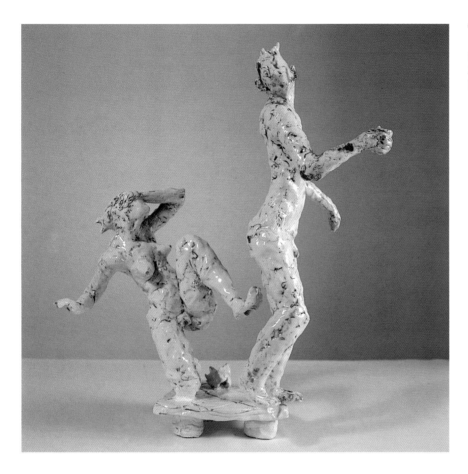

The King Drinks,
the Queen Laughs.
*2000. Porcelain; 51cm
high.*

the twenty-first century? I try then to take an idea or group of ideas from a specific cultural and historical context and transform them through fusion with contemporary stimuli from television, theatre, literature, etc. The way I choose to present the resultant object in terms of colour, form, aesthetic adds a further modification. I should add here that I do not think that it is necessary for the spectator to be fully aware of the process I have gone through to arrive at the finished object, only that some degree of resonance is provoked, perhaps through the subconscious recognition of elements within a piece. In other words, it is important that a piece contains enough universal signals, either inherent or stemming from the aforesaid syntheses.

'My choice of material, my choice of process is integral with the development of the idea. Ceramic has become my basic medium because it offers such a wide range of possibilities. Sometimes I choose a particular medium, porcelain or raku or salt-glaze, because it seems absolutely appropriate to the idea. Sometimes I make a similar piece in a different medium in order to see whether a different nuance is estab-

lished. It is important to me that the ensuing object is open to interpretation. The choice of image, the combination of images, is intended to broaden this possibility. Titles too play their part. They are usually developed alongside the pieces. Sometimes they are the starting point. Often they stem from literature but also from everyday experience. Usually they relate to the basic idea but may also be intended to provide an extra point of tension.

'This way of working draws upon many sources. To name one particular object as a constant source of inspiration is therefore very difficult. Literature is extremely important to me, many different authors for many different reasons: in the past couple of years Goethe's *Faust*, written over such a long period of time, reflecting cultural developments over some sixty years; Thomas Mann's *The Magic Mountain*, its ruminations on a society immediately prior to a moment of extreme change, the subtlety of its humour; Roberto Calasso's *The Marriage of Cadmus and Harmony* or *The Ruin of Kasch*, again combining humour, imagination and great erudition in the examination of critical points of cultural change.

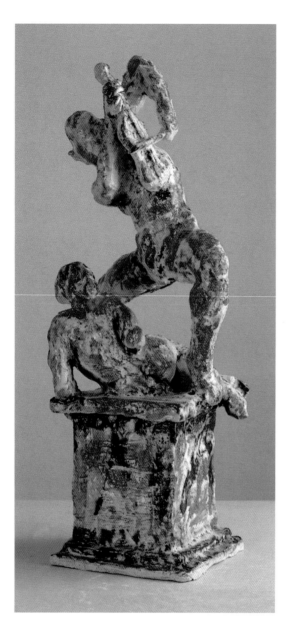

Obscenity and Truth. 1997. Stoneware; 12cm high.

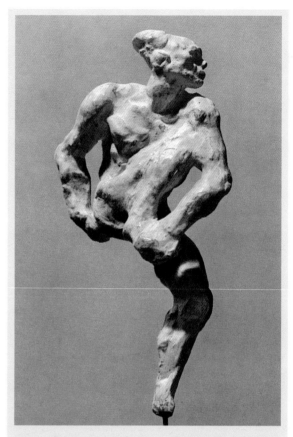

INFLUENCE

Rodin, Nijinsky. 1912; Bronze; 6½in high.
Courtesy of The Tate Gallery, London
From the 1890s Rodin was filled with the desire to savour the moving human form, to create by letting his eyes follow the movement as a phenomenon in itself. Rodin's enthusiasm for modern dance was such that he would bring the dancers to his own studio so that he could feed off their exhibitionism and raw energy.

'I listen to music continuously when I am working and it also has an influence. During the past year I have been listening particularly to Uri Cain's interpretations of Gustav Mahler's music which he feels in some ways portends the Holocaust, and to Michael Nyman's settings of some of Paul Celan's poetry.

'The visual art that interests me most also embodies concepts of change or the need for change, German Expressionism or Mexican mural paintings, for example. And what of cinema and theatre and so on? As with everyone, influences and inspiration flow out of every aspect of my existence. What underlies my particular selection is that most of what really grabs me reflects and comments upon the continuous flux and tension and shift of context that underlies social and cultural evolution.

'So back to the conundrum of citing a specific artwork that has had an on-going influence on me, an artwork furthermore that could be illustrated in this book. Several years ago, in an exhibition at the Manchester Museum and Art Galleries, a piece of my work was placed in a showcase alongside Rodin's small bronze of Nijinsky. I was delighted. I have never consciously drawn from Rodin's work in the way that I have done from, say, several of the German Expressionists, but I do greatly admire most of what he achieved, and in particular this small figure.'

Babette Martini [Germany/England]

My clay figures stand for certain situations and stages of life, and the human search for meaning. Human movement conveys liberation and freedom, but the Greek athleticism was also associated with struggle, competition and the mastery of physical suffering through the energy of the body. In this sense the inherent meaning of human movement transmits a certain Lebensgefühl *[feeling for life].*

Babette Martini's human forms are about poise, balance and the essence of movement. They have a wonderful fluidity and stretch to them. They almost burst with energy and joy. Each piece creates a fulcrum at which mind and motion fuse, then go free. But this movement is not symbolic of fleeing from anything or of trying to get away, but a vivacious centring of self. Her figures are firmly earthbound, being fixed

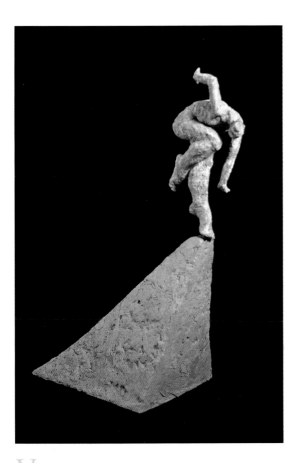

Vertical Start 1. *1997. Figure on base, fibrous clay slips; 0.95m high.*

to metal pins, then resined into ceramic bases, and it is important to the artist that these bases must be thought of as an essential and important part of each sculpture not simply bases as such, but acting as a kind of springboard for every figure.

Babette Martini's work ranges in size from approximately 0.25 to 1.80m. The larger pieces are suitable for exterior installation and can be dismantled for ease of transportation. The artist has, for example, made ceramic wall designs for both the dance terrace of the Tacchi-Morris Arts Centre in Taunton and for the Arc Theatre, Trowbridge. Both make suitable venues where her art can prove itself completely.

Her whole career has fuelled this fusion between mind and movement. The mind part was developed from a full career in counselling in Essen, Germany, where she was born. But later, she says, 'I decided to realize my dream of studying art.' She came to Bath, England, where she completed a first-class BA degree in 3D design at the Bath College of Higher Education, then an Honorary Postgraduate Fellowship in ceramics. Finally, she set up a studio in Bath.

Martini supports her clay work by an ongoing involvement with life-drawing, as well as observing and studying events, such as contemporary dance, athletics and other activities that have relevance to her work. Thus she is influenced not by one piece of somebody else's art in particular, but by movement all around her in the present, from living, breathing performances that are on the leading edge of new expression and competitive events.

She emphasizes that when dealing with movement, textures and colour have to be an integral part of her work. She was attracted to clay as the medium for her sculpture because of its immediacy: 'I can shape it', she says, 'because it behaves like a body, like skin.' The artist likes to use a variety of clays from red earthenware to porcelain. Most of her pieces are hand-built, some are formed inside plaster moulds. Combustibles and stains are mixed into the clay body beforehand, and vitreous slips and appropriate glazes are applied to the surface. There is only one firing in her electric top-loader kiln – to Orton cone 4-6. This variation in patina gives movement to the clay surface, highlighting the muscular springiness of her dancing, balancing and pirouetting forms.

The philosophy that influences her work is also varied and very much part of her life and ethics. The spiritual and the religious, in equal

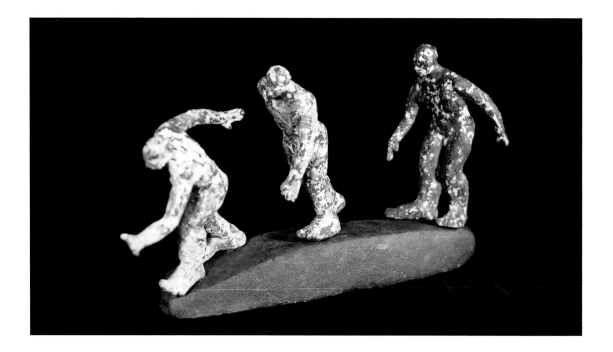

Walking to Alto Songo. *1999. Three figures on base, one piece, porcelain and coarse clay, slips and glazes; 0.31m high.*

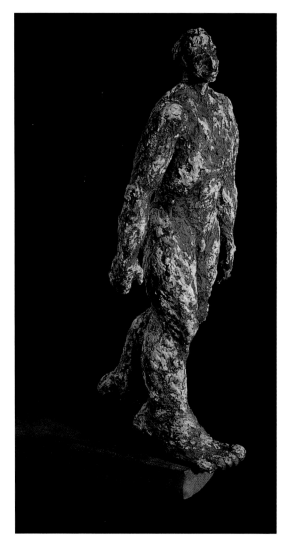

A Song of David. *1996. Figure on base: black chocolate clay, slips, stained clay; base: red clay, smoke-fired; 0.97m high. Dawn Giles*

measure, have been absorbed by her from cultures and philosophies all over the globe to become part of her work. She describes this central part of her life:

'The reading of Bruce Chatwin's novel *Songlines*, which describes the spiritual significance of the Aborigines' songs for their pilgrimage to the sacred sites of their ancestors and how they follow 'maps' illustrated in these songs, drew attention to the importance of movement for me personally and stimulated further research.

'Ethnic dances such as Australian Aboriginal or African have very defined social and spiritual functions and meanings. Through several years of personal experience with African dance I learnt that the re-enactment of stories, the dancing into trance, the collective expression of feelings at funerals or weddings and the communication with 'other worlds' are some of the main concerns of these dance forms. Movement serves here as a means of expression or as a catalyst, lifting the human spirit on to higher levels. Gestures of the hands, head and other limbs become key elements and contribute to the overall effect. Other examples of close correlations between dance and religion are the whirling dervishes and Indian dances such as the temple dances or the Kathakali. In Indian temple dance the individual soul seeks union with the universal soul. The dervishes induce the cosmic experience by whirling around their "master" and into trance.

'The strong reference to the environment and landscape and man's connection to the earth in African dance (stamping the feet), also visible in other ethnic dance forms, had visual implications for my clay work. By choosing earth-coloured clay bodies my figures remain earthbound creatures, and emphasizing the feet heightens the struggle between gravity and the desire to soar.

'In the same way that Chatwin did not only portray a special spiritual form of pilgrimage but also a ritual search for the aboriginal ancestry, I felt that I had to look for my own, European cultural references to the interaction between physical activity and state of mind. Physical activity and sports had a special meaning for classical Greek society. Aristotle did not regard the body's training as a meaningless drill of repeated movements but as a tool or device to realize a goal. The harmonious development of the body and every limb was of utmost importance in order to attain self-determination in the practical demands of life. Although athletic training was a military preparation, it was also perceived as the channelling of brute force. Training and educational aims differed from tribe to tribe in classical Greek society. In Sparta each age-group had its particular

amount of exertion to suffer, often weights were added and used during exercise. Here physical movement meant the mastery of suffering. The Olympic Games, the competition for the Crown of Zeus, were held every five years. Certain disciplines, such as the torch race or throwing the discus (a favoured male activity), were dedicated to or connected with particular gods, goddesses or heroes.

'Researching our more recent European history, I visited the porcelain collection in the Zwinger in Dresden. Part of the collection is formed by the porcelain figurines and animals by the eighteenth-century sculptor Kändler. Seeing particularly his smaller figurines made me aware of the existence of a continuous tradition of figurative clay work from prehistoric times to the present day. On the other hand, the widely differing scale of his work – from approx. 0.20m (figurines) to approx. 1m (animal sculptures) – inspired me to explore different sizes and scales for my own work. The animated dance scenes depicted by Kändler stimulated investigation into the ideas behind his work and his century. The eighteenth century defined gracefulness not only as beautiful physical expression but also as a sign of a person's condition or state of mind. Gracefulness is formed

*I*NFLUENCE
Photo: Martin Lixenfeld

by structure and order, its loss is a consequence of the destruction of balance, that is, the coherence of life and identity.

'In the twentieth century, artists such as Rudolf von Laban and Mary Wigman – two of the founding members and most prominent dancers of the German *Ausdruckstanz* ('expression dance') – had a fundamental impact on the spiritual aspects of life. For Mary Wigman dancing meant to move and transmute internal emotion into physical, visible motion. This way expression is breaking through from unconscious processes to a physical existence, a transformation Wigman called *Absoluter Tanz*.

'Von Laban defined movement as the origin of all being. Being the essential element of life, dance became its mirror. He looked at ethnic cultures where historically movement has been used for work and worship. In his opinion, Europeans had lost the capacity to pray with movement, using the spoken prayer instead. Von Laban thought of prayer as very important as it can bring about liberation from one's inner turmoil. He believed that man can reach beyond himself and achieve greatness through imaginative movement. Referring to its function in religious, tribal and folk dance, it was Von Laban's conviction that movement had a positive effect on man and could influence the rhythm of thinking and feeling.'

Matthias Ostermann [Germany/Canada]

I draw on dreams, human relationships, mythology, or any story that I can visualize and that allows me to create a dialogue with the viewer.

Matthias Ostermann is an optimist, as may be seen by the cheerful, sometimes contemplative figures of his narrative fantasy world. Painted-on tin glaze, with bright, fruity colours, some of his forms appear almost totemic, with figures balancing one on top of another, human, animal or bird. With the addition of a white sgraffito line drawing to encase the figures, the artist's work becomes a fusion of sculpture, painting and drawing, using the medium of maiolica.

Matthias Ostermann was born in Germany in 1950. A ceramist since 1974, he lives and works in Montreal, Canada. But he has also lived and worked in Toronto, Ireland and Australia and has lectured and taught in these places as well as in the United Kingdom, the Netherlands, France, the USA and Brazil. He has exhibited his work internationally and is author of *The New Maiolica: Contemporary Approaches to Colour and Technique* (A. & C. Black, London, 1999).

Ostermann speaks about his work and journey from traditional pottery to figurative work:

'I was initially trained as a production potter in high-fired stoneware, with small forays into drawing and painting on the side. My desire to combine my drawing with clay surface led me to explore the brighter colour palette of low-fire maiolica, which has now become my predominant vehicle of expression. It is, to me, a painting medium in its own right, with unique inherent qualities of colour-blending and light.

'Beyond the painted vessel (which can still serve as human-container metaphor) sculpture representing the human figure touches us on a profound level. It is the portrait, the depiction of our own selves, in whatever form, that exposes our inner stories, fantasies, small and large dramas, with ourselves as the central players. My human figure sculptures – personalities poised on the brink of movement or caught in a pertinent gesture – are definitely part of an ongoing narrative. My shapes are almost abstract, two-sided, simplified, body shapes, presenting two aspects of the same narrative and all relevant detail expressed in colour brushwork on the surface. The object is painted, yet free-standing in space. Clay becomes flesh and bone, glaze becomes skin, and paint the mask, perhaps the actors mutable make-up in the drama being enacted.

'German expressionism and the works of such artists as Chagall, R.B. Kitaj and Mimmo Paladino have, to some degree, inspired my work, which is largely narrative and figurative. Among the sculptures I admire the most are those of ancient cultures: the flattened, stylized early Cycladic and Cypriot figures, from 3,000 to 2,000BC and the works of the Benin and Yoruba peoples of Africa. Among the modern sculptors I am drawn to the simple, totemic, painted wooden sculptures of Louise Bourgeois and the works of Diego and Alberto Giacometti.

'More important than any direct visual influence is my love for stories of any kind. My mother was a professional storyteller in Germany, and I grew up with myths, legends – all

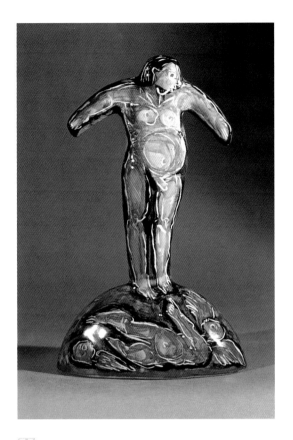

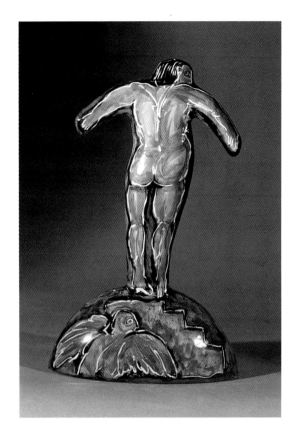

The Big Leap. *1991 Front view; slab and pinch-constructed earthenware, with maiolica glaze and applied layered, coloured stains and oxides with sgraffito drawing; 33cm. Courtesy of The Victoria and Albert Museum, London*

The Big Leap. *Back view.*

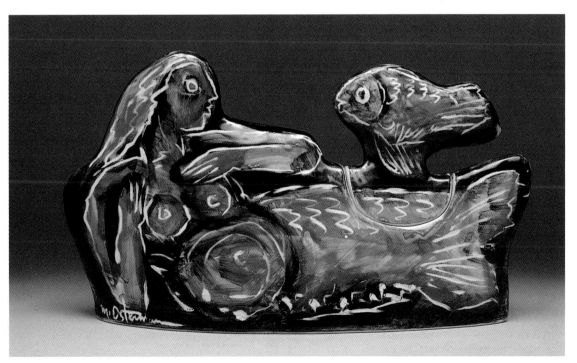

Fisherman. *1992. Slab and pinch-constructed earthenware, with maiolica glaze and applied layered, coloured stains and oxides with sgraffito drawing; 29cm. Jan Thijs, Montréal. Courtesy of The Prime Gallery, Toronto, Canada*

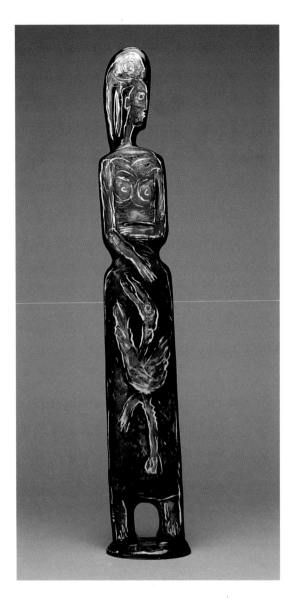

Bird Woman. *1993.*
Slab and pinch-constructed
earthenware, with
maiolica glaze and
applied layered,
coloured stains and
oxides with sgraffito
drawing; 53cm. Jan
Thijs, Montréal.
Courtesy of The Prime
Gallery, Toronto,
Canada

INFLUENCE
Stone idol; Early Bronze Age Anatolian severely
geometricized abstract figurine. Third millennium
BC; 8cm high. This extraordinary figurine comes
from the same culture as the Cycladic figurines from
the Greek islands. This type from Anatolia (now
Turkey) showed different degrees of abstraction. The
tall part is the neck; there are always two
attenuated arms and the rounded part represents
the body. Courtesy of Desmond Morris

sorts of stories. Stories can be many things: an escape into fantasy, a lesson, an analogy, an explanation, a direct link to other people and times. They are as basic to most cultures as dance and music. My stories sometimes emerge as painted narrative in sculpture form. The sculptures are usually presented in a thematic context where the human figure is concerned. I sometimes draw and sketch on paper with occasional colour studies, but do not as yet define a precise object shape. Various slab-constructed forms are assembled, and those most pertinent to the imagery I propose are bisqued, and then glazed with low-fire, tin glaze. Each white form then presents me with the "canvas" for the painted image, and the painting is rapidly executed in watercolour or acrylic-fashion on the raw-glazed surface. Coloured pigments and

oxides are loosely layered on-surface, and a final white sgraffito line drawing through the colours into the glaze finalizes the image. The work is fired low, for maximum colour effect, in oxidation to 1,040°C. Occasionally, when more in-depth colour is required, I will repaint the glazed surface with additional, thicker pigments and refire at a slightly lower temperature.

Kate Thompson [England]

Figurative work is powerful in that it can directly communicate emotions or states of mind. The objective of my work is to communicate feelings of

self-worth which, I believe, fluctuate in all of us. My making process continually feeds my conceptual development and I find myself constantly referring to skin with a single slab.

Kate Thompson works with great precision and a clear mind, folding the skin-like clay with no tools except for her own hands. These hand movements she has created are still inherent in the pieces, so that you imagine that her human forms will go on completing the movement that has been instigated. Her sculptures are still in a state of becoming, of unfolding or folding up, leaning or conversing together – certainly not in a state of suspension. Her figure on the cushion-like stand, for example, is full of curled-up, coiled-up energy in the process of springing open.

These are personal interpretations of self, and their minimalist, abstract qualities compound their strength. The artist's interest lies in the skin qualities that clay possesses when it is stretchable in its elastic state. She says, 'With this seamless slab, I am able to set up ripples and folds that, to me, appear taut. I have found that this surface tension is essential in my work since I strive to describe feelings of a changeable or fleeting nature.' It is Kate Thompson's ability to take advantage of this sheet of clay that makes her pieces special. Her movement is exe-

cuted in a way that requires a great deal of thought, followed by accurate, unfussed action, similar to that a gymnast might make.

Thompson says of her technique:

I generally work with either porcelain or stoneware clay. I use a very thin slab of porcelain, for example, which is then painted with raw glaze and rolled out. The resultant effect is that I can achieve an integrated surface and form right from the beginning. I find that my surface may then suggest a form, but only to a degree. After the manipulation of the form is complete (using just my hands to produce surface qualities, achieved only when the clay is in its plastic state) I dry the piece and single fire it to around 1,260°C in an electric kiln. I have developed my own raw glazes. Previously I have tested wood ash and dug clay from the ground to make stoneware glazes, as well as using other firing techniques such as smoke firing.

Like her work, Kate Thompson is single-minded and orderly. She has worked as a marketing administrator as well as undertaking legal secretarial work. She has had many exhibitions and won prizes. But her latest position was as Artist in Residence at a secondary school in Dumfries and Galloway. This has meant that she was able

Foetal Figure. *1999. Stoneware; 13cm long.*

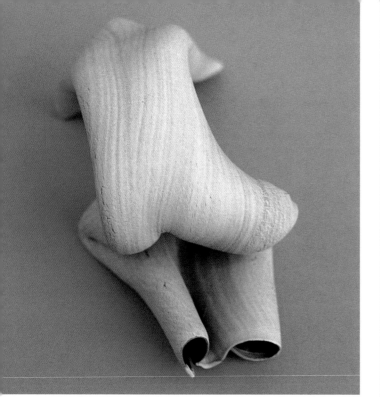

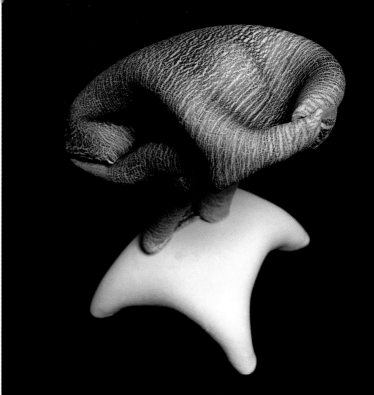

Study. *1999. Stoneware, crouching figure, mounted on ceramic base; 16cm high.*

Post-MA. *1998. Stoneware, kneeling figure; 15cm long.*

to continue her own work as well as gaining valuable teaching experience.

Thompson was born in 1968 in Nantwich, Cheshire. In 1991–92 she did a part-time art and design foundation course at the Weston-super-Mare College, then was accepted at the Manchester Metropolitan University for her BA. There she achieved first-class honours in 3-D design (wood, metal, ceramics and glass). Finally, between 1996 and 1998, she did an MA in ceramics at the University of Wales Institute, Cardiff. She enjoys gathering new information by attending conferences and travelling on overseas visits to galleries and museums. Kate Thompson also does experimental collage and uses both life-drawing and photography to inspire her work. She says:

> many people, too, have influenced me along the way, but the person who has inspired my figurative work the most is Susan Halls. I have admired her work for many years, but it is her skills as a visiting lecturer which have left their mark on me. One tutorial which took place at the University of Wales Institute still resonates. I was at a point where I had developed a visual language but was unclear what I wanted to say. She advised me that it was vital that I set up a personal dialogue in my work if I was to sustain an interest in it. This advice has proved invaluable to me over the years since leaving college and has certainly shaped my current work.

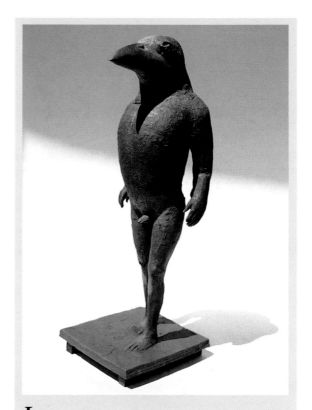

INFLUENCE
Susan Halls, Bird Man. Susan Halls combines animal and human forms to produce challenging and witty 'hybrids'. She is not afraid to play with the ambiguity in her work, that is fascinating for the viewer. Susan Halls also makes raku animal forms and superb observational drawings.

Graciela Olio
[Argentina]

My art tries to be pluralistic, to provide a space that is not uncritical but that is not completely defined, closed, replete, dictatorial. I prefer an open dialogue and a certain degree of ambiguity. From this art perspective, the human figure can be seen from different angles: irony, satire, distort images and social roles.

Graciela Olio's characters are dynamic, multiplex creature-persons almost roaring out of the artist's fecund imagination in colourful dramatis personae. This artist is a satirist who melds together seemingly disparate subjects that are classified under various titles and brought together in a grand circus of social comment, cultural comment, global issues, political debate, childhood memories, bestiary fantasies, daily trivialities and carnival characters – all of which are almost bewildering – until Olio puts them into eight distinct classifications which make them more like chapters in her artistic book – or, more aptly, scenes and acts in a huge historical drama which ends right up to date. These are: social satire; masquerade; the saga of the Spanish Conquest; automata; games; bestiary; dwarves, and self-referential work. Graciela Olio has exhibited these series mostly in the southern hemisphere and in Europe.

Graciela Olio's work, schizophrenic in variety, not only bombards us with its diverse groupings, installations and assemblages, but it is constructed from anything the artist can lay her hands on which seems right for her artistic purpose. This consists of many ready-made ceramic objects (bricks, roof and floor tiles, plant pots and electricity insulators, for instance) which she will mix with non-ceramic materials such as cardboard, fabric, paper, photocopies, scanned images and photographs. Even then she will add to this melange, with painting, engraving, drawing, or adding plaster, metal and wood. There seem to be no bounds to the material that can be incorporated if that is what is needed to create impact. Olio says:

> I define it as 'mixed technique'. The combination of materials enables me to project my ideas through the medium used, which in my case is assembled ceramics. These ceramic collages, these 'objects' that belong with the 'objectual' [sic] art genre, the 'assemblies' or 'ready-mades' at time give me the freedom that my spirit craves.

> For modelling ceramics I use a smooth, porous body, or clay with added grog, white, red or coloured, china or porcelain. In general, I work with cones 03 to 05. I use manual modelling from slabs or hollowing. I take great care at the joints of different materials to make sure they are well integrated and that the final image is not disturbed. Surface treatments are varied and sometimes used in combination. I use engobes as a base and, in addition, I combine oxides, pigments and glazes, either commercially made or prepared or modified by me. My pieces are fired several times over until the desired effect and quality are obtained. Next comes the assemblage of different parts that will make up the object. I do this from cold using a good-quality commercial adhesive. This stage requires much care and attention, because a single component out of place could ruin the whole piece. Finally, installations require the prior study of the place where they will be erected, its aspect and lighting.

The group shown here illustrates a lit installation termed *Bowling* and some of its characters which falls into the category of Olio's ludic

Bowling Installation. *1995. Ceramic assemblage, earthenware with slips and oxides, smoked roof tiles; 5.00m × 1.80m × 1.70m. Cyntia Dazzi*

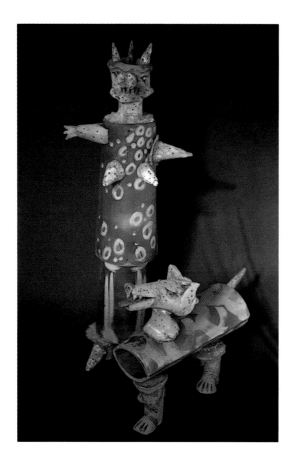

Vieja Verde. *Detail from* Bowling Installation. *Cyntia Dazzi*

and multiple cultural influences. I want to render the art open to the most diverse meanings, to temporal dialogues, to the complexities of the present time, to the interface between high culture, low culture, and mass-media culture; to mix and combine Western themes with those emerged from our region, to represent the most irreverent fusion of historical events, childhood memories, games and power, which is another type of game; the fantasy of childhood and the fantasy of bestiaries; the mask of carnival; the daily triviality with its clichés and stock phrases, all of this plus a touch of humour, irony and nostalgia.

Olio was born in the city of La Plata in 1959. She studied at the Arts Faculty of the National University of La Plata, specializing in ceramics, and graduated in 1983. In 1990 she joined the Ceramics Department of the National University Institute of Art in Buenos Aires, where she lived from 1987 to 1998, making, as she puts it, 'most of my art … and from there made my brief incursions into the international stage'.

imaginings under the games section … into which the bestiary section might stray … as the artist points out:

> The 'toys' of childhood give place to the 'toys' of adulthood, when power is used for playing games. Images of play are gradually invaded by images from the bestiary. In this merging of play and bestiary scenes, the beast, as the metonym of power, converges with his perverse logic, the playing of games. Beasts are depicted as fragments: their open jaws, teeth, fangs, panting tongues, snouts, ears, all proclaim the predator instinct.

Graciela Olio tells us that she wants to

> try to reclaim indigenous folk tradition – a period debased by our modern lifestyles and which has been ignored in the history of our country since the Spanish Conquest and later waves of immigration which turned our nation into a crossroads of many cultures. But I also want to challenge these folk and traditionalist movements by creating a 'neo-baroque' style to reflect this complex identity

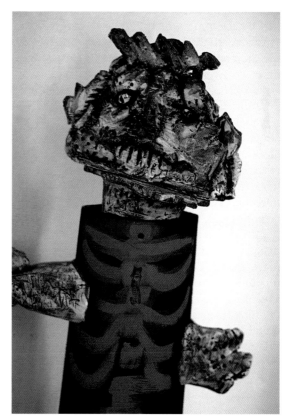

Hombre Esqueleto. *Detail from* Bowling Installation. *Cyntia Dazzi*

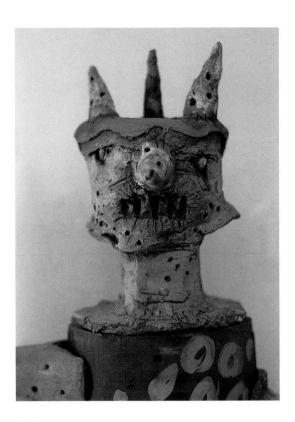

Vieja Verde. *Detail from* Bowling Installation.
Cyntia Dazzi

Today she lives in La Plata, where she has her studio and divides her time between research, teaching and new art work.

The artist's influences are, like her work, a 'collage'. She describes this, saying:

> In consonance with my mixed blood origin, rooted in the post-modernist era, my sources of influences come from the pre-Columbian period to the twenty-first century and the Internet era. But particularly there is the Nasca pottery of Peru, of Santa Maria (Argentina) and the Spanish-American baroque altar-pieces as roots of our Latin American identity; then Picasso, with his irreverence and grandeur, had a profound effect on me. All his art, not only his ceramic works, influenced me greatly. The revolutionary English pop art, and later the American, opened the doors of freedom and brought about the popularization of cultural systems. I was greatly interested in the demystification of the past and the playful treatment of popular myths.
>
> In the 1960s an artistic movement in Argentina with international projection included the great master Antonio Berni, with

his humanistic approach – militant but with existential roots, and who vindicated the socially displaced; and Luis Benedit, who combines art, architecture and science. I was attracted to his primitive instinct and his use of the anti-aesthetic and rehabilitation of discredited values. Lastly two Italians, Enrico Baj and Luigi Ontani. Baj, from the Absiola group of artists assembles fragments, constructs and deconstructs; and Ontani, regarded as one of the precursors of Italian *citacionism* of the 1980s and of the post-modernist group Nuovi-Nuovi. His artistic endeavour goes beyond the physical act of producing the work of art, given that he does not make his ceramic pieces himself. He is like a traveller who goes from India to America, from the Middle Ages to the neoclassicist period from fable to fiction. In them I find my historic identity. Both are rooted in the classic tradition, using and abusing it to construct their own message. With this collage of influences I learned that my work is like a 'Latin American mosaic', made up of fragments of history which in the last analysis are the ones that make up my own life.

Herman Muys [Belgium]

In life only a few things have always attracted my attention. One of those is the reactions towards dramatic moments in life. The cheerful as well as the dreary moments. Studying someone's state of mind, his feelings and behaviour by his body language and expression, always generates new and unexpected perceptions. From this particular point of view, I have always admired artists who have not only succeeded in catching breaking points in life, but who above that have also been able to bring the feeling of an immense physical energy into the sculpture, which it nevertheless seems unable to release. I also try to keep this energy alive in my pieces by raising the emotions to the highest possible level. It is then as if this 'person' has all his pent-up rage or sadness inside him, but that he was petrified just one second before the final blast.

I had just been looking at the Flemish art in the Städtliche Gemäldegalerie in Berlin. Then I came back to find a parcel containing Herman Muys's work. I was filled with excitement and

tender feelings of familiarity to recognize the 'creatures' from Bosch and Breughel come to life. I do not mean as a copy – but Herman Muys's work is steeped in the tradition of Flemish art; it has that same vitality, same meticulous craftsmanship, same emotion and similar tales to tell – most of them about the unremitting folly of man. The artist is much loved in his country, has taught there, won many prizes and exhibited widely the world over.

He was born at Sint Amands in 1944, and later studied at the Royal Academy of Fine Arts and at the National High Institute of Fine Arts in Antwerp – which was where he met his wife Monique Muylaert. Both are artists with a strong vision and both work in clay; Monique Muylaert makes wall pieces; Herman Muys, sculptural forms. His are fragile, delicate temporary beings, arriving angel-like for a fleeting existence on earth. They look as if they had been curled off a butterpat – or possibly a wood-shaving would be more accurate – since they are matt, dry-surfaced and patinated with faded, sandy colours. Each piece is carefully and

B lue Angel. *2000. Stoneware clay, fired to 1,250°C, with oxides and glazes; 60cm.*

P etrified. *1998. Stoneware clay, fired to 1,250°C, with oxides and glazes; 75cm.*

sensitively constructed as a fiercely dedicated modeller might assemble a model aeroplane. And they are slightly toylike but more brittle, like stick insects or those fragile skeletons of birds you might come across in an old loft or on a walk in the wood.

Muys produces compressed, scaled-down versions of human forms. But this only heightens their impact, for you are compelled to bend and look more closely and marvel at their finesse – and their wit. As political and social comment, they make modern-day fable-caricatures. In effect, they are 'everyman': not quite male nor female, adolescent or old. The bodies have taut, filled-out shapes. They are not macabre nor grotesque – and their compressed scale could easily have turned them into little manikins or munchkins – but the modelling is so elegant and executed with such delicacy and neatness that they become too exquisite to be Rumpelstiltskins.

His work, with all its intricate incident, evokes not just certain paintings, but also those of drawings – Felicien Rops maybe – and also works of literature (Saint-Exupéry and Beckett's *Waiting for Godot* come to mind. These creature-beings have a great deal of movement in them: a

casual movement as if caught unawares, interrupted while travelling along with all their wrappings and trappings. The wrappings on Muys's pieces are skin-like. Sometimes one piece of torso will emerge from under or outside another, resembling empty eggshells stacked one inside the next, and we are allowed to see the thickness of the 'skin' or 'vestment'. There is little difference between vestment and skin; they are usually treated the same. Maybe a second head, resembling a second skin and coming complete with eyes, will be shucked upwards to form a cap or helmet piece, at other times patches are cut away and added like an assemblage. Because the eyes are sightless, the hands, the feet and the stance take over the outward, expressive content, while the inward emotion bursts out from behind closed eyes. This emotion within the stretched skin is robbed of the potency to act, blinded by an inability to change situations. But sometimes the mouths are open in a tight scream – especially when the pieces resemble the aftermath of war. Often the figures are fragmented which makes them all the more vulnerable. The trappings are usually things that they carry, like staffs of office, crosses, wings, moons, archbishops' mitres – all held in arrogant display – all evidence of man's pumped-up importance, and they symbolize his lack of true understanding of how this gift of life might be

used to better effect. Often the figures act as reliquaries, sometimes seated on throne-like constructions from where they show their importance. We do not feel like laughing if they are blind or angry, but we do when they are arrogant and foolish. Muys's constructions from peelings, shavings and curlings might fool one into thinking that they could be the work of a skilful silversmith rather than a worker of clay.

The artist says of his material and philosophy:

'Clay, the material that I use, is in fact a mixture of different types of clay. In my studio I have a barrel filled with red-black and white firing clay. All kinds mixed together. Out of this mixture I roll thin, moist slices, that are modelled into bellies, arms, legs and heads. Afterwards I carefully assemble them with clay-mud. At the end, after this firing process, this mixture of different types of clay results in a nice pattern of fused colours. The ability to do this can, of course, only be obtained after a lot of experimental try-outs that sometimes turn out to be very destructive. Even now it still happens that the sculpture explodes during the firing process. Different sorts of clay have different qualities. One shrinks more than the other, another one needs more time to dry before it can be fired. On the other hand, when a sculpture comes out of the

Walker. *1996.*
Stoneware clay, fired to
1,250°C, with oxides
and glazes; 50cm.

Green
Mooncarrier. *1990.*
Stoneware clay, fired to
1,250°C, with oxides
and glazes; 50cm.

kiln it is always a surprise to see the final results that can never be predicted nor reproduced.

'As it is written here, one might easily think that modelling clay is a simple process. Or that after your sculpture comes out of the kiln, your work is done. Unfortunately this is not the case. A piece of work goes into the kiln only when I am satisfied with its form. Once it is fired, it is practically impossible to alter the model. Even after it has been put aside to dry out thoroughly, it is not easy to assemble. The firing process takes a lot of time. After the first firing turn, the toning can start. Glazes are mostly sprayed on so that the rough ceramic surface keeps its fragile structures with minuscule scarves, wrinkles and peeled-off fragments. Depending on the kinds of glaze that are used, pieces can be fired over and over again and after each firing process new colours can be added. This process can go on

and on until the moment I judge the sculpture is ready.

'Although I admire those artists who succeed in catching emotions of real-life situations, this has never been my motive to create art. In some way the final result may seem the same, but I have never intended to copy the visible reality. The fact that many of my sculptures appear to be rather atrocious makes people reflect upon the reason for this atrocity. Some say that distortions in a piece of art can be considered as a way to express one's sensibility and even one's sentimentality. Probably some artists do have these intentions, and in a way I also use these emotions in my art, not so much to express them, but to awaken them. In order to achieve my aim I try not to equal reality, worse still, I deliberately deviate from it, in order to make this purpose even more obvious. The violence,

or the results of what can have been violence, exposes the vulnerability of the human being. A confrontation with it is what really causes emotion. It suddenly makes you realize how fragile life is. To attain this, my sculptures have, for example, a much smaller size than that of the human body; it stresses the fragility of it all. I also leave (or make) the surface rather rough or scraped-off instead of polishing it nicely which awakens a feeling of inhumanity. The sculpture often appears to be a fossil, but we all know it has never been part of real life.

'The fact that people reflect upon the sculptures I have made proves that I achieve my goal. I don't have to explain why these beings have been created. Sculpting is not something that is done in one day, it is a process of evolution. Not only how I make my sculpture evolve, but also my personal ideas. A piece of art evolves together with your own personality. In a way you gradually give concrete form to your personal history. Of course, your personal feelings are always there, but they are irrelevant to the viewer. The sculpture itself is supposed to be interesting, not the story or the motives behind it. If you listen to Bach's music you realize that his music is far more important and complex than the motive to make it. This music is interesting and therefore the anecdotes around his person become uninteresting. Naturally your own stories, feelings and experiences remain a part of what you make. Art cannot function except on a platform of feelings. Without feelings, art is not explainable. But apart from that, art does not need any explanations. Indeed, what is most essential in art cannot be explained. An interesting sculpture is an illusive one. If you want to look for any explanation, I can only tell you that I'm not giving them through words, but through the sculpture itself. Explaining pieces of art is superfluous. By doing so the whole mystery of it disappears. Your work should not be demythologized; you have to leave the imagination to the viewer.

'Looking at my entire oeuvre one could conclude that there are only a few subjects that have inspired me: people and mythological creatures. Both of them express very strong feelings. Not only by the way some of them stare into darkness or by the way their faces may be deformed, but also by the way their bodies express their strong, their weak or their broken mind. To produce these sculptures filled with expressive force, a concept alone is not enough. You do not only have to be creative, you also have to be aware of the possibilities and the limits of the material. Something that can only be obtained after years of experience.'

Stilte. Stoneware clay, fired to 1,250°C, with oxides.

4 The People All Around Us – As Reflections of Oneself

This is a lively chapter which reflects the diversity of global cultures, celebrating both the ordinary and the exotic, and showing how we differ, yet are the same. Some of the sculptors offer a scrapbook of the past: we glimpse a Japanese village – Nobeoka, Kyushu – which is *Akio Takamori*'s memory of his childhood village; we visit *Viola Frey*'s childhood on the West Coast of the United States, a past which is celebrated in the form of giant figurines. In the present, we learn from *Peter Johnson* what the modern-day working men and women are like in Australia, and we stray into an English drawing-room to see *Ruth Dupré*'s family and friends as ceramic busts dressed in exotic costume. *Sally MacDonell* and *Eileen Newell* take their observations from the polymorphous nature of our society. Both use strong cultural references from both past and present to elevate their work to the exotic. *Henk Kuizenga*, *Antony Gormley* and *Luo Xiaoping* turn us inwards to distil the essence of our inner selves, revealing that we are all alike in a true globally-shared culture, and also that we are close to nature, and responsible for it.

Antony Gormley [England]

We must live closer to the earth and close to the sky … We are the world, we are the poisoners of the world, we are the consciousness of the world … My work is a bridge between art and life … The work is about questions.

Antony Gormley is a responsible artist whose explosive ideas, so full of energy, have the ability to touch us in a universal way. His work is unconventional because he intentionally seeks out the unusual to create impact. He puts out global homilies – large ones – he wants to confront us with a direct approach, so that his work can be seen by the maximum number of people and command maximum interaction. The intention is the same wherever he places his work in the environment. 'I want to see whether it is possible for art to be everyone's … for people to be engaged and excited by the sculptures', he says. 'I want my work to reach out … to have meaning, potency, and relevance. In public, sculpture accrues all sorts of meanings.'

Antony Gormley puts himself right at the core of his work, and the pith of that core is inside the body. He aims to get you thinking from the inside and to be aware of his sculpture's spiritual content. To emphasize the spiritual this artist has an instinctive ability to choose very moving settings for his pieces where their impact can be greatest. In February 1998 his *Angel of the North* – the tallest sculpture in Britain made of steel – was erected beside the A1 road. For his Millennium sculpture *Quantum Cloud* he scanned his own body

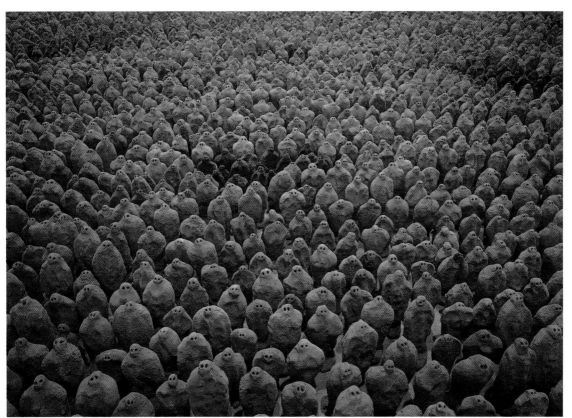

Field. *Terracotta, 35,000 figures (varying from 3 to 10in in height.). Courtesy of The Salvatore Ala Gallery, New York*

and set the resulting sculpture near the Millennium Dome in London. *Sound II* is another single figure standing in the annually flooded crypt of Winchester Cathedral, which adds religious density. And there are figures on the shore washed by the waves of the North Sea, which the artist says could 'offer back to the elements a kind of gift or sacrifice'.

Gormley is truly universal, a global artist in a modern world, where cultural and media events are now shared. 'I think that mind is collective: a collective subjective', the artist says, 'and one of the tasks is to make that collectivity more apparent.' Often he does this by using installations. In one such in 1998 called *24 Hours* Gormley created a long line of terracotta figures walking in collective moments of the present throughout one day. You could identify with the progress of this human from one moment to the next, and smile.

With *Field*, begun in 1990, an ambitious project was realized. It was probably the most powerfully effective public participation ever held involving clay. The first *Field* was made with the help of the Texca family, brick makers in the parish of San Matias Cholula in Mexico. Sixty men, women and children worked on the pro-

ject over three weeks. Each participant was given a simple formula: one hand-sized piece of clay to be modelled by pulling a head from the body lump, turning the face upwards and pushing in two eye sockets (damp lollipop sticks were found to be the most efficient way for making these eyes). *Field*, in all its engaging intimacy, was made in several versions and spread its pasture by touring throughout the world. The English *Field*, for example, was made by about a hundred volunteers of all ages from the community of St Helens, Merseyside, over one week in September 1993. Then it was fired in the kilns of a local brick company. In Kiel, in northern Germany, a similar army of 40,000 clay figures densely crowded the complete viewing space of a gallery, and the same happened with the 35,000 figurines in New York. And this was Antony Gormley's idea: to fill an entire gallery completely with figurines (the tallest was only 30cm), creating a perspective, and with the only space being the air above this population. It gave an extraordinary feeling of a wave of people coming towards you. It was practically impossible to try to look at just one of the figures; each individual was merely representative of the whole sea of them.

Gormley states that *Field* is an internal work, internal architecturally and internal in imagination. 'If we had done it outside, I feel it would have been like a re-enactment of the storming of the Winter Palace or Tiannamen Square or Stalingrad … it happens in personal, interior intimacy, a space where the white walls of the gallery simply become a condition of our mental set.' These small-scale homunculi, all naked, all the same – but carrying slight differences – like us, create great tension because viewer and objects share the same space. There is almost an invasion taking place and the sculpture does not let you in or through its mass. You are startled at this furore created by such small-scale creatures below you – and Gormley is very good at scale – it is an effective way to make you notice. (Often you look down at or up to his pieces; this always arrests you with surprise.) Here, we feel like parents looking down at our children – but they seem to be holding some kind of mass demonstration, and you feel disturbed – especially by their echoing landscape of eyes.

And you see that the artist has cleverly transferred the spectatorship: his work is looking at you as much as you are looking at it … and suddenly you realize that in that gaze it is ourselves staring back, human souls speaking in direct dialogue. These works of art have collared us; they are appealing with upturned faces, staring with a dark, deep-set gaze. They come as supplicants to us humans. We are the omnipotent ones. And they ask us to think and question. They evoke the past, they evaluate our present predicament, perhaps present a foetal presence of an over-crowded future. 'Open your eyes, open your minds to receive the message', they seem to say. 'Take notice. Make the changes. It is you who are responsible for the planet's future.' 'This is the trick that the work plays', the artist explains, 'life becomes the subject … The eyes are there to make connection … to transmit feeling, not to identify, to categorize. I am interested in the senses because they are the channels through which we are immersed in being rather than distanced in knowledge.'

Field. *Terracotta, 35,000 figures (varying from 3 to 10in in height). Courtesy of the Savatore Ala Gallery, New York. Photo: Joseph Coscia*

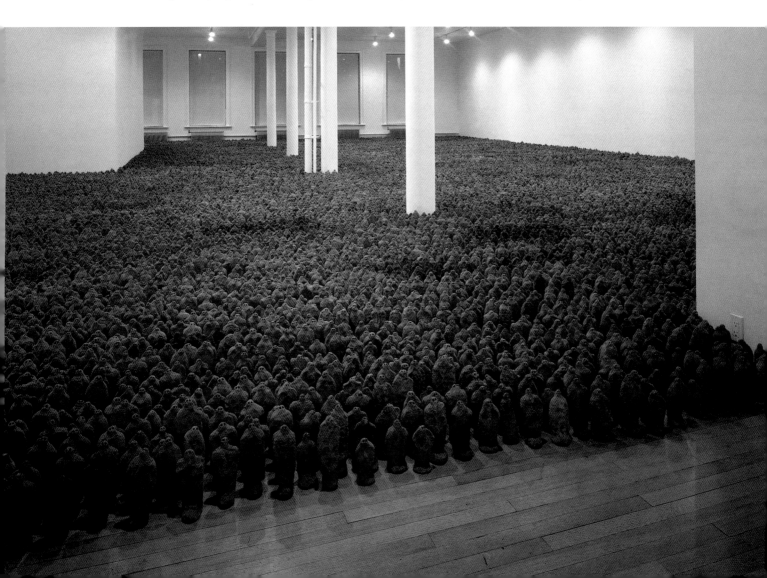

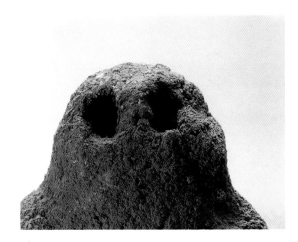

American Field 1991. *Detail.*

Field is a little like the terracotta Chinese army, but perhaps even more reminiscent of Magdalena Abakanowicz's serried ranks of mute beings in bronze, which also speak directly to our senses. So where does Gormley's inspiration come from? Mostly from inside himself – though it can be triggered by things around him, such as the large cooling towers or electricity pylons that make massive statements across the countryside.

Gormley, born in 1950, was often on his own as a child, although the youngest of seven children. He had a strict Catholic background. Later he went on to get a Cambridge degree, plus lots of art training: the Central School of Art, 1973–74; Goldsmiths College, 1975–77; then the Slade School of Fine Art, 1977–79. He has won many prizes (including the Turner Prize in 1994) and has exhibited globally. But he decided to become a sculptor only during the three years he spent in India (1970–73), 'because', he says, 'I couldn't do anything else … and sculpture felt more real.' Besides, in India, he had learned a kind of meditation called *Vipassana* that, he explains, 'stresses the importance of giving close attention to the sensation of being'. This replaced the religion of his Catholic upbringing and offered him a new kind of spirituality, one where he could begin to allow himself to be used as the source of his sculpture, be the starting point of everything he made, for, as he explains,

The rest of my body is behind my skin – this gives the body relevance and meaning … I think I deal with first-hand experiences. I deal with matter. I think I deal with stuff. I got fed up with dealing with illusion. I got fed up with making two-dimensional equivalents of a three-dimensional world or three-dimensional equivalents of a four-dimensional world. I want to use time like matter … What excites me is the potential of sculpture as an inert material to produce energy … work is an attempt to bear witness to this time.

So the artist began fashioning total body casts, and each resultant form – 'our' human form – was compacted into a simple shape, thus becoming a more powerful metaphor with which to express both man's vulnerability as well as his steadfast hope. Gormley goes for simplification because essence can render something more directly and make it more riveting to the senses. 'The body is the thing that we all share', he says, 'I want to produce a generic human being with which we can all identify … I want to use my own existence, in a sense, as the raw material … The body has its own energy and way of making apparent what was always hidden.'

The use of terracotta for his work came in the mid 1980s, when a terracotta figure was spotted growing out of the head of one of his inorganic lead pieces. This terracotta turned out to be suitable to use for both *24 Hours* and *Field*. But Gormley will employ any material he thinks fit; he has used bread, wax, concrete, fibreglass, lead, stone, cotton and plaster, and clay. He also paints and draws. Today, Antony Gormley lives

Twenty Four Hours. *1988. 24 terracotta figures, 2–23cm high, 900cm long.*

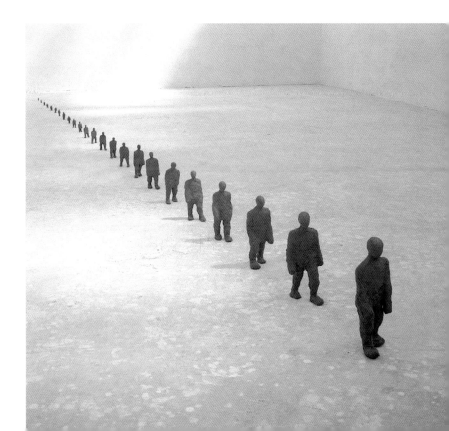

*H*ome. 1984. Lead, terracotta, plaster and fibreglass; 65cm × 220cm × 110cm.

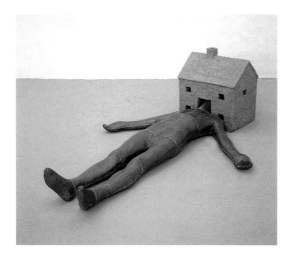

and has his studio in London, where he continues to have good ideas and the energy to see them through. 'My work keeps me sane', he admits.

He has successfully spoken to the universal psyche and become a great reflector to us, his audience. He is interested in whether we will laugh, cry, be angry, or be affronted by whatever he creates next. He says: 'I am trying to express an opening of the senses. An awareness of being in space … I work to avoid a human disaster.' And he reminds us over and over again, 'We are all responsible for ourselves. We should all be thinking globally.'

Luo Xiaoping [China]

The ideology of Buddhism, Taoism and Zen in ancient China has exerted direct influences on my artistic ideas. I prefer natural beauty, originality and indifference to fame and wealth. I believe in the theory that man is an integral part of nature. You can find these ideas expressed in my work.

Only a few years ago the human forms in clay of Luo Xiaoping were robed in multi-folded garments with complex, naturalistic details. They were rather like the traditional masterpieces from the later Chinese dynasties. Then, suddenly, his work was transformed into creations of simplicity and charm. He had arrived at a totally new way of thinking. 'I have made all efforts to weaken "skills", and, as the ancient thinker says, "great minds do not carve trivial details"'. At the same time, Luo Xiaoping made an inspirational journey back in time, travelling

a thousand years or so to the Qin and the Han dynasty.

Nowadays this artist creates his human forms with that kind of majestic precision that one associates with the sweep of a Chinese paintbrush, and you feel that the same principles must apply. In fact, Luo Xiaoping studied and taught painting before he became a sculptor and the method must have presented itself to him as a means of creating his sculpture, and, yes, they do remind one of the grave figures from the Emperor Qin Shihuang Di's tomb. They are expressively-folded, clay forms, handled with great wisdom and accuracy. They have both movement and composure – but now it is only the inner emotional content and the grace that are complex. This central quietness comes from the artist's study of Zen, Taoist and Buddhist concepts which he has integrated into his way of life.

He was born in the Jianxi Province of China on 9 July 1960. His parents both came from Hunan Province. He says of himself,

I think that I developed catholic tastes and intense emotions because I have been fond of hot peppers since childhood! I particularly loved painting during my childhood and was eager to become a painter. Although I developed well as a painter it was to study sculpture that I eventually enrolled at the Jingdezhen Ceramic College. Two years studying Western sculpture and painting there were of immense benefit to me. I achieved my BFA in 1987, then was assigned to the Shanghai Tongji University as a teacher of painting in the Faculty of Architecture. This I did for five years before resigning in 1992 to start my own ceramic creations.

Today, Luo Xiaoping does much to promote and organize the ceramic arts in China. In addition to exhibiting and winning awards, he holds down such positions as Deputy Secretary-General of the Sculpture Board of the Arts and Crafts Institute of China and President of the Yixing Ceramic Art Association (which he founded). He also edits a ceramic magazine. One also discovers from his biography that he is famous for making teapots of a shape inspired by Chinese bamboo. This type – the famous Yixing Zisha teapot – is not made by throwing, but from slabbing and folding. And Luo Xiaoping has adopted this same technique to make his sculptural forms – a slabbing

method developed from over 500 years of exploration and development.

He uses the same unique 'teapot' clay from the region for his sculpture – the purple Zisha clay of Yixing. It has coarse particles and belongs to the type of kaolin-quartz-mica similar to the clays of the Jingdezhen and Longquan kilns but with a higher content of iron and silicon. The clay is also very plastic and therefore eminently suitable for folding and stretching. It yields a colour range – from purple and light purple, through to yellow, red, green and more – an exceptional variety from which to coax interesting natural patination through the process of reduction firing.

Luo Xiaoping describes his method:

I often mix several types of Zisha clay together. First I make slabs by thwacking it with wooden clappers, then I construct my figures working both from the outside and inside. I look for natural beauty and the pleasure and delight of form – methods quite opposed to those I studied in the Western University. Starting from the feet, I work upwards to the head without making any corrections in between. I need to keep the freshness throughout the whole piece. By relaxing figuration, moving naturally and melting calmness and introspection as displayed in the Chinese sculpture model within it, my work has become much more pithy, simple and dextrous. For the firing technique I have changed

the conventional manner of Yixing red earthenware oxidation by increasing the temperature to between 1,150 and 1,180°C in a gas kiln and making a quick reduction at high-temperature oxidation. I combine this with the ancient process of using saggars filled with firewood and sawdust in a 'pit firing'. I always leave my work unglazed because glaze is not appropriate for the kind of surface I am looking for. Once the firing is complete I often polish the work with sandpaper and other abrasives.

I work towards the plastic properties of simplicity, vigour and natural beauty, and, above all, the ancient art of expressing spirit in form, and I enjoy natural forms and structures as a language to express them. For example, in ancient Buddhist sculpture, the proportions of the body in the 'arhat' figures are different from those seen through the viewer's eyes; the exaggerated and deformed proportions are seen as better expressions of the artist's ideas. I enjoy, too, the scholastic paintings of the Song Dynasty and its ideas of 'being above all material desires'. The artistic conceptions expressed in the traditional paintings are the goals that I seek in my series *The Witty Fools*. The arhats in Chinese Buddhism are mostly gods of great intelligence. Most are bald-headed. I base the construction of my images on these, the characteristics of Taoist figures, the spirit of Zen and my inspiration from other arts. In reality, the *Witty Fools* are men of great intelligence.

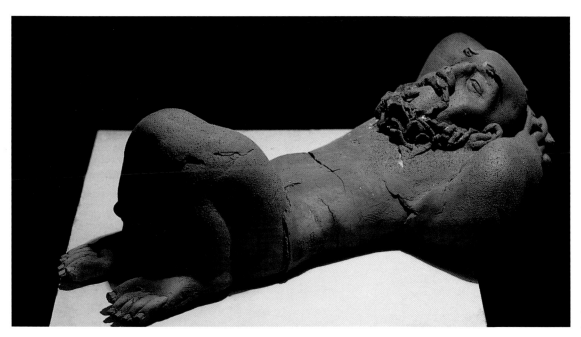

Fool No. 5. *Purple sands; 1998; 70cm × 30cm × 23cm.*

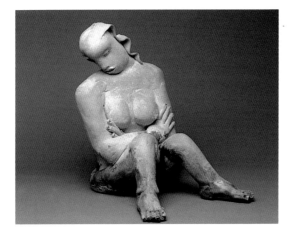

Body No. 4. *2000;*
American clay; 48cm ×
40cm × 64cm.

This sounds like a settled philosophy of work, but in fact Luo Xiaoping went through agonies trying to combine his exposure to Western art with that of his own Chinese tradition and to make sculpture from the experience of both. He says,

> I realized gradually the limitless vitality and connotations in the spirit of traditional Chinese culture and Eastern aesthetics. So how to combine Western academic art with its sculpture patterns and technique of working accurately, with the Chinese disciplines? And what should be my next step? The night wind in the countryside could not appease my anxiety and the sweet smells in the field could not dispel my loneliness.

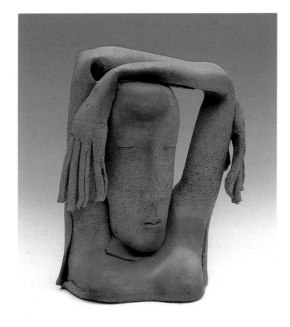

Shadow No. 4.
Purple sands; 1999;
27cm × 16cm × 35cm.

His mind was made up when he was offered a lectureship at an American university and got a visa, but, he says: 'I gave it up and turned my head towards the countryside of Yixing, the sacred place of pottery.' At first he had to do a large amount of religious ceramic sculpture to earn a living, but gradually he found himself 're-understanding' the ancient Chinese traditions. Today the qualities in his work which are humanist and tender have grown from his love of ancient Chinese beliefs. In effect, his work is the result of four different influences coming together. The first is the manner in which he creates from Chinese painting, using the 'free-hand brushwork' concept and the philosophy of 'learning from nature and create a world in your heart'. The second influence comes from the slabbing 'teapot' technique: that of rolling, folding, piling up and pressing the stretched blankets of clay, working within the rhythm of the clay, and keeping the 'creases, cracks and crackles' that result from the behaviour of the material and which give it its vivid expression. Doing this, the artist endeavours to capture the 'sense' and the 'taste' of the clay by going in the direction the slabs dictate, allowing the expressive behaviour of elbows, knees and wrists to take on character. He learns to allow the presence of cracks and leave the 'coarse appearance' of where clay plates are joined. But an artist has to be careful not to go too far along these lines. There is a Chinese saying, 'Only the rational skill is the fundamental guarantee to have everything realized. A blind pursuance of the unconscious "free will" is irresponsible for artistic creation and a misunderstanding of the "free will" in art.' Also, in employing the slabbing technique, it is sometimes too easy for the artist to believe that 'nothing is something' … The aesthetic significance of 'nothing' lies mainly in its strength of expansion from the inside of the artist's feeling, being active and full of vigour and vitality.

The third influence comes from his reactions and emotions of the present and what is around him. This takes in the style, form and ways of seeing Western art (which involve feelings of a search for eternity). The fourth influence comes from a deep spiritual understanding of the Chinese culture, which embraces Zen, Tao and Buddhist tradition: such works as the elegant terracotta figures of the Qin and the Han dynasty or the holy and serene Buddhist cave sculptures. This influence forms the core of each piece – the quiet centre, the animus.

*I*NFLUENCE
Arhat of the Song Dynasty, AD960–1279.

Henk Kuizenga
[The Netherlands]

The sculptures are hollow. The space within the sculpture is part of the space around it. So, I do not give shape to something that lives within me, on the contrary, I see a group of people in a certain situation, of which I want to express the essence. The group is not modelled as a whole (they all have their own base) but are yet closely connected.

Henk Kuizenga sculpts the essence of what it is to be a person, and says it all in a few gestures. His work is like an origami flower, so beautifully folded that it looks deceptively simple. His chitinous skin encompasses completely what we know inside the form. It is as if the snake has just shed its outer layer and slithered away leaving the memory of content. For a few seconds you are fooled into thinking there is substance supporting the carapace. His figures have great presence, and come bearing information on our human predicament – usually not singly but in powerful groups with the same intention. They

symbolize the whole in a few. They are not large – half-size at most – but always placed on a base so as to be viewed at eye level. Henk Kuizenga explains that 'by positioning the sculptures in this way the observer is both kept at a distance and involved'.

Kuizenga came by this idea for this work when he says,

'I once saw an old film, made shortly after World War II, about the village I grew up in. In a flash I saw the villagers passing by. I recognized only a few of the faces, most of them remained strangers, although I may well have known them in my youth. Yet all these people as a whole had a "face". Even though they were all different their postures had something very characteristic. They were all farmers.

'My figures, therefore, do not represent individuals but a group, sometimes even several groups at the same time. A warrior is not one particular warrior, he represents all warriors. Outward characteristics are almost absent, the only attribute represented is his spear. This spear is a sign of his inner force, and at the same time a symbol of power. This way the warrior is not only depicted in his traditional role: he may also represent soldiers, or even a shepherd or a bishop with a staff. Some parts of the body are also missing. A hand, for example, is never worked out in detail with fingers. Sometimes this part of the body is only hinted at, sometimes fully absent. Usually the head is also missing. Representations of the head would turn the warrior into an individual again, while I want to express the universal and the timeless.

'In my work standing figures are dominant. Often the feet are fully fitted with toes. This is essential. The feet symbolize the connection of the figures with the earth. The figures sometime stand alone as a *Guard* or a *Beggar*, but often they form a group. The way these separate but interlinked sculptures are exhibited is, therefore, of the utmost importance. The space between them is related to the situation in which I observe the figures, but also to the underlying idea. Through their positioning they become the bearers of an idea, an idea created out of my observation of the world around me. The group *Men of Gdansk*, for instance, came into being because I saw men at the entrance of the Maria Church in Gdansk. They stood rather closely together as if trying to find protection.'

Kuizenga's figures are composed of very thin slabs of clay which are rolled out on a cloth to

Sitting Figures. 1999. 9cm. Porcelain fired to 1,380°C in gas kiln. J. Zweerts

avoid sticking. 'Sometimes', he says, 'I use the texture of the cloth to make the surface more lively, sometimes I roll dry engobes on the slabs of clay. These slabs are cut in smaller parts of different sizes. These parts – whether or not coloured with oxide or pigment – are slipped and pressed together.' It is extraordinary how such thin slabs can produce such strong forms with so much inner tension, and even into these fragile slabs, Henk says, 'to add a further

sense of vulnerability to the figures I often make holes in the membranous skin.'

Kuizenga used to work in bronze, modelling his figures to be cast from slabs of modelling wax. His new porcelain work corresponds with this earlier work in that the slabs are bent in the same way as the former wax. They certainly have the same fragility and feeling of a wax model. But Henk explains the reasons why he gradually turned to clay:

> Clay has qualities that give more expression to my work. Moreover, it enables me to work more directly. And in modelling the figures I leave the imprints of my fingers on the clay to show how I work the material. I also do not want to enhance the beauty of the material, as its earthy purity must be preserved. That is also the reason why I avoid glazes and rather work with oxides and pigments. I do not weigh the quantities but add them intuitively to avoid uniformity.

Recently the artist has moved from firing his unglazed figures from a home-built gas kiln to an electric one. He says,

> I use a mix of different kinds of clay, both earthenware and stoneware mixed with grog. I prefer working with Vingerling K130 or clay

Woman. 1995; 23cm. Porcelain fired to 1,380°C in gas kiln. J. Zweerts

Women Undressing. *1994. Grogged clay, various colours of slip; 80cm. Fred Van Rijen*

'In those days', he describes, 'there were quite a few brickyards in that area and as a young child I went to get clay for the small sculptures I modelled. At a very early age I came to know artists in the city of Groningen, who were interested in German Expressionism. My interest in the German sculptor Barlach, dates from that period. Again, at his retrospective (in 1961 in the Boymans-van-Beuningen Museum, Rotterdam), I experienced his simple but powerful sculpture, particularly his search for what is profoundly human and which surpasses the individual, which was what appealed to me. Barlach has a preference for simple figures that are created by means of a few sweeping outlines. His figures are recognizable but stripped of any detail and therefore express something that transcends triviality. By their simplicity and clarity, Barlach's human figures, usually rather small in size, create an impression of great monumentality.

'Sometimes it is as if I evoke "images" from a remote past or bygone cultures, for instance, the warriors from the burial site of the first Chinese Emperor Qin Shihuang Di (246–210BC). Yet the past is not my source of inspiration, for I place these figures outside the context of time. They are also related to contemporary situations,

from the Colpaert company (B). The basis is clay that turns white in the firing process, perhaps mixed with a small quantity of red and/or grey clay. Sometimes I use a stoneware with coarse grog from La Borne. On this basis I apply layers of stained engobes. Ever since I started working in porcelain, I have tried to expand the possibilities by mixing stoneware with porcelain.

Henk Kuizenga was awarded the golden medal at the XIe Biënnale International de Céramique d'Art at Vallauris in 1988. But equally important to him was meeting the Polish ceramist Anna Zamorska, who invited him to participate in a symposium on the theme of 'Porcelain: Another Way', and who has inspired him to create porcelain sculpture for this gathering in Walbrzych ever since.

Kuizenga was trained at the Academy of Fine Art in Rotterdam with Jaap Kaas as his teacher. Later he taught modelling and ceramics himself at the Ichtus College in Rotterdam. He was born in Warffum, a small village in the north of the Netherlands in 1933.

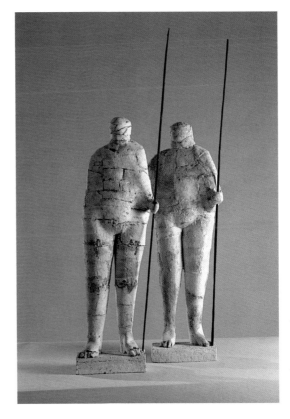

Warriors. *1990. White grogged clay and slip, 80cm, spear from wood, 100cm; Fred Van Rijen*

*I*NFLUENCE
The Avenger. *Ernst
Barlach, 1914. The
Tate Gallery, London*

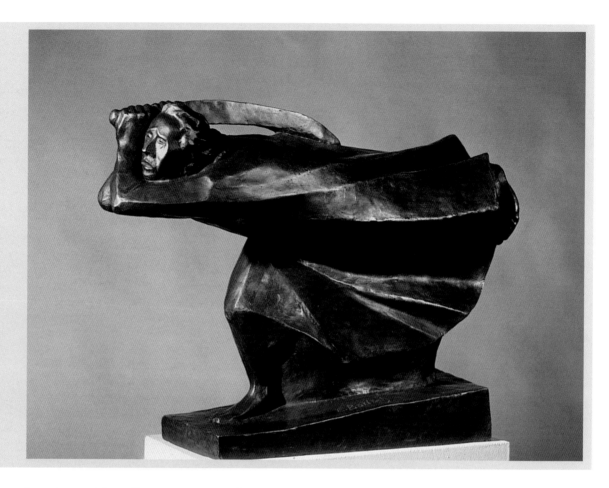

*I*NFLUENCE
The Avenger. *Ernst
Barlach, 1914. The
Tate Gallery, London*

though specific references to our time are absent. They become universal timeless figures. In fact, I myself am my most important source of inspiration. Certain ideas of which I am hardly conscious are dormant in my head. On seeing certain real situations these ideas suddenly become manifest, and not until then can I try to realize them in shape. The titles of my sculptures hardly say anything about the figures portrayed. They underline the metaphoric meaning of my work. Much is left to the observer.'

This feeling is especially so with Kuizenga's two suited figures, which say in a few foldings everything you need to know. They are intimate and relaxed. With one, the suit/skin is patterned like cloth – a blue flecking of Harris tweed or a smart Italian material. For the other, the white purity of porcelain is enough. It probably sounds banal to say that they look as if they had just been formed a few minutes ago, but Henk's easy origamis really do retain that first, fresh, folding of clay, now preserved forever. A distillation is hard to arrive at. You have to conceive of the whole as you make the part. Yes, Henk Kuizenga has the ability to sculpt essence.

Peter Johnson [Australia]

I like to refer to the tradition of ceramic figurines, often placed on the mantelpiece in the family home in the past. Royal Doulton, perhaps, being the best known of these, displaying romantic pastoral and domestic themes. However, my work does not embrace these romantic notions, rather it attempts to portray a social realism set in the Australian idiom.

These delightful and personable pieces of Peter Johnson's are packed with humour and fun. They depict the ultimately ordinary working man and woman in everyday life. It will come as no surprise that Johnson has chosen Stanley Spencer for his inspiration; his figures have those same stilted poses of complete naiveté which gives them their charm. They also have the same tinge of mystery and show a tenderness for the commonplace. They each portray a busy person taking a moment off from work – maybe in the tea-break – while they are persuaded to have

their portraits modelled. Or maybe there is a personal 'moment of glory' that they are experiencing which is captured forever.

These pieces are larger than they appear in reproduction, and this gives them added presence. The figures standing on their own project an extreme feeling of isolation. The smaller figurines that Johnson groups together do not work quite so well since, as the scale diminishes, so does the presence. But they cling to their own proud, individual personalities, reminding you of *The Borrowers*, those endearing characters created by Mary Norton who live beneath the floorboards of the houses of normal-sized humans. They, like Peter Johnson's working men and women, use all the ingenuity they can muster to survive. Johnson's social-realist gems may turn out to be collector's pieces.

Peter Johnson tells his tale:

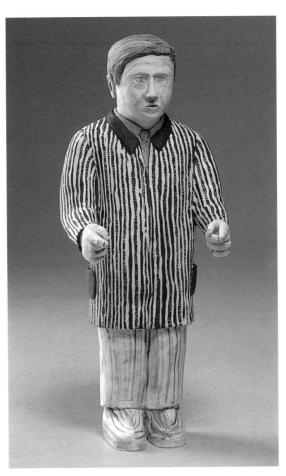

Between the Posts. *2000. Stoneware clay, black and white slips, sgraffito and text, mid firing temperature; 80cm. Michael Kluvanek*

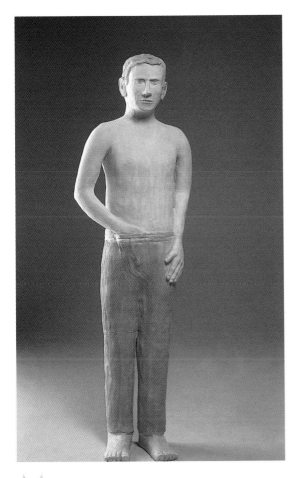

Man in Pyjamas. *2000. Stoneware clay, colloidal and ceramic stains slips, mid firing temperature, wet and dry paper after firing; 1.75m. Michael Kluvanek*

'I was born in 1952 in Pinaroo, a wheat and sheep region of South Australia, and then moved to Adelaide as a young child, growing up and going to school in the city. The weekends were spent playing and working on the farm with my family. Before studying ceramics at the age of thirty-two, I trained as a toolmaker and then travelled in Europe, North Africa and South-East Asia for two years. On my return to Adelaide I utilized my skills as toolmaker to design and make surgical equipment in a hospital for six years. It was from here that my creative pursuits began, studying at the University of South Australia and completing a degree in design in ceramics and glass in 1988.

'After a short residency at the University of South Australia I rented space at the Jam Factory Craft and Design Centre in Adelaide to produce thrown tableware and develop sculpted figures and lidded vessels. I then spent several years working at the Jamboree Clay Workshop, a ceramic co-operative that two colleagues and myself established in 1990. During this period I exhibited ceramic work throughout Australia, gaining recognition as a skilled

'The life-sized figure *Man in Dustcoat* is constructed in three coil- and slab-built pieces. The sections were separated by newspaper or thin plastic during construction, then parted when they were ready for firing. I generally use stoneware clay, sometimes with grog to create a textured surface with a dry stone finish. I paddle and push the clay to express sensitivity as well as strength of form and line. The images of industrial scenes, smoking factories and parts of machinery fading into the sculpture create a sense of contemplation; a history that the viewer may reflect upon. *Man in Pyjamas* may evoke a similar response. This figure is also life-sized and made in the same way, with the exception of surface treatment, which is a

practitioner, experimenting with unglazed surfaces, applying colloidal slips and stains to form a smooth soft surface.[1]

'In 1994 I received an Australian Council grant for a residency in Barcelona. This was an opportunity to take time out from ceramic practice – experimenting, developing new concepts and visiting galleries and museums throughout Spain. It was a time for reflection – to realize the strengths of my own ceramic work and its meaning and relevance in the Australian context, and to plan future projects. The figurative works that followed attempt to capture an Australian genesis. They contain social realism, ambiguity and humour, reflecting both the extraordinary and the everyday life of work and play, of factories and backyards … the community in which we live. There's action and inaction, a created tension, a sense of time gone by – something we all experience.

[1]The colloidal slips I use in my work are derived from Australian terracotta clays. They are the finer particles within the clay body. They are separated by adding dry clay powder to a bucket of water (5l) with a deflocculating agent (sodium silicate, 5g). They are mixed together and allowed to stand, letting the heavy particles sink to the bottom and the colloid remain. The suspended material is removed and the excess water is allowed to evaporate until the right balance is achieved.

INFLUENCE
Stanley Spencer, Shipbuilding on the Clyde: The Riggers. Detail. Courtesy of The Imperial War Museum and the Spencer Estate

ory, a personal history but maintaining a relevance for today. These characters, which represent our experiences of everyday life, record a history of a contemporary civilization, possibly like the terracotta figures in the Chinese tomb of warriors.'

Sally MacDonell [England]

I try to relate my observations of the human form to my experience of people; 'that nature peculiar to man'. Through subtlety of posture and momentary gesture I aim to instil humanity into my figures; expressing the characteristics we all share. It is with the creation of tensions within or between figures that I hope to engage the viewer in relationship with my work.

Sally MacDonell's people are all friendly and exhale amusing ambiguities. They have poise and nobility, yet they are ordinary in the postures they take up, seeming perpetually to communicate with the viewer. They adopt a universal 'I am approachable and ready to chat with you' attitude which is all very unthreatening.

MacDonell was born in 1971 in Boston, Lincolnshire, the youngest of four sisters. After following the training necessary for a career in graphic design, she suddenly changed direction. This, she points out, came as 'the result of realizing the limitations of desk-top graphics

smooth rendering of colloidal, coloured slips, worked into the surface of the clay.

'The smaller-than-life figures create a manageable world. With their doll-like size they convey humour, unpretentious gestures towards a simple world. For example, the character *Between the Posts*, gesturing with pointed finger, symbolizes the frozen point in time when the football umpire, experiencing his moment of glory, captures the attention of the crowd. While the figure *Standing on the Lino* is caught in the point between stasis and action; her decorated dress of yellow, orange and blue reflects the pattern of the lino she is about to move from.

'Stanley Spencer, the English artist who painted the Glasgow shipyards, provided insight into the place that industrial workers inhabit, portraying the significance of their activity, such as welding, hammering or drilling of metal. Like the scenes in Spencer's paintings, my work moves beyond what may be viewed as the mundane to take on a metaphorical, almost spiritual significance. In my work I hope to capture that moment; it may be a nostalgic mem-

Reclining Figure. *1999. Smoked stoneware with pewter details; 40cm × 26cm. Fiona Hills*

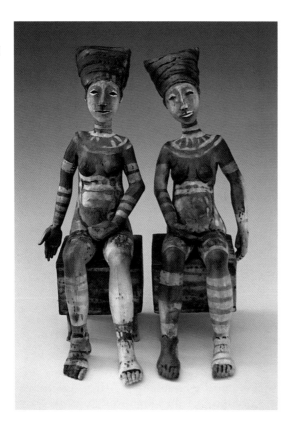

Pair of Seated Figures. *2000. Smoked porcelain and pewter; 26cm.*

living people viewing them. She is adept at elevating the ordinary to something special.

The noble aspect of her work is achieved by such effects as the decorative bandings of pewter which resemble the torques, anklets and armlets of tribal or early cultures. Also, by the heavy-looking headresses or hair, which resembles the wigs worn in ancient times for prestige. It means that the head always has to be held high. The ordinariness comes when the figures are relaxed into all manner of informal poses to make them approachable. MacDonell often groups her figures together. Two similarly-decorated figures may be chatting away, using hand-gestures that all of us use in such circumstances; or three related figures sitting on a fence will, with their identical hairdos, suddenly remind you of some singing group from the 1950s, the Beverly Sisters perhaps. The strange mixture of nobility and casualness gives you the sort of jolt you would experience if you saw the Queen, wearing her regalia, but sitting on her throne cross-legged and relaxing back in one corner.

There is another conformation of style that draws Sally's work together. This is its decoration

on my need to make and build things'. So she went on to graduate at Bath Spa University in three-dimensional design. She now has a studio with her husband Alasdair Neil MacDonell. They also share space and energy, and possibly influence one another in amiable ways.

Sally is an observer of people, watching with the avid closeness of a twitcher; collecting mannerisms and behaviour patterns like a trained zoologist. 'I am fascinated by people wherever I am', she admits. 'Especially good venues are waiting rooms at railway stations, cafes, hairdressers or the foyers at museums. I sometimes sketch when I'm out but more often have to rely on mental notes of poses – people move!' She particularly likes watching people who are themselves commenting on others. 'A recent visit to the Victoria & Albert Museum in London provided me with material for several pieces', she recalls. 'I watched two girls sitting waiting in the foyer, and, as they interacted together, watching the "talent" go by, I put them down on paper. A series of pairs has evolved from this expedition.' It is not often that artists are inspired by the people who visit museums, rather than by the exhibits. The result is, however, that her work may become a fusion of the inanimate artefacts inside the museum with the

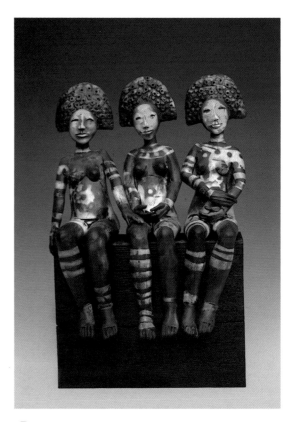

Seated Figures. *2000. Smoked stoneware with pewter, on wooden base; 38cm × 25cm.*

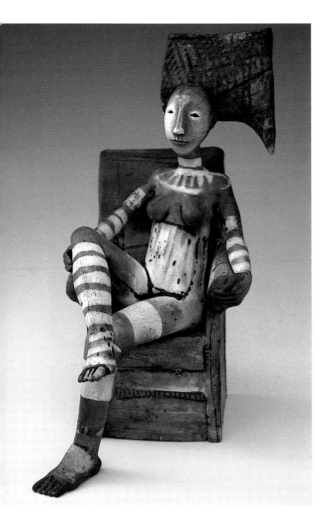

major influence a terracotta group of two girls playing knucklebones (Greek, made in Taranto, southern Italy, *c.* 340–330BC, in the British Museum).

Seated Figure. 2000. Smoked porcelain figure in stoneware chair; 28cm.

> I adore the fact that this piece shows two figures doing something so ordinary, playing as friends have done together throughout history. It truly has that quality of a frozen moment that I seek to express in my own work. The modelling is so natural and full of life and its scale so immediate I can imagine the maker fitting into their hands and turning the figures over as the detail is added. The original finish of the work has been eroded, leaving a surface only experience of time can create. I feel that this decay and damage helps to make it more beautiful than it would have been when newly finished. These two women are so full of humanity and beauty they inspire me to strive to put the same qualities into what I do.

Spontaneity is the most important part of Mac-Donell's technique, because this echoes the everyday gestures of people. This is produced by her choosing to model from the inside of each piece. She uses slabs of clay (Potclays porcelain DL 1147 or Earthstone Original) fashioned into tubes like brandy snaps to make sections of limb. By pushing and pinching from the inside of these, she creates a sense of the body. 'I find', she says, 'that modelling from the inside leaves the outer surface of the clay fresh and still carrying its own life. It prevents the clay becoming tired.'

She prefers to harden each of these sections under the bulb of a spotlight rather than using an armature of any kind. This also adds to the spontaneity of the process. There follow three further stages. First, the bisque-fired figures (to 1,050°C) are washed with copper oxide, which collects in all the cracks and creases of the joins. Secondly, a white engobe clothes the figures before they are returned to a further firing (1,170°C). 'It is important to me to have this higher firing', she says, 'as I need to know that my work is strong.'

The enriching process of smoking the work makes up the final stage. This involves wrapping each figure with masking tape to allow uneven penetration of smoke across the surfaces, thus creating the variations of colour. 'Experience has taught me how to achieve tonal contrasts and patterns by the way that the tape

and treatment, both labelling them indisputedly the work of their maker. For instance, it all shares quirky little irregularities – each limb being differently patterned, perhaps. None of her figures is clothed, because they come from an exotic world where clothing is not necessary. But they all bear decorative markings, each of which appears to have semblances from the past, the present … or the future? And each, nicely and wittily, shares body-space with ambiguous accessories; for instance, stripy winter leggings/leg bracelets from India?; essence of bedroom-slipper/Roman sandal?; leopard angora neck-scarf/Egyptian necklace?

'I feel that my work shows the accessibility and influence of different cultures coming from the multimedia society in which I live', she writes. And on visits to museums and galleries she says, 'I look at all forms of primitive art, and I enjoy the braveness of African art, the way the body is expressed and the use of different materials. Also I admire painting, especially the work of Balthus, Cranach, Schiele.' She names as a

*I*NFLUENCE
*Terracotta group of two girls playing knucklebones. Greek, made in Taranto; c. 340–330*BC*; 14cm. Courtesy of The British Museum*

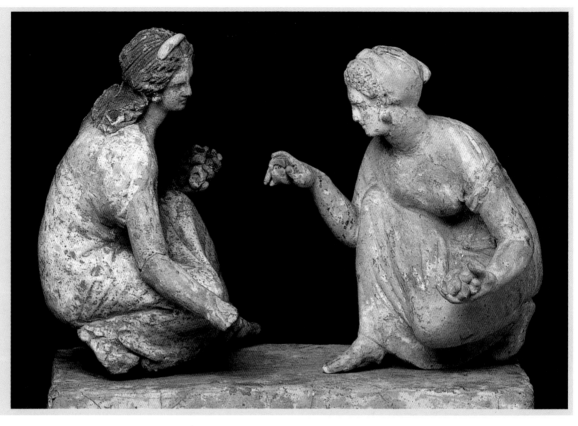

is cut up and applied', she explains, 'The possibilities seem infinite and are influenced by the quality of the masking tape; the type of sawdust; the dampness of the day; the heat of the fire.' The work is packed inside a loosely-built, brick structure with a tin lid, tucked inside layers of newspaper and sawdust. The fire is lit from the top and allowed to burn through, taking between 10 and 12min. Once the work is cool enough to handle, the pieces are cleaned up with turpentine or methylated spirits, then sealed with a high quality beeswax polish. Only when this has been buffed with a boot brush and then a sheepskin mitten can the pewter detailing be added for decoration. MacDonell's post-firing technique brings about a new set of intriguing ambiguities. Her treatment of smoking imparts a dusky patina, the exotic appearance of which tells you that they dwell in some clime of scorching sun; yet it also gives them a musky quality, which, together with the pewter decoration, takes them back to the sunless interiors of the museums.

MacDonell's figures used to be more awkward-looking and slightly tense. But nowadays they are becoming more relaxed. Their postures are very much those of people caught unawares, and the artist tells me that she is in the process of making a series of new, 'really comfortable armchairs' in which her next set of people can sit entirely at ease. Perhaps it is because she is trying even harder to break down any sense of distancing between her work and its dialogue with those who are introduced to it. For Sally is essentially a sharing person, loving other people's reactions to her work, enjoying their extrapolations as to the meaning of what her human forms in clay are all about. Are they, perhaps, from the past or the present? Or are they people from a future when civilizations might have become intermixed and portray a medley of characteristics from each culture and way of life? Wherever they come from, it is the sameness of all people as well as their multifarious differences that MacDonell celebrates in her work. 'We are all so curious', she says.

Eileen Newell [Wales]

The human head – a never-ending fascination – each one unique – each one replete with memories, possibilities, happiness and sadness; so much hidden and sometimes so much shown. When I start to

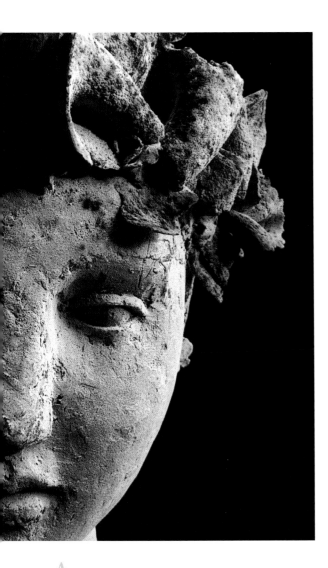

rcadians I. *1999. High-fired ceramic, barium base glaze, copper oxide additions.*
This head has a certain Arcadian, bucolic quality; an air of happiness known and lost.

work with a lump of clay I don't know what is going to happen, there is no preconceived visual idea. I respond to the forms that clay suggests and the instinctive, intuitive knowledge of our shared humanity starts to turn into a solid form.

Eileen Newell works in a completely spontaneous way. Her *Heads* are simple, effective and expressive, and her creative force motivated by the sheer joy of working with clay. She has created her own personal set of antique inspired busts, a group of wise and thoughtful-looking personalities, so gentle and tender that you would not mind sharing living space with

them. Each is covered with glorious patination, directly inspired from the rural part of Wales (Blanenau, Ammanford) where she now lives with her husband, the painter Robert Newell, and where she has her studio.

'The mineral qualities of the land are all around me', she describes, 'stony, gritty textures, rich and subtle colours revealed by a damp climate.' It is these shifting lights, shadows passing over the ground and over stone-like textures from the mountains, and the power and size of the mountains themselves that the artist metaphorically lifts up and puts into her work. For her modelling, Newell has chosen 'crank' – a tough, open clay that can be handled without kid gloves. It allows her to fire at temperatures of between 1,200 and 1,260°C to produce a stone-like appearance, and it gives the strength and character of body she needs for her particular method of working.

> At the moment [she explains], 'I am using two 25kg bags of clay as a starting point. (I have stopped using paper clay because of the fumes it gives off and the labour of wedging it all up. Crank seems to be the answer and it allows me to work from great blocks of clay.) I hollow out my sculpture as I go along – and as soon as the structure will let me without collapsing. I am left with a large amount of scrapings which I happily donate to my local art college; there is no way I can recycle it all; I don't have the stamina. Features develop spontaneously as I work on a head. I remove clay from one place and it inevitably goes straight back on to an adjacent area – this happens again and again – an almost organic spontaneity takes over – I just seem to be arranging matter, similar, of course, to a potter throwing on a wheel. I often think of this When a piece gets to a certain state of workability, still moist and plastic but firm and strong, that is the most important time for me – make or break – I have to work to the dictates of the material as a thrower would, the volumes within the form shift around and suddenly it seems to balance – then it is time to stop.

Newell applies the same intuition and logic to her glazing techniques.

> I work using a barium base glaze, adding oxides in sometimes quite a spontaneous manner. I don't test – I take risks – sometimes they work and sometimes they don't. I can

Porphyry'. 2000.
*High fired ceramic,
various oxides in
barium base glaze;
22in. The artist
 I remember looking
at Egyptian sculpture in
a Bristol museum with
a similar quality: a
volcanic rock composed
of large crystals.*

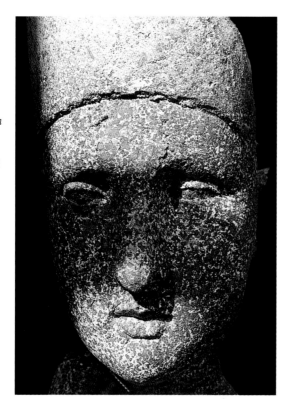

always refire. When a piece is complete, I
name it from my own response to the work.
My work is getting larger, but it still seems to
me to be too small as I build it … the reverse
of Giacometti's problems; he kept making
smaller and smaller … it is only when some-
one stands next to a finished piece that I real-
ize it could be about twice life-size.

Newell started to train for this career in the
1960s, when she was seventeen. But her parents
were terrified, deeming art college to be some
sort of den of iniquity. 'Parental disapproval
made continuing study impossible and I was
pulled away and sent to work in an office as a
secretary – a most heartbreaking time for me',
she says. Finally, however, when she moved
from the Midlands in the late 1980s, she found
opportunities to study at Swansea, Cardiff and
Carmarthen. She variously studied general
illustration, visual art (50 per cent art history
and 50 per cent painting) and ceramics. And it
was ultimately clay, with all its technical com-
plexities and the fact that it allowed her to
express herself in three-dimensional form, that
won the day.

Her delight in the human form was rein-
forced through an enjoyment of observational
drawing. This subject ran as a common thread

Veriditas. 2000.
*High-fired ceramic, low
temperature lead glaze
with copper oxide;
22in. The artist
 The material
qualities of the surface
and the feeling of age
and wisdom in this
piece of work started
me thinking about
alchemy. Veriditas is an
alchemical term
associated with the
changes that occur in
metals; changes such as
rusting, but in this case
verdigris, in alchemy, a
sickness of the metal.*

through each of these courses and became vital
sustenance for the artist. She says, 'It is only
when we draw that we really look at something
very, very intensely and there is always so much
to discover.' Newell's subject matter came quite
naturally from a response to all the cultural,
physical, emotional and intellectual stimuli she
had experienced. 'All the subjects I studied feed
into my present work', she says, 'from art history
[I learned] an enjoyment of classical antiquity,
the Renaissance, the baroque, modernism – they
are all still influencing us today.' So it is not diffi-
cult to understand why a particular head, found
in a 1939 book on Michelangelo, has been a
picture that has continually inspired her
through her artistic career. She writes:

> Michelangelo's work is full of drama and ten-
> sion emphasizing other qualities of sensitivity
> and tenderness, wisdom, uncertainty … My
> other influences – Picasso and de Chirico –
> both contain classical humanist elements,
> too. Could they have been influenced by
> Michelangelo I wonder? There is a piece of his
> work, which I feel sure I first saw when I was
> very young, on the ceiling of the Sistine
> Chapel – the *Head of a Libyan Sibyl*. Its quali-
> ties have never left me. Reproductions of
> sculpture are always disappointing, but when I

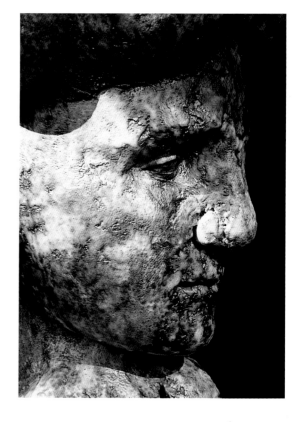

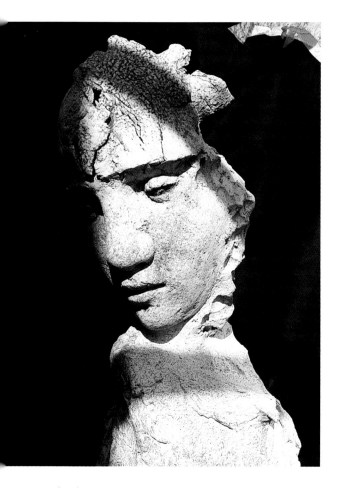

Medea.; 2000. High fired ceramic, barium base glaze, manganese additions 24in.

A head with a tragic air. I have taken a character from Greek legend which seemed very appropriate. Medea, a sorceress, helped Jason to obtain the Golden Fleece. They were married but he deserted her, in revenge she killed their two children.

look at the painted Libyan sibyl I know it to be a sculptor's work. No doubt this particular monochromatic reproduction (before restoration) emphasizes the expressive qualities of chiaroscuro and volume. Also, the cracks that run through the work suggest a connecting feature common to all organic matter – its vulnerability. The vagaries of the material endow the work with the changing qualities of life.

But Eileen Newell's subject matter for her *Heads* comes, too, from the present. For, when 'the lack of human contact and visual stimulation from an urban environment' gets to her, the artist visits London. On the Underground she sees material for her potential *Heads* in people's

faces from all over the world. She finds them fascinating and has to take just glimpses so as not to stare. After visiting the museums and galleries, she says, 'I am so stimulated by everything that I long to be back in my studio working … The series of *Heads* that I am working on now are the outcome of frustrations over problems encountered with making larger complete torsos. I experienced numerous delays because of body casting, the work was difficult to dry, to move, to fire … the *Heads* were started as a way out … now they have taken over. I have favourable responses to them from many people, and ultimately, this is what the artist working alone hopes for – something personal becoming something universal – a sharing of human experience.'

Ruth Dupré [England]

The figures I make are usually inspired by my family and friends, and sometimes strangers – people I might see on a bus or a train.

*I*NFLUENCE
Michaelangelo, Head of the Libyan Sybil. *Ceiling of the Sistine Chapel. Courtesy of The Phaidon Press*

Ruth Dupré's family is her whole world; she uses it as her main inspiration, having developed a gentle art with a simple philosophy that is both effective and pleasing. This has enabled her to create a kind of family photograph album of sculpture, one that could easily find a place in the National Portrait Gallery, in the Elizabethan period perhaps. For, with an artist's imagining, she sees her children as princelings and little queens, dressing them in the wonderful hats and costumes of aristocrats (though occasionally they descend a few ranks, masquerading as medieval peasant children). She is carrying on the tradition of the type of portraiture you would find in a stately home, but with a modern slant: touchingly serious and enriched with delightful conceits of ruff collar, frill, delicate embroideries or a peasant boy's cap and coat. The artist is a master of decoration, working in sensitive colouring and soft glazes in a language never overdone.

Each piece is about 2ft high by 1ft wide, but you could be confused into thinking (without the benefit of captions) that they were miniatures. They have that all-enclosed tightness of composition which allows the form to sit easily on an area of polished furniture. Some pieces are set off with a rounded plinth (upon which something might be written) that would go well on the mantelpiece instead of the family photographs. You have to look at them closely and with concentration to appreciate what they offer: a domestic gallery of family intimacy.

Her 'strangers', too, 'spotted on a bus or a train', have been drawn in by Dupré to become part of an enlarged family group. All are bonded in feature and manner of dress, showing the same thoughtfulness of expression. All have been dressed up – rather in the way that Rembrandt swathed Saskia and himself in gorgeous robes; not for the intention of elevating themselves into higher social standing, but for the sheer delight of painting the exotic, the brightly-coloured textured cloth adorning the body.

Ruth Dupré's family line descends from ancient Huguenot roots. She herself was born in 1954 in a small village in Essex and soon moved to another village outside Cambridge. She left home to study in London, first as a student at Goldsmiths College, then Ravensbourne Art College and finally on a four-year BA course at the Middlesex Polytechnic. During that time she met her husband Michael Glover, writer, poet and journalist, who had come from

Sheffield to be in London. This is where they now both work and live, with their two children represented here. You see that each child has sat patiently – not in boredom, but proud to be what they are: part of a happy, contented family. Their mother has captured their innocence and protected them from the harmful world around by the sheer glory of their clothing and their aristocratic bearing in her fantasy land of dressing up. The artist has chosen a strong T Material to form the main portrait structure as well as the gorgeous embossings of collar, frogging, buttons and buttonhole flowers or embellishments like the impressed woven design for the materials. Dupré describes how she 'handbuilds these by rolling out rough slabs of clay (often textured) which are then torn and used as building blocks. I use a riffler [a curved file] on the face and neck. The pieces are biscuit fired to 1,000°C.' After this, a thin layer of porcelain slip is applied. This 'skin' provides a soft surface for more decoration over three further firings. The artist describes this: 'On top of the dried slip I apply stoneware glazes in some areas and fire to stoneware. I then apply some earthenware glazes and underglaze colours and fire to 1,060°C.' The final bejewelment comes with touches of enamel and lustres applied with knowledge and safety because, as Dupré explains, 'enamels and lustres are very predictable in their tone and colour, so I feel confident that what I am painting will stay as I want it. This final firing is to 750°C.'

Ruth Dupré's style is influenced by the individual qualities she sees in each portrait, changing them to suit the different personalities. She says, 'I try to express my sensitivity to them in the way that I make the features of both my children. My daughter is gregarious and outgoing and I use bright, vivacious glazes and lustres for her; and for my son, who is quiet, shy and thoughtful, I use soft glazes and slips to describe him.' Altogether, the artist looks for serenity in her work and life, and it will be exciting to see the portraits grow as the children get older.

There is one particular piece that has influenced the artist throughout her career, because she sees in it close affinities that are instantly recognizable as the qualities she seeks to produce in her own portraits. She says:

When I was in Paris, I saw this sculpture of Sainte Mabille. It was a fourteenth-century wooden bust of a woman from the Musée de

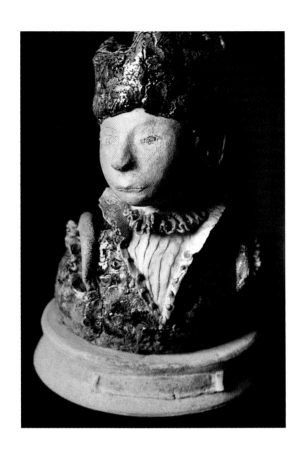

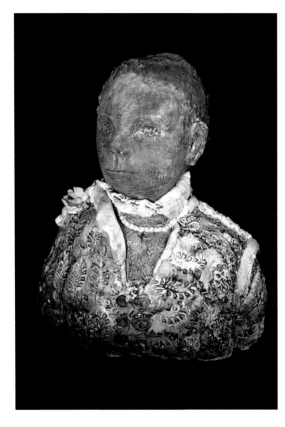

My Daughter Jesse. *T Material with porcelain slip; 24in × 12in. (far left)*

My Niece Lucy. *T Material with porcelain slip; 24in × 12in.*

A Young Boy. *T Material with porcelain slip; 24in × 12in. (far left)*

A Young Girl. *T Material with porcelain slip; 24in × 12in.*

Cluny. Sainte Mabille is by a Tuscan artist (perhaps Angelo di Nalduccio?). She has an extraordinary, serene presence. Her face has the confidence and arrogance of classical beauty, and her hairstyle and clothes give her an ornate dignity and elegance. The gold and the jewels and the carving give it a wonderfully rich and exotic glow. She has an extremely long neck, which gives the piece an edge of humour, not amusing exactly, but somehow odd and unexpected. I try to incorporate many of these aspects into my own work. I am convinced that it is very important for artists to feel totally free to be influenced by work that inspires them. Ideas will always change when they are processed through an act of making.

Akio Takamori [Japan/USA]

My interest leads into investigating who we were in the past and who others were in different cultures. I am interested in human images that represent ordinary mortals like myself.

The extraordinary thing about this gifted artist is that he seems totally unafraid to produce anything he wants – and his output is prolific. Akio Takamori's startling and super-real figures are the artist's memory-portrayal of his village in Nobeoka, Kyushu Island, where, in 1950, he was born. But they could represent any ordinary village mortal and they could be any of us, celebrated as a family group or waiting at the bus stop. Each figure wears an expression of dignity, grace and humanity; each is individually animated and carries the respectfulness of his or her own personality; yet all are interrelated. Although they work well singly, they are certainly more striking and moving seen in a group, when their impact is magnified by solidarity and social variety. They glance at one another, not inquisitively but with self-composure. Only one or two stand apart from the crowd, their importance distancing them. They are *Emperor 2000* and *The General*. Isolated by their position in society, they appear to stand slightly ill at ease, almost to attention.

Akio Takamori used to make pottery before he decided to concentrate mostly on figurative vessel forms. He had, after all, been apprenticed to work at a traditional domestic production pottery in Koishiwara from 1972 to 1974, after he had attended the Musashino Art College from 1969 to 1971, in Tokyo. So it was a momentous occasion when the vessel maker went to stay in the Netherlands' famed European Ceramic Centre, 's Hertogenbosch. There, for three months – and in an atmosphere of experiment backed up by wonderful technical facilities – Takamori was reborn as a sculptor and began to build his village of people.

All the 'Millennium' work shown here is painted with a light touch and apparent simplicity using black brush drawing. This artist has the ability to capture everything in a few deft strokes: the villagers' clothing – jackets, printed cloth and vests – as well as the outline of their expressions. Although he is undoubtedly inspired by Japanese woodblock prints in the way he depicts his loose-yet-formal patterning, the whole idiom of his work is very much a product of his own strong imagery – inimitable, because no one else could possibly create it. The artist uses a buff-coloured stoneware sculpting body to build his figures. He works with rather thick coils, using more clay on the lower parts to give weight for stability and less as he progresses upwards towards the head. He draws straight on to the greenware forms using

Figural Group 2000. 2000. Stoneware with black and white under-glazes; 16–37.5in in height. Ayumi Horie. Courtesy of the Garth Clark Gallery, New York

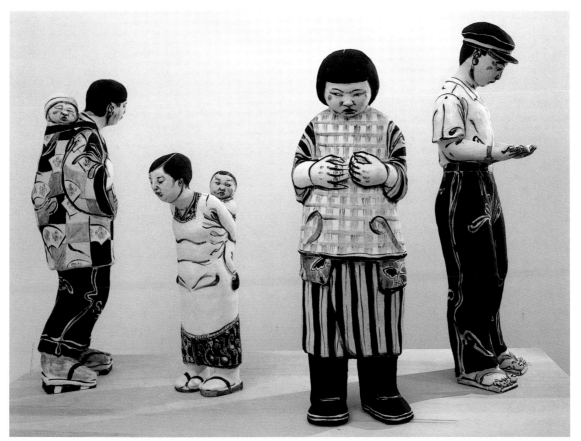

Installation View 2000. 2000. Stoneware with black and white under-glazes; figures from left to right: man and baby, 81cm high, woman and baby, 61cm high, sister 84cm high; boy reading 94cm high. Kate Preftakes. Courtesy of the Garth Clark Gallery, New York

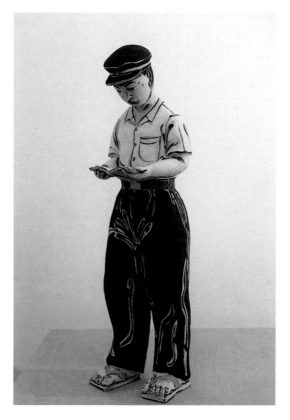

Boy Reading. 2000.
Stoneware with black
and white under-glazes;
94cm. Kate Preftakes.
Courtesy of the Garth
Clark Gallery, New
York

1993 he has been Associate Professor of Art in Ceramics at the University of Washington. He lives and has his studio in Seattle. People look forward to Akio Takamori's exhibitions with great pleasure. His work is collected, admired and loved. This is undoubtedly because his figures are expressions of pure existence; a celebration of simply being alive; and their chief delight is that we can all easily identify with his villagers, whose feet are so chunkily set upon the ground, showing that they are earthly beings like ourselves.

Takamori interrogates himself and answers some of the questions:

'How do I see myself? How do I appear? Who am I? are the questions I ask through my work. Those anonymous people with their cultural and historical personae intrigue my imagination and curiosity into looking into each individual mortal's inner life. The grouping image of individual, anonymous people in visual art connects my sense of time both past and present together and helps me understand my questions. I like clay figures from earlier histories around the world, especially the Han and

a black and white underglaze, rather in the manner of a fresco being painted on a gessoed wall. Doing this, you cannot make mistakes, so your head and heart and hand have to be ready. When it works – as it does here – an artist can produce freshness and vitality. The shapes of his figures, too, with their smoothly curved outlines banishing all rough protuberances have, since 's Hertogenbosch, become more fluidly modelled to match that free – even casual looking – quality of brushwork over the gentle buff stoneware surface. They have also become increasingly large, more confident, more economical.

Once the figures are completely dry they are fired to around 1,150°C in an oxidizing atmosphere. The artist's aim, he tells us, is to reach towards 'coloration and an amiable surface, instead of a cold and hard surface.' You feel that the artist will not rest until he has re-created the whole of his former village in sculpture, surrounding him with the security of a family album of his roots in one huge body of work.

Takamori left his homeland in 1974 and went to the United States. There he obtained a BFA from the Kansas City Art Institute in 1976 and, in 1978, an MFA from the New York State College of Ceramics at Alfred University. Since

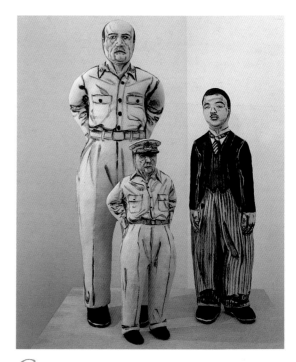

General. 2000. Stoneware with black and white under-glazes; 117cm; General MacArthur with Hat, 68cm high, Emperor, 89cm high. Kate Preftakes. Courtesy of the Garth Clark Gallery, New York

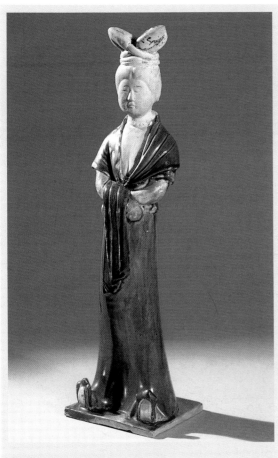

*I*NFLUENCE
Sancai pottery figure of a court lady. T'ang Dynasty;
16¾in high. Courtesy of Phillips Auctioneers,
London

and contracts, which allows me to examine myself in a wider context. Filtering through my memory I become more aware of connections with my personal history and my cultural heritage and into the present reality. On the other hand, memory is the place where I am less restricted from structural reality. I examine and visualize the meaning of scale, space, material and dimensions in my memories.'

Viola Frey [USA]

Figurines function in order to make acceptable those things our culture finds unacceptable … These figurines – they're cross-time, cross-cultural, they're everything, Michelangelo's David, The Last Supper *– thousands of them have been made for the kitsch market, whatever that means. There's plenty out there – more than enough. You can only get good art from bad taste. Good taste leads to ruination.*

Viola Frey's achievement is truly personal and original. To an outsider, her figurative art epitomizes West Coast America. Her human forms display an American self-confidence and audacity. Their images are massive, all very bright, light, colourful and zany. They are usually displayed in groups that demand notice because of the surprise of their sheer scale. They are a new hybrid of American high-rise creature with a crash, bang, wallop of vibrancy.

Viola Frey has been categorized as a post-abstract expressionist humanist (her sculpture is certainly far too serious to be called kitsch or funk). She has admitted the influence of Dubuffet, Picasso, Miro, Matisse, Philip Guston and also of Art Brut in her work. But really she has had no single influence; she tends to rely on herself, drawing the pictures out of her own mind. Frey knew early that she wanted to be an artist. She selected clay because, as she says, it was 'about the hand and so allied to painting and drawing'.

She was born in Lodi, California in 1933, on a farm set deep in the vineyards. Their household was inclined to hoard junk. Both father and grandfather were avid collectors – especially loving oriental nick-nacks of the kind which proliferated in thrift stores all along the West Coast. The young Viola excavated the farm's trash heaps with her brothers in search of things such as discarded toys and bits of porcelain. She

the T'ang Dynasty in China. Pieter Breughel's paintings and some of the Chinese and Japanese hand scrolls also get my attention. I am attracted to find in those ordinary people who live in the secular world a sense of presence and even their inner life.

'I like to simulate the atmosphere and sense of space which I experience in the hand scrolls by placing groups of clay figures together. I am also interested in the relationship of materials in the drawings – which is sumi ink on oriental paper – and how it compares to black underglaze drawing on the buff surface of the clay in my work.

'I am intrigued by the relationship between a three-dimensional form and two-dimensional drawing within the clay figure which gives information and articulation to the persona. I tap into my memories to create figures. Memory is the place where the sense of time expands

Two Women and a World. *1990–91. Glazed ceramic; 83½in × 238in × 68in. Courtesy of The Nancy Hoffman Gallery, New York*

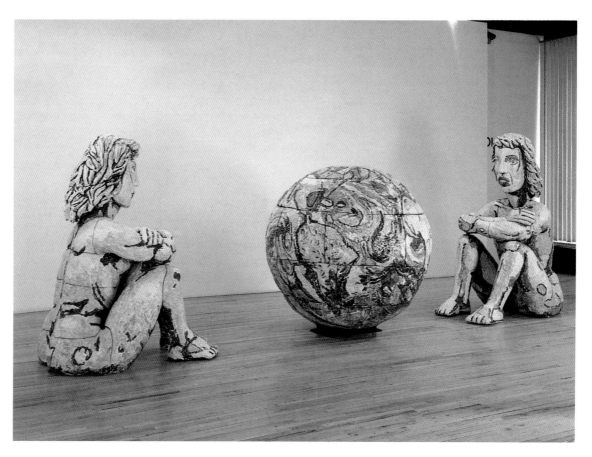

Gesturing Woman. *1988–89. Glazed ceramic; 103in × 33½in × 28in. Courtesy of The Nancy Hoffman Gallery, New York*

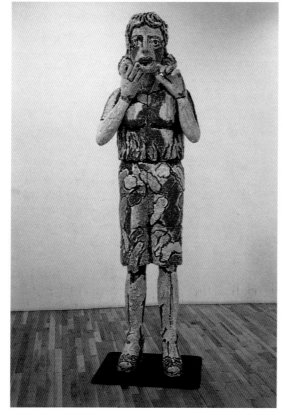

loved playing with figurines – especially the Japanese and Chinese trinkets – there was nothing much else to play with. 'Lodi had nothing other than people', Frey explains, 'and the most beautiful things you ever saw were women in dresses, hats and gloves. That was on Sundays. There were no museums, no original artwork to see. There was the library. The landscape was all five-foot-high grapevines!' However, one day, all little Viola's much-loved playthings were collected together, made into a huge bonfire, and burned – as part of wartime, anti-Japanese sentiment. Viola has kept this cast of figurines as the main leitmotif throughout her work. She began to re-create them in 1976, after a seven-year period of isolation. Since then, she has made these forms again and again obsessively.

Today Frey is Professor of Art at the California College of Arts and Craft in Oakland, where one of her tutors was Richard Diebenkorn. After getting her BFA there in 1956, she went on to do her MFA from 1956 to 1958 at Tulane University, where she studied painting under Mark Rothko and ceramics with Katherine Choy (whom she joined at the Clay Art Center in New York). Viola Frey has won many awards

and fellowship grants. She exhibits almost exclusively in the United States where she is thought of as a 'living legend', acting as a kind of mirror to middle American man. Between 1958 and1960 she was working in the business office at the Museum of Modern Art. But by 1960 the West Coast Bay Area with its important ceramics community (which included Peter Voulkos) lured her back.

It was while teaching part-time at the CCAC and working full-time at Macy's, that Viola Frey could forage for figurines and other items in the Alameda flea market, and it was there that she made her rediscoveries of the kind of object she had lost to the bonfire. It was finding these again that inspired and became the vital constituent of her future work. Frey describes how these new childhood toys

> had to be small enough to fit into a handbag. Nothing more than $2 or $5 to fit on my nick-nack shelf … I was so thrilled when I found Manikin Man, made in Hong Kong. There he was, all pink and naked – and with a six-head height, unlike the Western canon. It was exciting to find a naked man with a Chinese scale – but a European man! It shows the weight of culture. The Manikin Man is a bully without a penis. I even made him 6ft tall, smoking a cigarette. This is because I wanted to make him intrusive.

In Frey's sculpture these figurines become giant icons, rather than monumental ones, remarkably intense, modern power gods with vibes of both comedy and comment. And the interesting thing is that you are put in the position of a small child looking up at toy-adults. The fact that the adults are around 8½ft high only emphasizes this scale of a child's vision. The tall adults are often so high up that the deadpan expressions on their faces cannot be seen except from far away. These expressions are intended because the face is as important as any other part of the body – all, in a way, are out of reach. None of Frey's human forms holds much intimacy; they are all around her, undemanding and detached, just like the figurines. Their painted-on clothes have formed a kind of ecto-skeleton, like the moulded sections of figurines, and the same fixed, unchanging expressions are employed. These colossi do not engender much in the way of movement. Their gestures are posed and fixed forever – Frey intends them to

last – or she would have made them all out of papier mâché.

Each figure is created from heavy, 50lb clay segments, hollowed out (with assistance) and bisque fired to cone 02. Then, rather like a small child, Frey has opened her box of bright crayons and gone wild in the colouring of her creations. All the movement occurs in this joyful medley of fauvist coloration. All are in plastic colours: bright reds, yellows, blues, greens, applied in splodges, dabs and blocks in heavy texture. Some of the drawing on them, like the underlining of the breasts in black and on other parts of the body, makes them like a child's painting of a ghost. On the other hand, muscle is zestfully outlined and dress patterns picked out in a vibrant, emphatic manner over which an excess of glaze is applied. A second firing sets the glaze at a lower temperature than the first (all fired below cone 4). The similar, all-over patination of coloration makes colour, form

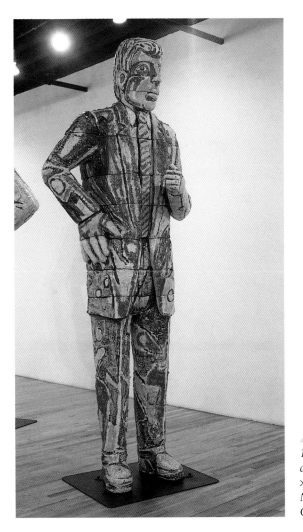

Answering Man. *1988–89. Glazed ceramic; 120in × 43in × 72in. Courtesy of The Nancy Hoffman Gallery, New York*

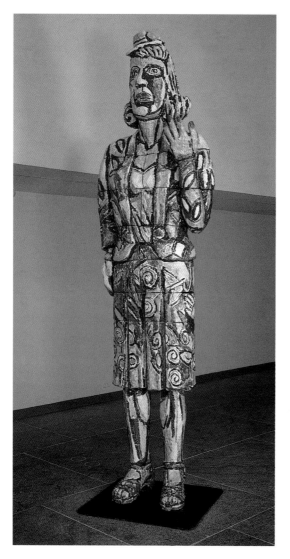

Woman in a Suit. 1987. Glazed ceramic; 108in × 33in × 28in. Courtesy of The Nancy Hoffman Gallery, New York

blue and pink American 1950s automobile thrown in. The finished segments are finally stacked one over the other – not glued together but bolted with steel bolts. Some reach to over 9ft high, others recline – all are now too large to be moved without difficulty … or ever destroyed.

Frey's depictions of the male look disturbing. They appear dismal, belittled or laid low; their blue power suits and red striped ties avail them nothing. They are an extrovert colouring over an introverted form. But Viola did not suffer anything such as being a neglected child with an absent father. Her father – a rancher – was at home all the time. And she tells us that 'the confused-looking expressions of the men came from my years in New York, watching men walk to and from Grand Central Terminal.'

She also makes tondo plates and amphora. They, too, are a scrapbook of her memories and often house her new collection of figurines, slip-cast whole and added in high relief or drawn on in bas relief. And the artist is always there in her work, touchingly peeping through a window or as a self-portrait. Sometimes it is her hand prints pressing in. If not, then across most of this work the child-like signature 'VIOLA' appears. Her work is herself! No, you can never miss them with their intense vitality, these play-thing-inspired pieces that exist in a kind of junk shop 'Somewhere over the Rainbow' world. Frey is prolific and a hard worker who overcomes great technical problems. She says,

> I myself like art where the artist has laboured. It is a test of the mind to have the will to continue what you're doing, to create excitement, even though it is a very mundane, labour-filled effort. I've never found making art easy. I used to be more aware of plateaux, and I realized that you had to get depressed before you could make a step forward. It wasn't automatic. Sometimes you just had to get started working and the ideas would come. I do know that the hardest step that anyone, including myself, ever makes is that step into the studio.

and expressions meld at a distance into one of formal refinement.

Viola Frey's human forms glory in their fairground mass of swirly 1940s and 1950s print dress and patent leather shoes, of the kind that grandma, mother or the ordinary, middle-class American woman would have worn. All the familiar figures around her during childhood – with a hint of ice-cream sundae, jazz, and powder

5 The Mystical, the Metaphysical and Traces of Memory

This is a chapter of mysteries and memories which gives us journeys into the complexities of the mind and of the dream-world. *Heidi Guthmann Birck* takes us deep into our own psyches, revealing the male/female aspects of our personalities, and shows us our animal characteristics and the 'potential role-playing which we often engage in'. While *Patricia Rieger* whirls us out somewhere into the realms of a surrealist existence, *Jean-Pierre Larocque* probes into darker areas, where chaos and our own mortality are touched upon. 'I am interested in that place in our psyche where nature and culture have to sit down and deal with one another' he says. *Yasuko Sakurai* is interested in the contrasts between our interior and exterior, spirit and matter, shadow and reality. *Tracey Heyes*, *Regina Heinz* and *Daphne Corregan* look at imprints and suggestions of where the human has been. Daphne Corregan says, 'I am searching more for an emotion, an identification, a nostalgia or an intuition of something we all know is within but are not quite sure just what it is.'

Heidi Guthmann Birck [Germany/Denmark]

My sculptures refer to a range of ambiguities in the human character, for instance, hidden aspects of our personality or the other sex – the relation between our animus and anima. They can also reflect the animal characteristics of the human being at a biological, psychological or mystic level, the latter as we know it from the mythologies of many cultures. My sculptures can also reflect the ambiguity in our social relations, that is, the potential role-playing which we often engage in. My business is to lift a corner of the veil that covers these complex aspects of the human being, and to find a point of reference from where to depict it in a sculptural form.

Heidi Guthmann Birck's 'human' forms are dramatic, muscular, forceful – and rather disturbing. The artist means you to experience them fully in one glance. When you do, they startle you with their sheer existence, staring from their positions of importance set up on pedestals – some even higher on columns. Their arresting presence compels you to look up and ponder. For they are about ambiguities and interpretations; fractures and fusions. But there is also wit – a very dry, sophisticated wit – that underlies the message; for they are all loaded metaphors. They ask, 'Are we what we seem?' or 'What is the reality behind the mask we present to the world? Must we confront it?'

This remarkable sculptor was born in Cologne in 1941. From 1959 to 1962 she trained in crafts and arts in Munich. After a few years of working at different workshops in Germany and France she established, in 1965, a workshop in Copenhagen together with her husband, the ceramist Aage Birck. Today, husband and wife

live and work in Haderslev in Denmark. A book on their retrospective exhibition in Denmark and Germany has recently been published, *Résumé 1966–1999*.

At one time Birck belonged to a group called 'Multi Mud'. This was an artists' coalition, established in 1980, that brought six Danish ceramists together, and held exhibitions in Scandinavia and the rest of northern Europe. It was during the most important of these, one held at the Ny Carlsberg Glyptotek in Copenhagen, that the artist came across a piece that was to inspire her in her future development as an artist. This museum contained the largest Danish collection of Egyptian, Greek, Etruscan and Roman art, and this enlightened place was to allow 'Multi Mud' to produce and show work inspired by the specific atmosphere of the location, and which would both challenge and complement the existing collection.

> After years of preparation [the artist describes] the exhibition was established in 1983, and displayed our new work next to the sculpture they had been inspired by. I have always been fascinated by antiquity and Egyptian sculpture, and I was especially absorbed by one particular example *The Double Poet*. This is a fragment of a bust which presents both Virgil, the Roman poet, and his Greek colleague Hesiod, with the back of their heads against each other. What fascinated me was not the quality of the form (since it was but a fragment), nor its historic tradition. It was the 'doubleness' of the sculpture that captured me. This doubleness corresponded to an ambiguity reflected in my previous work. I made my own version and called it *The Double Poet*. The double message in my version is the ambiguity in one individual, contrary to the one of its source, which is a portrait of two individuals. One face has been doubled and then split up into four parts. These four parts have been put together in a way which allows every second face to face the other. The result is a tension between the forms, created by the tension between the faces that are turned the right way and the ones that are turned the wrong way. At a level of interpretation, the sculpture can be perceived of as an image of our acknowledging

Cat Manimal. *1996. Saggar-fired stoneware; 33cm × 36cm. Aage Birck*

ntelope Manimal. *1996. Saggar-fired stoneware; 33cm × 36cm. Aage Birck*

that the ambiguity intensifies our insight into the surrounding world. On the other hand, it may show the opposite – a lack of awareness of the hidden sides of our character.

Heidi Guthmann Birck's images do not split or disintegrate forms in any way. They merely shift them subtly. The fractures are split vertically along the same plane, and this makes you look and think about their identity in a different way. Picasso-like, profiles confront and oppose, slices are packed tightly and fused; cleverly faulted, yet unified. In the sculpture *Man–Woman* the artist celebrates what is feminine in our masculine natures and what is masculine in our feminine natures. It is about equality between the sexes, not dominance of one over the other. This is symbolized by clearly structured contrasts. 'The relation between anima and animus is visualized', the artist explains. 'A man's and a woman's torso have been split vertically. Half of each has been joined as one on a plinth. This plinth unites the two sexes into one figure which, indeed, reveals the physical differences, but at the same time forms a harmonic whole.'

Birck's series *Manimals* is truly striking. A cat, for example, is elevated to cat-god, Egyptian-style, and therefore omnipotent. The head-

pieces of that and the antelope *Manimal* can at once be both headdress or ears and horns. They remind us that we are closer to the animal world than, in our arrogance, we like to admit. We must be aware, too, that animals have a dignity that should be more respected. 'The *Manimals* visualize a unity between animals and the human beings', the artist tells us 'they display features which we consider to be animal features. But could they, on the other hand, be human features – only found in animals? The levels of interpretation are manifold.'

The modelling of the *Manimals* is direct and finely executed. They are so believable, so super-realistic that you feel these chimeras must have been in the artist's studio posing for her, sitting still and very upright on a chair. There are no slack areas, no frayed surface textures which might detract from what is contained in the statement. The outer edges of the busts are often steeply curved to frame and centralize the subject still further, slicing the portraits off from the surrounding space. They need no help from elsewhere; they have already drawn enough energy into themselves.

Birck's technique echoes precisely her messages in ambiguity. Her pieces may be created to appear solid and chunky, but in fact they are only a few millimetres thick, allowing the artist's hands to work doubly – both behind the face/mask and in front. And the sculptures were

irdlike Woman on a Pole. *1992. Stoneware with slipglaze; 128cm × 64cm. Aage Birck*

solid once. The artist explains the process: 'First of all, I model a sculpture which is to be my point of departure. From this sculpture I develop a press mould from which I then produce a new sculpture, using millimetre-thick slabs. This method allows me to work with both the inside and the outside of the sculpture, after I have cut holes for my hands through the millimetre-thick wall.'

All the artist's work is created from stoneware clay, and fired to a high 1,285 °C. But there are different treatments, depending on the expression and surface required. Birck has developed several slip glazes which alter the intensity of the colour according to the thickness of the layer applied. *The Double Poet*, for example, has been slip glazed and fired in a salt-kiln, but without salt. The glazing is purely the result of salt deposits released from salt glazes embedded in the kiln walls during previous firings. The glazing of *Man–Woman* has been obtained by sprinkling a saline solution on top of a slip glaze then, afterwards, reducing the piece in a gas kiln. The *Manimals* have a bisque firing, and are then placed in saggars with sawdust and wooden sticks. Finally, they are fired to 1,280 °C in the gas kiln. The smoke treatment renders them uncannily dark and dense, and the subse-

quent high firing gives them a strong, stone-like permanence. All Birck's figures have a solidity and permanence about them, and many of her pieces go on to be successfully cast in bronze.

Nearly everything the artist creates revolves around the human being. She says,

What engages me the most when I sculpt the human form, is not specific people or historical events. My sculptures may refer to the style of former epochs in art history, but my intention is that they visualize the multiple meanings which can co-exist in the same form. In this case the human form. Even though I work with the many layered human being, it is no ambition of mine to account for all of these aspects, nor to describe the cause and effect of the relationship between them. Whereas literature, music and staged art must be perceived of in the course of time, a sculpture can be experienced in one glance. If an image succeeds, it may provide an emotional insight or a crystallization of an experience to even the unaccustomed spectator. This insight or experience is thus more easily achieved than through a more intellectual approach to the work.

*I*NFLUENCE
The Double Poet:
Virgil and Hesiod.
1983; with some of
Heidi Guthmann
Birck's sculpture. The
Ny Carlsberg Glyptotek,
Copenhagen. Aage
Birck

Heidi Guthmann Birck's striking images do live with you once you have seen them. You feel they really exist somewhere in our universe, following us to explain our realities and illusions through life, and reminding us that ultimately there should be harmony in the universe, not dissent.

Patricia Rieger [USA]

I am interested in allowing the unexpected to occur in my work, that which does not fit into the accepted norms of reality.

Patricia Rieger is an imaginative artist who has conceived of a personal world peopled with presences that are not really part of our known existence. They appear remote and unapproachable. These are dream-world pieces telling their own stories, sending out a narrative vision with a detached mysticism that is both complex and difficult to define – and the artist wants to leave them that way, for we can interpret them how we will.

The influences that have affected Rieger stem from her innate knowledge and dream experi-ence. It is a self-involvement from which are born individual 'tableaux' presented to us for consideration, and, although the artist states that her pieces are not in any department of perceived time, they have titles that appear to involve time: *A Moment Ago*, or *At Times in the Afternoon*, for example. This merely adds to their mystery and incongruity. Yet we are able to both identify and recognize elements of her dream-world, because they use symbolism and reveal emotions that are similar to our own. They then become a universal sharing of a phi-losophy that we all understand in every part of the world: they are a wake-up call to our spoil-ing of the universe with the arrogance of our own superiority. They instil within their own myth our need to conserve, preserve and value what is precious on our planet. To this end Rieger has invented images that, as she describes, 'come from the natural, the material, the metaphysical and the dream world'. And, as in the case with all images from dream-worlds, their content tends to be crystallized into some-thing rather potent and mystical.

Patricia Rieger was born in 1952 and edu-cated at Goddard College in Plainfield, Ver-mont, where she obtained her BA in 1976. She went on to receive her BFA in 1983 at New York

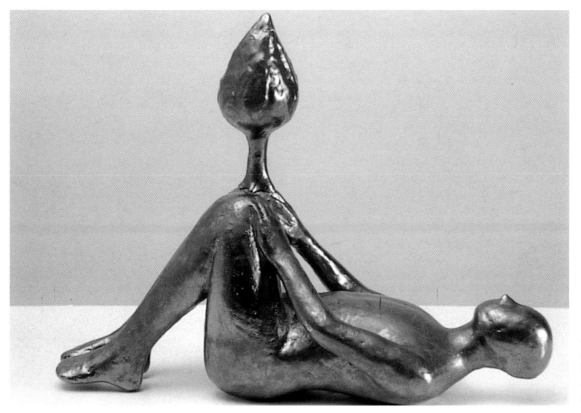

At Times in the Afternoon. 1998. Ceramic plus lustres; 32in × 11in × 24in. Peer van de Kruis

Each Movement.
*Ceramics plus glaze;
1998; 12in × 7in ×
25in. Peer van de Kruis*

In my assembled pieces the choosing of the different elements is very intuitive and yet very precise to the point that, once discovered, I can no longer imagine the piece without them. It is as though I have recognized rather than invented them. The figures are awkward, tense. Their presence presents a question, touches the unknown. The images do not offer answers. This is provoked by the paradox of containing familiar elements in uncommon relationships that do not offer comfort or simple explanation. Caught in between worlds, in transition, the figures are generally solitary and absorbed in their world, inner and outer. They are unselfconscious, outside of time, without haste they are in transition, waiting, moving.

State College of Ceramics, Alfred University, and finally, her MFA in 1986 at the University of North Carolina, Chapel Hill. In 1991 she travelled to France to be in residency at the Cité Internationale des Arts, Paris, and now she is an instructor at the School of the Art Institute of Chicago. She has exhibited both as a painter and ceramist mainly in the USA but also in Spain, where she has visited at least once a year for the last twenty years.

Her ceramic forms in clay are a collection of sensitively coiled or slabbed pieces. She uses a white body that is glazed and fired to low temperatures, and her figures are sometimes allowed to remain white, creamy and dreamy. Their forms are sylph-like without roughness or acute changes of angle; for they are of spirit substance and could walk on a cloud. At other times lustres are applied for a second glaze firing. This coating gives them a kind of ethereal quality that makes them glow like celestial beacons from their alternative plane. Her figures are conjoined with surrealist appendages. These additions appear to act as conveyers, as they emanate from the 'human' body, or are placed on the head, emanating from the 'human' mind. The artist describes her pieces as follows:

A Moment Ago. *1998. Ceramics plus lustres;
10in × 10in × 28in. Peer van de Kruis*

Light Beings. *1999. Ceramics plus glaze; 22in ×
14in × 32in. Peer van de Kruis*

Yasuko Sakurai [Japan]

*I am interested in the qualities of ceramic materials
which change to another material in the kiln as the
temperature goes up. I am sometimes surprised by
the material after firing; it is a natural change
beyond all imagination. I like to see the emotional
changes in my work that correspond with these phys-
ical changes.*

Yasuko Sakurai is a young artist, born in 1969
and brought up in Kyoto. She is full of good
ideas and great fun, seeing with both subtlety
and wit the fleeting impression and small dis-
placement that mankind makes in a lifetime,
compared with the seeming infinity of the
world before we even arrived on this planet. She
has already won the Fletcher Challenge Award
from New Zealand and competitions at Faenza,
Italy, and Mino, in her home country.

Her work is steeped in contrasts shown
through ambiguity, and there is a great list to
think about: being and not-being, form and

substance, shadow and light, male and female,
this side and the other side, positive and nega-
tive, the interior and exterior. In order to cap-
ture such opposing qualities she has taken
slices and perforations, polished exteriors
against roughened textures. To these she has
added further elements; she can, for example,
light her work to gain an interplay between
shadow and substance, dark and light. Also she
enjoys the reaction between her work and those
who look at it, perhaps waiting for a smile. Hers
is a theatre of event and, with original ideas like
these, this Japanese artist is only at the begin-
ning of her quest, travelling to learn, and
admiring Antony Gormley's exhibition, for
example, which came to Japan, or discovering
the work of the renowned Polish artist Mag-
dalena Abakanowicz, whose exhibition, she
says, 'impressed me with its strong and unique
existence, so that after looking at it, I found that
it left a lingering impression'.

This is how she recounts the story of her life
and describes her pieces:

'In Kyoto, where I grew up, there is a long and
great tradition of both arts and crafts. It is a
prosperous town with many ceramists. When I
was young I was interested in the tea ceremony
and I particularly liked the beautiful tea bowls
that were used as part of this ceremony. For this
reason I chose the ceramic art course in Kyoto
Seika University for my four-year BA course.
There I learned the techniques of ceramics,
glazes and of creating ceramic sculpture. I grad-
uated in 1991, and from 1992 to 1993 I was a
graduate student there, going on to complete a
ceramic course of instruction at the Municipal
Kyoto Industrial Research Center, specializing
in glazing techniques and the ceramics of
Kyoto.

'Since then I have worked for three periods as
artist in residence, first at the Prefectural Shiga
Shigaraki Ceramic Cultural Park from 1993 to
1994, and again for three months in 1999. Here
there were both Japanese and international
ceramists, both well known and just starting,
from whom to learn. Also there were large
kilns, tools, spacious studios – all very con-
ducive for widening my ceramic exploration.
Since 1999 I have been artist in residence at the
National School of Decorative Arts in Limoges,
France. Once again this has given me the experi-
ence of learning different techniques and meet-
ing more interesting artists.

'With my pieces *A Pair with Shadows* and *Light and Shade,* the black shadows on the front face of the sculptures are created from changes in the kiln made by charcoal deposits on the work. I wanted to express the contrast of light and shade with these black shadows. They also relate to the interior or the spirit of the human character. And I show the interior and the exterior by contrast of texture. The form is sliced longitudinally in half to form the smooth side while the other side remains rugged from marks left by my fingers. I try to let the clay direct the form and the texture emanate from the touch of my hands. The two figures are male and female; and because the theme of the human being is one that is close to us all, I often choose this theme as having many possibilities for expressing my ideas.

'To make them I used a clay called *Shigaraki* and mixed it with a small amount of manganese. First I made a clay slab which became the surface of each figure. Then I put this on a base and finished the exterior by hand building.

The pieces were fired to 1,100°C in reduction, using the wooden base as the means of depositing carbon naturally on the surface of the sculptures. For *Loopholes* I used the *Shigaraki* mixed with fireclay. I consciously sculpted both the exterior and the interior, and made many holes so that you could see through to the other side. (This was achieved by assembling a lot of clay tubes.) Finally, the finished figures were fired in a 1,150°C reduction firing using sawdust. This *Loopholes* sculpture is meant to emphasize pure existence.

'In the *Footprints* installation, the soles of the feet face towards us. The appearance of the three layers that make up the soles comes from the presence of iron oxide included in the clay body. Again I fired the wooden base to create a reduction, but fired it higher this time – to 1,150°C.' (I love Yasuko Sakurai's idea of burning the wooden base that are the sculpture-stands as the means of fuelling instant reduction in the kiln. With original ideas like this she will go far.)

Loopholes. *85cm × 28cm × 10cm and 81cm × 28cm × 10cm. The Shigaraki Ceramic Cultural Park Foundation*

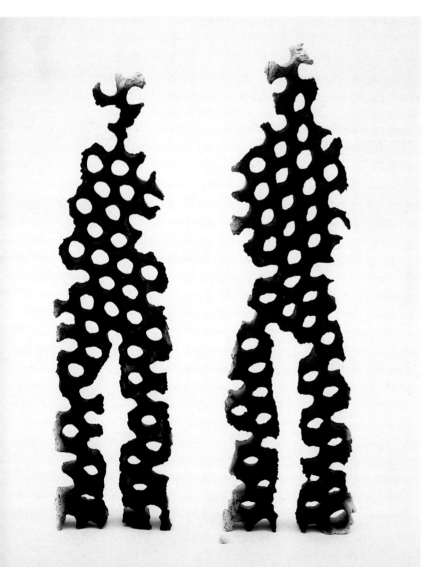

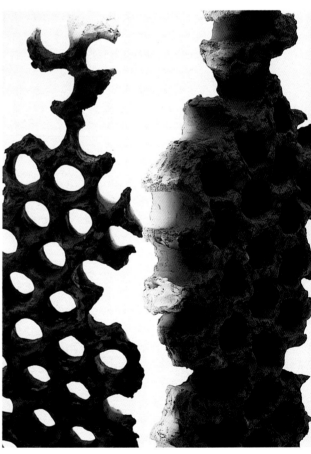

Loopholes. *Close-up.*

A Tribute to Magdalena Abakanowicz

Magdalena Abakanowicz was born in 1930, in Poland. Her hauntingly eloquent and powerful sculptures have influenced many artists, including Yasuko Sakurai. I wrote to her in Poland to ask whether she had ever made anything in clay and she replied by sending some images of her work which I have placed next to Yasuko Sakurai's pieces as her influence pictures. Her clay pieces are called *Syndrome* and are still in her private collection, although she has shown them in numerous exhibitions. She also included some thoughts on using clay: 'I think about this material with interest and may return to it one day. It is important with its sensitivity to our touch and with its fragility so characteristic to everything alive. It is also mysterious by being part of the soil to which we also belong.'

Abakanowicz has chosen to remain living and working in her native country despite great difficulties with the harsh economic and environmental realities of post-Solidarity Poland.

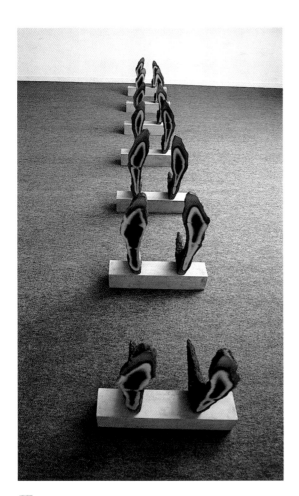

Footprints. *1998; 75cm × 52cm × 45cm; 5th International Ceramics Competition, Mino, Japan*

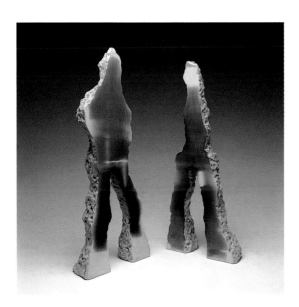

A Pair with Shadows. *1996; 80cm × 37cm × 17cm; Fletcher Challenge Ceramics Award, courtesy of the Auckland Museum, New Zealand*

INFLUENCE *Magdalena Abakanowicz,* Syndrome. *1982. Fired clay; 15cm × 30cm × 20cm to 20cm × 35cm × 25cm; from a series of 16 metaphoric forms. Jan Kosmowski*

Detail of Syndrome.
Magdalena
Abakanowicz

Since 1961 the artist has made both woven constructions and cast sculpture, and, since 1979, she has been Professor at the State College of Arts, Poznan. The artist said in 1993:

> Art will remain the most astonishing activity of mankind born out of a struggle between wisdom and madness, between dream and reality in our mind… Art does not solve problems but it makes us aware of their existence. It opens our eyes to see and our brain to imagine. To have imagination and to be aware of it means to benefit from possessing an inner richness and a spontaneous and endless flood of images. It means to see the world in its entirety, since the point of the images is to show all that which escapes conceptualization.

Daphne Corregan [USA/France]

I've eliminated the body itself but still represent or suggest it through life-size, hollow dresses, black, either entirely decorated on their insides or the vision of their interiors totally blocked by a clay grid at the neck of the garment. Here, I am searching more for an emotion, an identification, a nostalgia or an intuition of something we all know lies within but are not quite sure of just what it is. I admit being fond of this sort of ambiguity. I'm not always positive of just what it is I am aiming to communicate but it is there in my head, and so I turn it into clay and witness whether I'm faithful to that initial intuition or not.

Daphne Corregan is an American, born in Pittsburgh, Pennsylvania, in 1954. But in 1971 she moved to the south of France and has been there ever since, although making the occa-

sional study trip back. She trained at the School of Fine Art in Toulon and Marseilles, then at the Fine Art School in Aix-en-Province to do drawing, sculpture and ceramics. Eventually she set up studio with Gilles Suffren in 1980. Corregan used to make human forms, but then turned to pottery. However, since making trips to Burkina Faso in west Africa, she has decided to represent the human body once again 'since', she admits, 'my pots were looking more and more like people, and I succumbed to the urge … The handles have become exaggeratedly long arms, the body of the vessel a real body, etc.'

Corregan's figures are as important on the inside as they are on the outside, with the content, emotion and strong feeling of presence creating a balance between. But they are defensive ceramics, protective armour plating against

Enfant Noir. *2000. Smoked clay; 60cm.*

Robes. *1999–2000. Smoked clay; 150cm.*

the evils of the world. And the tension in the tautly-stretched walls and dark patination reinforces these bastion qualities. The artist weaves into both inner and outer surfaces decorative ideas that are her and therefore a feminine response. These are 'defence' patterns drawn in from everything around her, as well as her travels to Africa and other places. The strength of her sculptures is in their unity of form and their defiant stance, symbolizing the outer garment of our inner selves.

The artist describes the influences upon her and her manner of work:

'It seems that I have always used elements from my everyday life as a source of inspiration. I think I can safely say that this might even go back as far as my childhood memories. Our home was filled with arts and crafts and my parents and their friends communicated a strong feeling and understanding for these objects. I particularly remember visits to their friends' studios and how they handled their work and I remember silently listening to their conversations. I remember figures modelled from brown paper bags and painted with bright colours, wooden cut-out ladies, abstract clay angels. I remember the books … Picasso's ladies and

children, and I recall regular visits to museums where I could actually touch and measure myself against Giacometti's thin, tall walking men, caress Moore's reclining women and witness the presence of Segal's moving crowds.

'In my early figurative work I believe I was probably unconsciously trying to re-create these childhood treasures. I worked on figures inspired by Robert Frank's *Americans* and Irving Penn's portraits of workers, as well as designing a more commercial line of ludicrous, bright coloured fat ladies and acrobats. When I began teaching ceramics and sculpture at the École Municipale d'Arts Plastiques in Monaco I pretty much abandoned this part of my work, until I went to Africa in the early 1990s. Then my figures came as an absolute necessity and as a reaction to a sudden awareness on my part of what people undergo in other parts of this world less comfortable than mine.

'Nowadays, my mind is constantly being filled with new images coming from my immediate environment … from the work in my studio, my teaching, travels, conversations, music, books, news on the radio, etc. In our society we very rarely experience a void. All of this information mingles in my brain, becomes something new, intimate, personal, mine. I work these new ideas, emotions, sensations or reactions in my head, then on paper until I feel able to translate them into something palpable, reminiscent of what was before or placing the accent on my main preoccupations of the moment. Some

Feet. *1997. Smoked clay. 55cm × 55cm.*

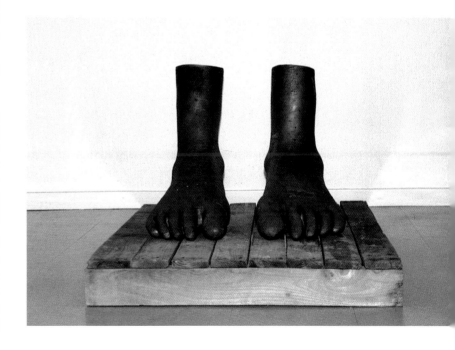

important common factors in all of this work are an obsessive concern for tension, the inside of pieces, an intenseness of colour, a taste for placing objects where they most normally would never be or putting them way out of scale.

'I deliberately kept these resulting figures relatively small, 35 to 45cm, not because of technical problems but because I like to refer to all the dolls, fetishes, idols or other transfers that peoples all over the world surrounded or still surround themselves with, perhaps to feel a bit more secure with the aggressive and unknown elements in this world. The only idea my dolls might convey is the admiration I personally have for bush dolls, Hopi kachinas, peasant good-luck dolls; I pay homage to these figures by doing my own. There is no message. They exist for what they are. My favourite wooden figure was brought from Burkina Faso. I believe it to be Lobi. I have no idea of its date, perhaps only a few years old, but this is of no importance to me. This is only an example of the numerous dolls we hunt for there, never chosen for any other reason than a terribly strong and immediate attachment. I find these dolls so much alive and so much reminiscent of my most favourite artists – Picasso, Baselitz or Lupertz, as well, of course, of all those African artists whose names we don't even know. I love its distortion and its lopsided posture, the total

absence of embellishment mixed with its strong feeling of presence, a presence I try so hard to capture in my own work.

'It is only when I'm working on a part of the body that I allow a more symbolic meaning to take over, big hollow heads entirely decorated inside and out with a repetitive pattern as if wrapped in wallpaper and placed on their sides or presented upside down, huge black feet with dry, cracked skin modelled from the inside out – and my hollow robes. I generally use a white raku clay with a high talc content. I almost polish some of my surfaces in order to obtain a larger variety of blacks, going from deep matt to a metallic slate colour. I find that some of the more metallic blacks are suggestive of moonlit nights, images of sophisticated ladies or even a more sexual connotation and I use them for these very reasons, depending on the emotional intensity I want to put into my figures. I use only one glaze and one engobe I mix together freely because they both contain the same ingredients: Gerstley borate, kaolin and silica but in different proportions. I use commercial stains for the pinks, oranges and yellows, copper, cobalt and iron for the rest.

'I fire my raku to about 1,020°C and give close attention to the smoking. I'm using less and less combustibles (a handful of sawdust, a few sheets of newspaper or some straw), and I no longer remove my pieces from their bins

Head. *1998.*
Smoked clay; 65cm.

before they are cooled in order to limit thermal shock. This doesn't seem to alter my colours. My larger pieces are fired and smoked within the same kiln. Once it has cooled to approximately 850°C, and after having carefully sealed any eventual leaks with a mixture of ash, clay and sand, I introduce small pieces of inner tube every half an hour or so and this for about two hours. My colours are, of course, not the same although I have a suitable range for my purpose and I tend to use them in quite a different manner from the raku. I've been doing some intricate repetitive decoration on these pieces that I use as a means to cover them almost as if they had been modelled from fabric, or, on the contrary, as a way of attracting the eye to a specific part of the piece that might likely have been ignored, like the inside of a dress.'

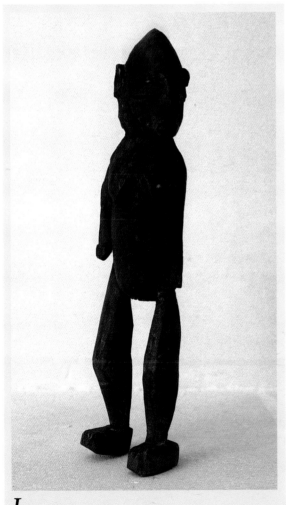

*I*NFLUENCE
African wood figure. 30cm.

Tracey Heyes [England]

I produce ceramic objects which are a personal response to the often obscured and fragmentary role of women within our culture. I am particularly interested in how convention and stereotypes have been reflected in the history of painting and sculpture and I attempt to draw upon the iconography of both to contextualize my work.

Tracey Heyes's mysterious forms in clay are to do with the transitory: imprints of human beings, glimpses of lives gone by, attic memories brought fleetingly back to life. The artist has the ability to form a kind of skin fabric through the sensitive way she works the clay, imparting an impressionist lightness to her textured substance so that for a moment these forms might move as though caught in a breath of air wafting through an open window. Their subtle colouring and delicacy of articulation gives them a filmic, dreamlike poignancy, a quality which has become a personal signature of the artist. Other pieces have a more formal presence, that of 'museum artefact exhibited behind glass'. These comment on those who had to wear absurdly tight corseting and other female accoutrements. And there is a third category, the most recent work, which sidles into the regions of the abstract, to act as metaphors for female vanity.

Tracey Heyes has an impressive curriculum vitae. She has taught, broadcast, taken many commissions and exhibited extensively. She was born in Doncaster, South Yorkshire, trained at Doncaster College and then at the Coventry Polytechnic, and for her MA went to the South Glamorgan Institute of Higher Education. She is now back in Yorkshire and living in Sheffield.

Heyes talks about her work, which includes some added comments by Ian Wilson which she thought pertinent:

'My work has always had a strong connection with women's lives and work. The earlier pieces had a direct visual relationship to the body, using the dress as a metaphor for the portrayal of the specifically female human condition. The dress acts as a powerful metaphor for the physical, emotional and social restraint that women have experienced, although the lacing, zipping and stitching of the dress subvert this image into a powerful evocation of the physicality of the body beneath. The manipulation of the clay

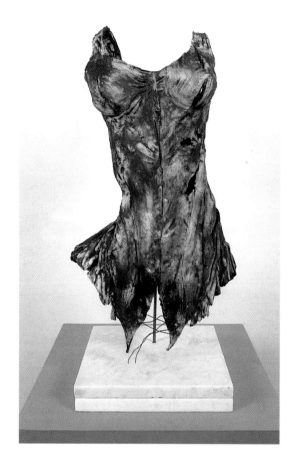

Corset 1. 1993/94. Hand-built ceramic mounted on marble base, reduction fired to 1,260°C; 75cm × 38cm × 38cm. Brian McClave

terns, with the codes and instructions, that formed the basis of clothing. I make references to my fascination with fabric, sewing and the 'frippery' that surrounds a woman from childhood. The use of mirrors and more recently of fruit make references to the vanitas paintings that influence and contextualize my work. The uncontrollable and irresistible fact of passing time and the evidence of this is a concern within my work.

'This is why I have chosen *Still Life* (undated) by Jan Davisz de Heem (1606–83/84). Seventeenth-century Dutch paintings have been of a particular interest to me since studying painting at college. Most still-life paintings of this genre include to some extent the aspects of vanitas. Images of vanity have often inspired the work and it is the luscious beauty of these still-life paintings that draws my attention. It is the heightened suggestion of the ephemeral duration

suggests a creasing and draping of fabric which at once reveals and hides the suggested body beneath; the ceramic surface becomes a fabric which bears the imprint of the body. The forms, although hollow, suggest "with wholly unexpected insistence", the physical presence of the figure, creating a "crowded emptiness"; they suggest both fullness and emptiness, reality and unreality. The duality expressed is also significant in evoking some of the complexities which surround the depiction of the female form in art; it is a fine line between celebrating sensuality and gender and deriding it. I am intensely excited by the power of glimpsing something which is not present but is suggested by the balance between such polarities and how one may powerfully evoke the other. Clay is a wonderful material for visually exploring these issues; it is soft, receptive and malleable but also probably one of the most durable materials used.

'As a child I learned sewing and the "importance of the stitch" from my mother; dressmaking was an activity that allowed us to have a common purpose throughout my teenage years, and I always loved the paper-thin pat-

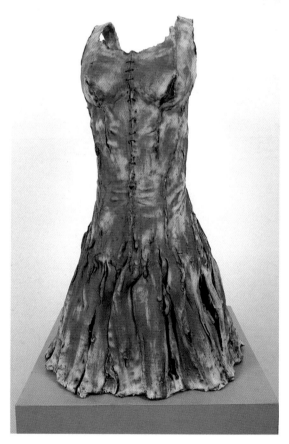

Dress 1. 1993/94. Hand-built ceramic, reduction fired to 1,260°C; 70cm × 30cm × 30cm. Brian McClave

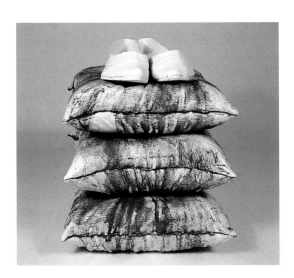

Cusp. 2000. Hand-built, press-moulded
ceramic, waxed and stained, fired to 1,060°C;
36cm × 30cm × 29cm. David Gilbert

of matter and life presented in such a way that I
find exciting as potential for subjects and presentation within my own work. I particularly love
the emblems used to denote the passing of time,
transience and mutability: the half-eaten fruit,
the withering flower, birds' wings. The tantalizingly suggested and insisted human presence
evoked by the half-eaten apple, the half-peeled
fruit, the reflected image, provide subjects from
which to work. The presentation of objects for
the viewer is also an aspect of the work that interests me, specifically where I have used the stacked
pillow forms to act as "thrones" on which to present the shoes, the cherries. The abandoned
aspect of the objects also for me strongly invokes
the once-human contact and presence. The use of
mirrors in my own work is an attempt to recall
the reflected images of faces in vanitas paintings.
The mirrors in my work draw the viewer into the
piece by reflection. They actually draw the viewer
into the piece by reflecting their own image back
to them.

'In my most recent work I am still exploring
themes which motivate the figurative work.
[The stereotypical women's shoes reveal the
shape of the feet that wore them as clearly as
the dresses aimed to reveal the body.] I chose
the cushion for its connection to the home and
to comfort, a domestic object we all closely
relate to. The stacked cushions elevate the
objects placed on top (the shoes) and thereby
iconize them and give them status beyond the
merely archetypal. Again, with these pieces I am
interested in the *frisson* evoked when using the
ordinary; for example, the pincushion, out of
context and within the realms of art. Symmetry,
organization and obsession are strong elements
within the work. I want to present an object

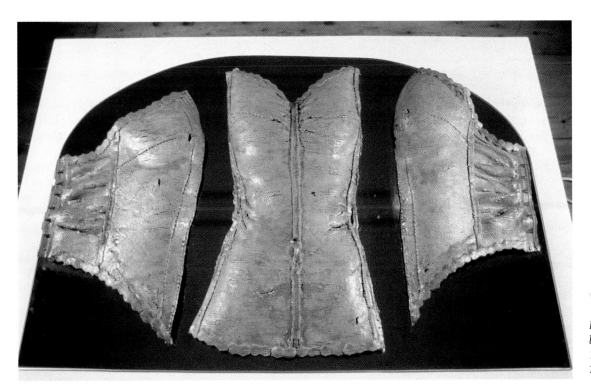

Vanitas. 1997.
Hand-built ceramic on
bronzed mirror, fired to
1,100°C; 100cm ×
75cm × 15cm.

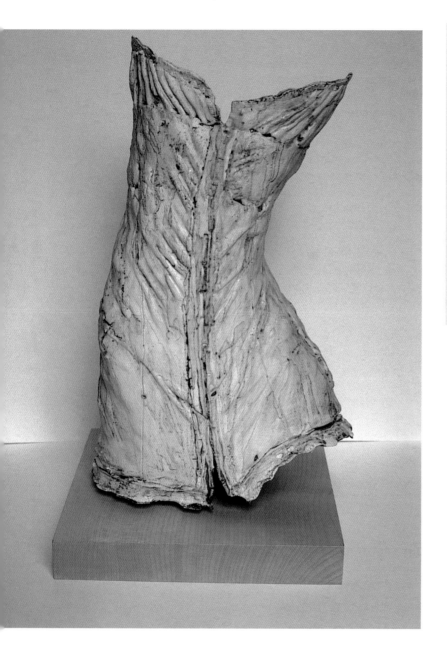

Corset V. 1996. Hand-built ceramic on wood base, stains, oxides and glaze, fired to 1,100°C; 60cm × 35cm × 25cm.

*I*NFLUENCE
Jan Davisz de Heem. 1606–83/84. Still Life Undated. The Kunstmuseum, St Gallen, Switzerland

Regina Heinz [Austria/England]

My chosen material is clay. Like no other material it records every movement of my hand and allows me to apply and suggest a force, which comes from within. I create a gently undulating surface, that, animated through colour, reminds me of the landscape of a body.

Regina Heinz's human forms are concentrations in clay; suggestively erotic in the way they seem to hold whisperings of desire, velvety close. Made with the utmost sensitivity and precision, the 'inscapes' have been reduced down to tender abstracts of body and mind. Although they are gentle, cushioned receptors of human skin and landscaped contours on the outside, the fourth dimension is inside the pillow form. Here there is compact power and a poetic element that allows us to feel that her sleep pillows are still warm from human contact, still holding the dreams of night. But Regina Heinz is also a painter and she patterns her pieces with subtle geometries and coloured creasings.

She explains her work and the influences on her and her journey from Austria to England:

'I grew up in a small town in Austria. Nature and outdoor activities played an important part; mountainous landscapes left lasting impressions and those images still feed my

which is both alluring and yet disturbing at the same time.

'Depending on my aspirations for the piece I am working on, I use a range of clays and firing temperatures. I do, however, use predominantly white clays with an application of slips, stains, oxides and sometimes a thin application of glaze. The earlier work tended to be mostly reduction-fired to stoneware, although at the moment I favour lower firing ranges in an electric kiln. I often wax the surface of the fired piece rather than use a glaze. The pieces are hand-built, often combining slabs with press-moulded forms. Other materials, such as pins, gold leaf are applied after the firings.'

imagination. At age eighteen I entered the Academy of Fine Arts in Vienna to study painting and art teaching. I taught art for seven years before I decided to leave school and to pursue ceramics as a second career. I left Vienna and started to study ceramics full time, initially at the École Supérieure d'Arts Appliqués in Geneva. Already then I was certain that I wanted to pursue fine-art ceramics rather than design and functional ceramics, and I entered the department called "Creation of Ceramic Objects". This was set up separate from the functional department in order to explore the material, clay, and thus was well suited to my personal aims. I was free to explore and to experiment with various techniques and themes. I was introduced to slab building and it was in Geneva that the foundations for my later ceramic work were laid.

'It was here, too, where I was profoundly impressed by the work of Carmen Dionyse. She was one of the most prolific Belgian ceramists of the 1960s and the 1970s. I was able to learn immensely from the way she uses clay as she freely builds with slabs in order to create a

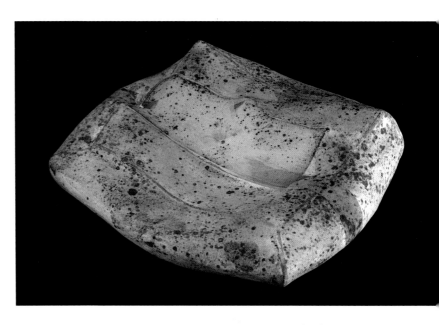

rough and cracked surface, to leave joints visible and to use the properties of the material in an expressive way. All those were aims I was also looking to achieve in my own work.

'Dionyse's main means of expression is the representation of the human body. Her inspiration comes from archetypes and figures from the Bible or mythology, for instance, Lazarus symbolizing the eternal human spirit that dies but is reborn. Many of her busts, heads and figures describe this point of metamorphosis, where out of decay new life is born. Their expression is concentrated in their eyes, holes most of the time, giving way to dark insides, but radiating incredible energy and life force. Sometimes the eyes are closed or half open, emphasizing the introvert character of the figures. They appear calm, serene, quiet but nevertheless powerful and filled with an inner force.

'My work developed in a different way, became less "dark", more abstract and colourful. But it is this display of an inner force, this physical and spiritual presence of her pieces, which I admire and feel related to and which made Carmen Dionyse one of the main influences on my work.

'In 1989 I moved to London and continued full time studies at Goldsmiths College and London Guildhall University, Sir John Cass Faculty of Arts. My teachers, Judith Gilmour, Annie Turner, David Cowley and Ken Bright, enabled me to find my own language, and visiting teachers like Magdelene Odundo and Takeshi Yasuda left profound impressions through their personalities. I was overwhelmed

Misty Dawn. *2000. Soft slab construction, grogged stoneware, brushed dry lithium glaze, oxides, biscuit slips, glaze fired at 1,035°C; 12cm × 32cm × 30cm. Alfred Petri*

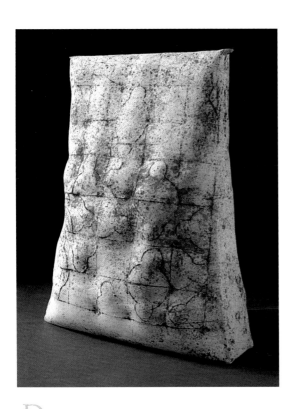

Dream Image. *1998. Soft slab construction, grogged stoneware, brushed dry lithium glaze, oxides, biscuit slips, glaze fired at 1,035°C; 50cm × 31cm × 14cm. Peter White*

and excited by the richness and diversity of British ceramic tradition and contemporary ceramics. I absorbed eagerly what was on offer, both through my studies and through exhibitions and aimed to build upon these traditions and influences to find new and original ways of working with clay.

'I have developed my own special slab building technique which emphasizes the softness and tactile qualities of clay. Slabs are rolled out and, while still soft, are either shaped over chicken wire to make relief pieces for wall hanging or joined and "tailored" to construct freestanding sculptural forms. The final shape and expression of the pieces is achieved by stretching, pushing, folding and incising the slabs, yet at the same time retaining and preserving their original surface texture to the highest possible degree. This technique is paramount to my work and requires both spontaneity and control. The soft slabs react immediately to every touch, every movement of the hand, and are easily overworked and in danger of losing their elasticity and freshness.

'For technical and aesthetic reasons, I use grogged stoneware clays (mostly, white St Thomas or crank). Grog provides tactile and visual texture as well as strength for better con-

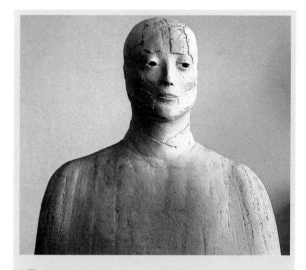

*I*NFLUENCE
Carmen Dionyse, Buste blanc-gris. 1983.
Stoneware, porcelain slip, two firings at
1,000°–1,200°C; from Ceramics Today, *1983.*
Courtesy of the artist and Editions Olizane,
Geneva. Photo: Luc De Rammelaere

trol during the forming process. All pieces are high biscuited and then glazed with biscuit slips, oxides, stains and a lithium glaze brushed on in several thin layers. All glaze firings take place in an electric kiln in an oxidizing atmosphere at 1,035°C with a 20min soak. At this temperature the lithium glaze is under-fired and creates an interesting speckle effect which adds depth and animation to the surface. The colouring is designed to enhance and unify form and texture and to contribute to the sensual, tactile qualities of the pieces. The final effect is the result of multiple firings, each adding depth and subtlety to the coloured surface.

'Having worked as a painter, I found that the flat surface was just not enough. Clay presented itself as the medium that would enable me to go beyond two-dimensional representation and to give back the images the third dimension they originated from. Painting still plays an important part in the generation of the pieces, both through colour and drawing. I start off with drawings or photographs of images I encounter in my daily surroundings or during my travels: images of landscape, close-ups of surface texture, details from the natural or the man-made environment. The images are then reduced in the best sense of the word "abstract", which means "drawing from nature". They are distilled and simplified until I have found their essence. I

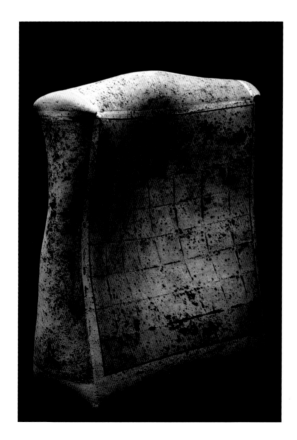

Blue Grid. *2000.*
Soft slab construction, grogged stoneware, brushed dry lithium glaze, oxides, biscuit slips, glaze fired at 1,035°C; 48cm × 44cm × 26cm. Alfred Petri

feel close to the German painter Paul Klee, who said in 1908, "Reduction. You want to say more than nature and make the absurd mistake to say it by using more means than less." Once a composition is established and drawn on to clay the slabs are then manipulated into three-dimensional object. Through this image the image becomes "tangible" and "concrete", occupying and enclosing space. The flat surface has changed into a membrane that can be breached, allowing the enclosed space to communicate with the outside through holes and cuts.

'Throughout my ceramic studies my work has been based on the representation of the human body. My current work still displays an organic quality but the importance of expressing certain specific qualities of the material itself has grown. I am fascinated by the pliability and softness of clay and its possibilities to enclose a void, an empty space, which can be felt from outside. My aim is to keep exploring. My approach is physical and through associations rather than rational. My aim is to keep exploring and to achieve the perfect harmony between colour and form, rather than to our intellect. Objects that record energy and carry the imprints of my experiences, objects that become containers for thoughts, dreams and memories. I quote Paul Klee again: "Art does not represent or analyse the world, but makes it apparent."'

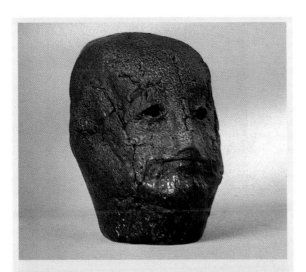

*I*NFLUENCE
Carmen Dionyse, Philippe Bleu. 1982. Raku clay, four firings at 1,020°–1,000°C; 18cm × 13cm × 18cm; from Ceramics Today, *1983. Courtesy of the artist and Editions Olizane, Geneva. Photo: Luc De Rammelaere*

Jean-Pierre Larocque [Canada]

My work is something better experienced than explained. It is the embodiment of a concept, a record and a witness. It is layered with clues, evidence of erasures and traces of numerous adjustments which provide some transparency to the means of representation.

Jean-Pierre Larocque's work is a process. He works the clay hard and effectively and out come workings of grandeur and dynamic expression. Although his pieces seem concerned with great mass and bulk, there are indentations, cavities, interiors and beginnings. This is obtained by the artist's constantly adding and subtracting, moving clay from one place to another, always leaving evidence of creation like mole tunnels or a snail's trail where he has been. His pieces may be fired up to five or six times before they are considered 'arrived at' – but you are left with the certainty they are still very much en route. He is an artist so involved in his construction and deconstruction process that his work goes through a 'history' of its own, and it is he that is its time-machine. The heads in particular are bigger than life size by quite an amount. This only compounds their fearsome impact. They are brave works in the direct way they speak of mortality. They evoke a primal response from us because death and dying are the fate of us all. He reveals our inner structure from under our skin; they are us as we might be; us as we shall be. And clay is a suitable medium to choose for making such a *memento mori*; because the artist is aware that he, like his material, will eventually sink back into the ground.

Jean-Pierre Larocque can form bone structure out of clay, and the heads have gougings and smearings so that the thumb, you imagine, is used more often than the fingers. But in the modelling they take on a beauty of expression which becomes very moving. The artist is as well known for his sturdy horses, and, for these and his figurative styles, he uses two or three types of stoneware clay together to get tonal variety. During the processing these may be used at different consistencies and have engobes added – even over his watered-down glazes. His work is fired to cone 6–7 in an electric or gas kiln. All have various detritus as well

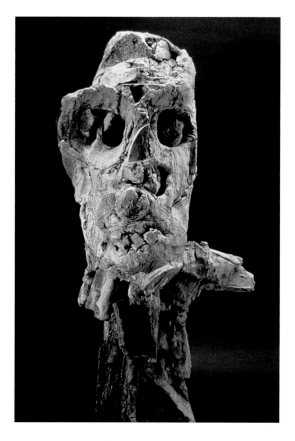

Skull. *1992.*
Stoneware, low-fire
glazes, multiple firings;
43in. Andrew Neuhart

some sense and attempts to fabricate meaning. A piece in progress is a likely place for a crisis to occur. It has the fertility of chaos. There, an unpredictable situation may build up that has to be dealt with. In the end what you get to see is the measure of resolution brought to the crisis. The outcome is the piece itself.

'Meaning is a by-product of articulation. It cannot be given. It is what one arrives at and recognizes, at best a relative and temporary solution. This has to do with the elusive, nomadic essence of meaning. Working in the dark with change and chance as partners, one is lucky to catch a glimpse of it as the nightly caravan speeds by. For my part, I am content in the aftermath if I can retrieve some aleatory marks. I work mostly from themes as starting points, mere parameters against free fall. Being an artist is like jumping off a plane and making a parachute on the way down.

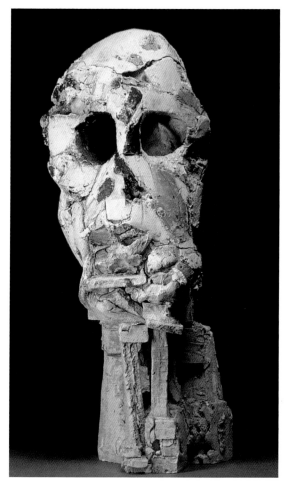

as their supports left behind as evidence of their construction. These supports elevate the pieces into totemic icons.

These sculptures Larocque exhibits mainly in the USA and Canada, where he was born (in 1953, in Montreal) and where he grew up. To begin with he studied printmaking (intaglio) at the University of Quebec in 1982. His BFA followed in 1986 at Concordia University there, and he did his MFA at Alfred University, the New York College of Ceramics, in 1988. Since then he has held professorships at Alfred University (1994–95), the University of Michigan, Ann Arbor (1995–96) and California State University at Long Beach (1995–99). Nowadays he is a full-time artist living in Montreal.

Larocque says of his work:

'I relate to media such as clay and drawing which are suitable for quick, multiple changes and allow for a direct approach. I have given up on plans and goals, they tend to interfere with the many possibilities generated as work evolves. In its raw state clay is a boneless, unstructured material, a proper metaphor for chaos and nature. It is well suited for the roundabout ways of a transforming mind as it struggles to make

Untitled Head. *1996. Stoneware with engobes;*
38in × 15in × 18in. Andrew Neuhart

'My finished work looks unfinished and sketchy as if I had walked away from it. By choice a piece is resolved as it reaches a feeling of open-endedness, as if stopped in its tracks, Pompeii-like, still on its way to a different appearance, unsure whether it is emerging or dissolving. The work is largely about its own making. It is preoccupied with language, this ordering device outside which no meaning is attainable. It is about assessing dosages of order and wondering what it stands for. I try to get as close as possible to the semantic fiction that a piece made itself while I looked the other way. This is what I need to get out of my work and what keeps me going. Those are primary questions. They may even be the only ones that matter.

'I am interested in that place in our psyche where nature and culture have to sit down and

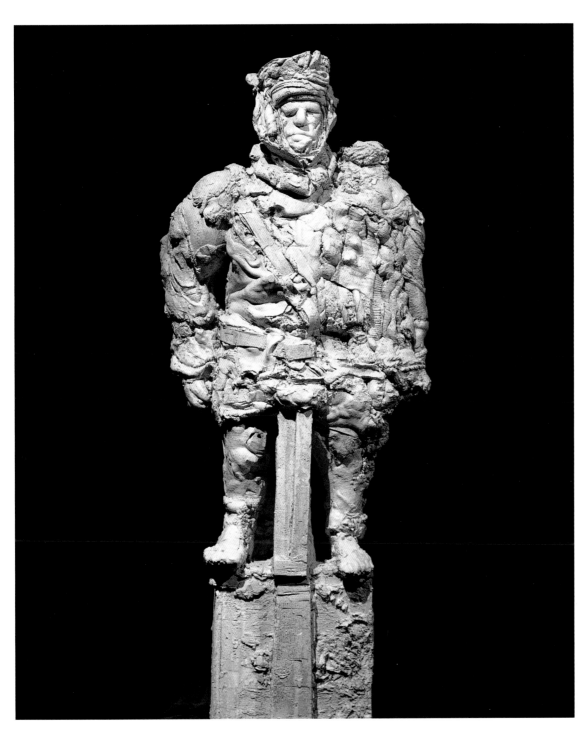

Standing Figure. *1998. Stoneware with engobes; 60in. Andrew Neuhart*

Head of a Man.
1998. Stoneware clay;
42in. Andrew Neuhart

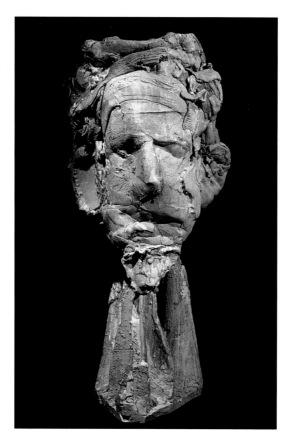

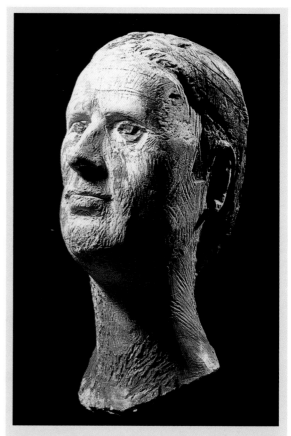

*I*NFLUENCE
Marino Marini, Self Portrait. Polychrome plaster.
Bayerische Staatsgemäldesammlungen,
Staatsgalerie moderner Kunst, Munich. Courtesy of
Fondazione Marini

deal with one another. Engaged in my work, I feel like I am in the front row watching this odd couple negotiate the more or less comfortable intersections that we have to live with; the crossroads of body and mind, materials and ideas, order and disorder.'

Jean-Pierre Larocque, who makes charcoal drawings himself, admires Auerbach's strong charcoal drawings of heads – particularly the *Head of Catherine Lampert* (1985–86) and *Head of Julia II* (1986). He likes, too, the sculpture of Marino Marini, especially a self-portrait head made in 1942 in polychrome plaster, of which Larocque says, 'Marini painted plaster, then scratched, cut, sanded through the paint to expose plaster and previous layers of colour – this resulting piece is an image that looks "livid", something that was experienced.'

The artist also likes a passage from Rainer Maria Rilke's *Letters on Cezanne*:

Surely all art is the result of one's having been in danger; of having gone through an experience all the way to the end to where no one can go any further. The further one goes, the more private, the more personal, the more singular an experience becomes, and the thing one is making is, finally, the necessary, irrepressible, and as nearly as possible definitive utterance of this singularity.

6 Fragments of Our Own Making

This is a complex chapter about fragmental sculpture; one of integration and assembling, of disintegrations and vulnerabilities. The forms are usually pared down to the essential, because, through distillation and compression, one part – even if it just a gesture – can say as much as the whole. *Stephen De Staebler* builds his pieces from fragments that are themselves undergoing transformations of erosion. They stagger into new, vulnerable forms. *Gertraud Möhwald* gathers her archaeological shards and uses them to create new compositions where they will lose their former meaning – except, perhaps, for a memory. *Susan Low-Beer* compiles totemic fragments of differing scale in space and time, or forms confrontations with positive and negative shapes. With his juxtapositioning of various classical fragments, *Doug Jeck* reinvents himself, but explains, 'I don't want to make the work about me, but through me and using me.' Both *Christie Brown* and *Gill Bliss* hone down their pieces to the essential elements. By working with paper clay, Gill Bliss is able to break off or join pieces, until she finds 'a completeness and balance in the form'. Examining the uses by archaic cultures of figurative concerns, Christie Brown casts her fragments into explorations of creation and reproduction, of loss and departure, which are 'the rites of passage in human life'.

Stephen De Staebler [USA]

The anxiety of our times is intensified by the rupture of our intuitive tie with the earth. Reverence for the earth as our nurturing, sustaining mother is acknowledged intellectually in our scientific age, but is no longer embraced by the collective human spirit. Through clay I have worked to unite my feelings for the earth with my feelings for the human figure. It has been a reciprocating experience of finding the figure in the landscape and the landscape in the figure.

Stephen De Staebler's pieces are both thoughtful and intelligent. He is an inspiration to many other artists because his sculpture seems to cut straight to what matters, and he can show the magic of what this material, clay, can produce, provided the language is right. His pieces are assembled from fragments built into a whole and stacked vertically. In a way, his work follows the chaos theory: pieces which are seemingly random are built towards a pattern of completion which is the sum of the parts in a repetitive structure that gives rise to others like itself. Maybe something like our own lives: organized chaos or chaotic organization?

De Staebler's life has much scholarship behind it in the form of awards and fellowships, exhibitions and teaching experience. From 1950 to 1954 he went to Princeton University in New Jersey. In 1951 he studied for a summer with Ben Shahn at Black Mountain College and from 1958 to 1961 he attended the University of California at Berkeley, where he studied with Peter Voulkos and received an MA.

As we look at his clay pieces, they ask us to look at ourselves in the context of the earth in the past, present and future and to get back to it in a more real 'primitive' cohabitation. To help us to see this De Staebler is forever constructing the broken and reassembling the eroded. Some of his sculptures have front-facing, stone-like sections, similar in shape to limestone blocks eroding straight out of the cliff face; yet at the back they stay embedded inextricably into the matrix or appear to be

sinking back into it. The artist says, 'In my work there is a tension between separateness and fusion.' At other times the figures totter on one leg, precariously balanced, propped into almost unbearable tension through taut, outstretched bodily fragmentation. The limbs themselves often act as a pedestal, not so much for support in the way the African Masai might stand on one leg, these mono-limbs can support nothing nor barely hold the weight immediately above. They represent the measure of human suffering and our precarious efforts to overcome it. The artist suggests that 'much of art is that kind of play in a serious sense, like magic, trying to restructure reality so that we can live with the suffering.'

Stephen De Staebler works in an impulsive yet organized way. His modelling is sensitive and full of interest, heightened with the occasional colour wash or intrusions of rills of brighter colour. His disparate themes are joined through contrast and he is a master at involving contrast – which also automatically adds drama to his pieces. Often such contrasts are introduced or subsumed under various categories.

They are, not surprisingly, about landscape, since we learn from the artist that he was 'born in 1933, in St. Louis, Missouri. From childhood, rivers and streams have always been important to me', he says. 'The sandstone bluffs along the White River on our family farm in Indiana embedded in my mind the forms of

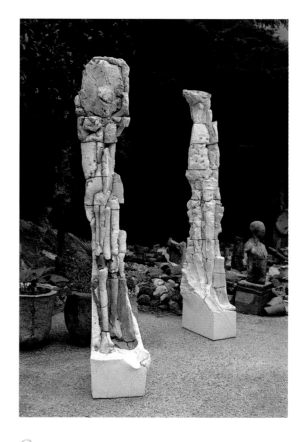

Standing Figure with Tilting Head. *1985. Fired clay; 91½in × 15in × 21in and* Standing Figure with Yellow Aura.*; 1985. Fired clay 92½in × 21in × 19in. Scott McCue Photography, Orinda, California*

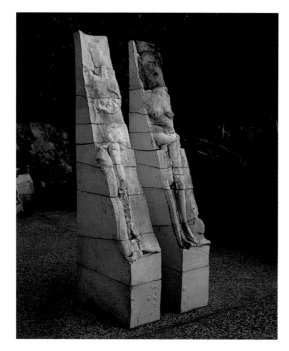

Standing Man and Woman. *1975. Fired clay; 96in × 36in × 33in. Scott McCue Photography, Orinda, California*

erosion, of wind, water and time.' So we understand where De Staebler's particular style of layering and stratification come from. These geological constructs, symbolizing creation and destruction through the weathering of time are shown as accretion and erosion, fractures and fused fragments. They also symbolize the frailty of our endurance. In particular, his work represents our treatment of the gift of earth that has been vouchsafed to us, but is spoiled or, as the artist puts it, 'no longer embraced by us'. They also give mystery: the mystery of coming across an archaeological fragment, a kind of Ozymandian discovery in the desert sands, eroded by sun, wind and time.

They are about male and female – they show both the qualities that we share as well as our differences. *Standing Man and Woman*, for example, is made from the same matrix block, sliced apart, yet shown together. They are our two selves: the female in the male, the maleness

in the female part of us. And in De Staebler's work these are often melded into an ambiguous confusion of androgyny, representing every-man.

They are about our existence – shown through the use of positive and negative. For example, sometimes a whole limb or arm, or whatever, will be missing. Yet a hollowed-out, negative impression of a leg or arm will be evident, as if the substantial part had been eroded by a rill of water carving its own pathway through. This sends out a strong message of the slow decay of the landscape. We humans should not be continually trying to subjugate nature, but living in harmony with it and through it. Time is not on our side.

They are architectural, or rather borrowed from architecture – De Staebler uses archaic sculpture and temples as a device and, by adding antithesis and irony as the cement, he seems to be suggesting we should always keep one foot in the past when we step towards the future. Scale is important to him and he often has the habit of stretching his figures into a linear Wilhelm Lehmbruck-like attenuation and choosing to house these in the form of a stele, so that his lengthened vertical 'slices' begin to resemble the carved Romanesque saints on a tympanum. Those of De Staebler's figures which reside in the matrix often sit on throne-like blocks cut into the stone, reminiscent of the seated figures carved direct from the rock at Abul Simbel in the time of Rameses II. In style his figures are also similar to the Etruscan spear bearers from the Ischtar Gate (Pergamon Museum, Berlin) which are composed of tiled blocks.

They are moralistic, conveying a feeling of loss. Not of the 'Golden Age' of archaic sculpture but of man's loss of a closeness to things that matter in our planet. De Staebler's work rails against all things material, motorized and mechanized in our world of instant gratification and greed. They point us back to a more primitive proximity with earth.

They are eschatological, but revealed as a combination of both the spiritual and the material in life and death. The stuff of mind, body and spirit in De Staebler's pieces is all opened up for you to see. You understand the feeling of insideness. His are sculptures of the inside out and the outside in. They are mainly about the human condition, but the suffering is, again, tempered with irony, when, for example, parts of our body structure, such as the leg,

are offered up in such pieces as *Altar to a Leg* (1981).

De Staebler studied religion at Princeton, and many angels make their way into his work as messengers; or, if they are earth-bound, then they still have accoutrements that are the stuff of spirit: wings, flames or spirit colours added in specific areas to intensify meaning in that part, or to meld spiritual/mental/bodily parts in one special zone – like a blue eye, a yellow limb, a lavender face – sometimes behaving like streaks of woad painted on an ancient warrior's face to scare the enemy away. Colour (added in the body or as engobes to the surface, or post-firing as acrylic or oil paint) appears to be life-assessing against the contrasting matt grey clay, which is more chthonic in quality.

Two Legs with Red Splint. *1996–98. Fired clay; 33½in × 12in × 10in. Sixth Street Studio, San Francisco*

Stephen De Staebler chose clay for the 'secret processes' that he thinks are inherent in this material for him to use. He explains what he means by this:

Clay has an inner instinct for form. If you let the clay do what it wants to do, it will do incredible things. It is like making a collage where you take fragments that speak to one another and bring them into some kind of field that is more than the sum of its parts. I try to let clay have its own way. What it wants to do is often much more alive than what I bring to it. Working with clay becomes at its best a dialogue.

I build with slabs of clay to keep the form hollow. This permits exerting force from the inside out as well as from the outside in. I like to combine different kinds of clay fired to a range of temperatures, often different from what is intended. I may colour the clay with oxides and stains, sometimes mixed into the body, sometimes pressed in to the surface. I use glazes sparingly because they diminish the texture of the clay. It was while learning sculpture at the University of California at Berkeley, that I happened upon a class taught by Peter Voulkos and discovered my love of clay.

While Peter Voulkos offered a prime motivation to Stephen De Staebler, Michelangelo provided for him a continued inspiration. The artist describes here why he is influenced by the *Rondanini Pietà*:

The *Rondanini Pietà* is a radical reworking of a sculpture begun over ten years before. Toward the end of his life Michelangelo laced into the earlier version, probably knocking off the head of Christ as he reduced and fused the bodies of Christ and his mother. He went to great pains to preserve the original right arm of Christ, stabilizing it by the thinnest of connectors. I am moved by this incredibly bold expression of evolution. The figures are weathering the passage of time, caught in a flux between fragmentation and completeness. The sculpture speaks of intense suffering, while the stone possesses eternity.

Gertraud Möhwald [Germany]

My goal is to create a new form in which I unite fragments and broken pieces that have nothing to do with each other – one could describe them as 'homeless'! – into a new composition. These fragments give my sculpture a quality that I could never achieve with even the most perfect modelling technique.

Gertraud Möhwald works rather like an inventive archaeologist, searching among the shards of civilization to cleverly recreate and recycle. The shapes that she creates beneath the fragments are sculpturally compact, but the ceramic shards add their own particular curves which the artist places accurately to enhance and overwrite that central density. Powerful yet tender forms emerge during the making process, while the pieces also develop heart and soul.

It is puzzling that Gertraud Möhwald's sculpture (even with all the firing, refiring, glueing with glazes, glueing with glue, painting and then further additions of pieces of steel, paper or cloth) emerge with such assured clarity. They have also gained personality and character during their gestation, qualities which stamp the artist's work with that inimitable Möhwald family likeness. It is probably the combination of these tertiary post-firing touches with a really

*I*NFLUENCE
*Michelangelo,
Rondanini Pietà.
1552–64. Courtesy of
The Sforza Castle Civic
Museum, Milan*

ead L. M. V. *1993. Chamotte clay, porcelain, glaze, oxides, broken pieces, found shards, iron stick, hand-built, fired to 1,140°C, 1,040°C, electric kiln; 37cm. Bernd Kuhnert, Berlin*

'Having grown up in a large city in the middle of twentieth-century Europe, I have been confronted since my childhood not only with European art but also with that of past and distant cultures. The silent Egyptian sculptures; Etruscan figures, sometimes broken; the pure, simple shapes of the Bauhaus vessels; the figures and heads of Giacometti – all have consciously or unconsciously influenced me. All have played their part in forming my conception of art as a whole. But there was one special, key experience: in 1980 I visited the Islamic Museum in Berlin. There I saw a vessel, pot-bellied with a wide opening – a perfect form, full of strength and expression. It was no longer whole. Many pieces were missing. It had been reconstructed with a yellowish plaster replacing the lost pieces. My eye sought to follow the lines of the Islamic decoration, inventing where there was none, creating in my imagination a whole from the many parts. I was overcome by a feeling of secrecy, of excitement and at the same time moved by a strange, unknown force. It told me that, in spite of the deep injuries, the power and the beauty of the vessel still existed.

strong basic form which most reveals her remarkable talent: touches like the pinpointing of a vital area with a painted slash of bright colour or a spearing of metal. Such striking statements elevate the pieces to that of magic votive or archaeological totemic god, each with a new energetic life of its own. But despite all the activity and energy, there is always, finally, a wonderful stillness to Möhwald's human forms, making them quiet testaments to what has passed – but also looking steadfastly towards the future.

Gertraud Möhwald was born in Dresden and, after schooling, became an apprentice to a stone sculptor, which is where her strong sense of form must have developed. She studied sculpture from 1950 to 1954, then ceramics from 1959 to 1964 at the Burg Giebichenstein School of Art in Halle – then part of East Germany. From 1970 to 1989 she was a member of the faculty at this institute. Today Möhwald is married to a painter and has four children. She lives and works in Halle. The artist describes her inspirations and her way of working:

orso of a Young Woman. *1999. Grogged clay, porcelain, glaze, oxides, broken pieces, paper, hand-built in seven parts, 1,140°C, 1,040°C, 900°C, electric kiln; 108cm. Bernd Kuhnert, Berlin*

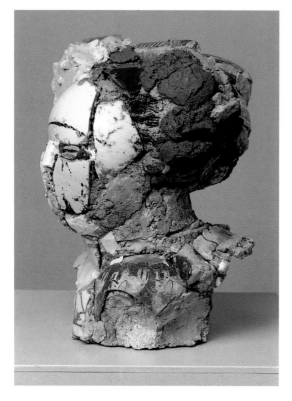

Small Head with Small Iron Stick. 1999. Grogged clay, porcelain, glaze, oxides, broken pieces, iron stick, hand-built, 1,140°C, 1,040°C, 900°C, electric kiln; 22cm. Bernd Kuhnert, Berlin

colour or consistency by adding oxides or firing them at a lower temperature. Perhaps the most obvious characteristic of my work is the use of broken ceramic fragments, which I press into the wet clay. They are held in place by a low-firing glaze, which serves as a "glue". The specific laws of ceramic material add another important facet to this collage technique: as the clay dries and is consequently fired, cracks appear, since the ceramic fragments do not shrink. I accept them as signs of natural living processes. They are not planned but desired. After the final firing I often add pieces of coloured paper, glueing them to the fired surface. Where a special accent is needed I resort now and then to the use of paint. Metal and cloth are incorporated for the same reason. I do not try to fool the eye. I want the material to be genuine and remain identifiable.

'I do not make my large figures in one piece. I divide them into blocks, stacking one on top of the other, and then work on the sculpture as a whole. There is a practical reason for this. They are more easily moved! But, more important, it

For years the memory of this vessel remained in the back of my mind. It eventually triggered, however, a new direction.

'The goal of the archaeologist is to reunite broken or lost pieces, as in a puzzle, re-creating the original from its many parts, whereas my goal is to re-create in a kind of 'collage-technique' for my sculptures where the shards, robbed of their original home, should no longer give information about their age or value. They are part of a new whole. I choose them for their form, their colour, their surface. A beautifully rounded piece of a broken vessel was not conceived as a chin or a cheek, but to me the lines suggest perfection. This I find fascinating.

'I build my ceramic objects from a red or yellow heavily calcined clay. This allows me to work on the piece over a long period of time and makes constant changing – adding or cutting away – possible. It is stable enough to be fired often, first at 1,140°C, then 1,040° for the more sensitive colours. Now and then I use 900° or 730°C for special glazes. It generally takes as many as four to six firings for me to be satisfied with the pieces as a whole. I mix black, green and bluish clays by adding oxides (of iron, copper, manganese, cobalt or chromium). I use commercial glazes, often changing their

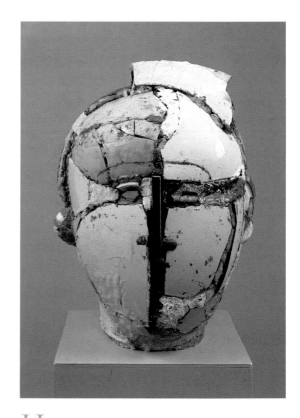

Head with Orange-Coloured Earring. 1999. Grogged clay, porcelain, glaze, oxides, broken pieces, paper, hand-built, 1,140°C, 1,040°C, 900°C, electric kiln; 39.5cm. Bernd Kuhnert, Berlin



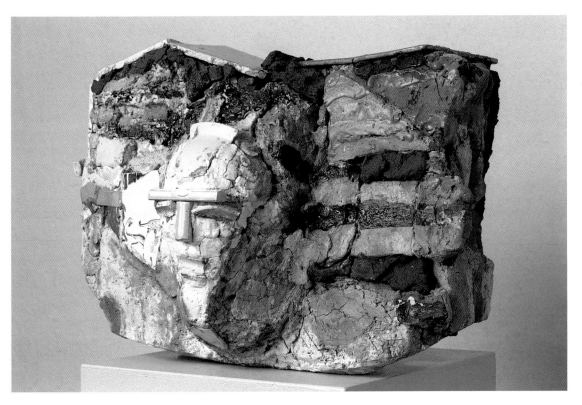

Head with Striped Hairstyle. *1999. Grogged clay, porcelain, glaze, oxides, broken pieces, paper, hand-built, 1,140°C, 1,040°C, electric kiln; 20cm. Bernd Kuhnert, Berlin*

also makes it possible for me to change the height or proportion at will. I fire the blocks separately. I do not try to conceal the irregular horizontal lines between the blocks. They interrupt the vertical direction of the piece and this, to my eye, adds an additional, aesthetic component. The inspiration for my work comes from the everyday world around us, but I am not a story-teller in my work. I try – certainly a never-ending attempt – to form faces and figures that are not strange to the viewer. Whether I have achieved this goal is the decision of each viewer; I would prefer that he or she views my art and then comes to his or her own conclusions. My goal is to have this person feel the long and strenuous process of creation which each piece has endured – from my hands and from the kiln. More important, I want him to sense a feeling of strength flowing from the "intensive stillness" of the sculpture.'

*I*NFLUENCE
Gertraud Möhwald, drawing of Islamic vessel. Lustre-glazed, broken, repaired with plaster; Staatliche Museum, Berlin. Drawn from memory (the hatching is the plaster part).

Doug Jeck [USA]

I've looked hard at the history of the human object. I wonder the same thing about it as I do myself: is what has been more blessed than what will be? This question is at the core of everything I make and, perhaps, the reason why clay is most appropriate.

Doug Jeck sculpts an assemblage of body fragments: cracked surfaces, cropped limbs, mended pieces and disjointed parts. All these are seemingly disturbed from different sources and compelled together into a modern, classi-

cal totem of reality. This brings with it a whole new group of puzzling proportions and brooding, fragile ambiguities. He mainly uses a strangely modified version of the familiar heroic male torso. The resulting statues bear the nakedness of a Lucien Freud – a likeness Jeck enhances by often painting in the veins, then covering them with layers of paint wash to symbolize the living, shallow, layer of surface skin. And occasionally, by glueing real hair on to the sculpted heads that top all the crumblings and fractures beneath, the artist adds an element of vulnerability. His statues take an age to make and are intelligently constructed. They reveal a masterful knowledge of the body. You have to know anatomy well in order to alter it into such disturbing creations, and he does it all with such prowess. We, as spectators, see that this modelling is identical to our own bodies, yet it is disconcertingly sliced and stacked up into disproportion in a single sculpture.

The finished pieces are always just a little smaller than life, or just a little larger. This produces a kind of aesthetic unease which, although thought-provoking and fascinating, distances us, because we are required to observe the pieces in a distorted way. The figures are

introspective and have unfocused stares that are non-confrontational, so that we are forced to bring our own feelings and critical gaze to their interpretation; but, at the same time, the pieces seem aware of being observed. Although fashioned from clay, the surfaces of Jeck's sculptures may resemble marble, or perhaps a plaster cast. And there is a deal of implied movement in his figures, produced by the closely-observed musculature. For example, the muscles are taut when they have to support a static, archaic weight, as in *Rule*; or fully flexed when he depicts a figure running, as in *Stopping*; or even tensed up when he makes them attempt to stand quite still on their plinths in a pose, in *Weeping Belief*, for example. You may glimpse the statues wobbling slightly, but their maker performs a clever balancing act. This is because he builds his figures so sturdily from the feet upwards that – as he explains below – he is constantly aware of the juxtapositioning of various weights that are to come up above as he juggles with the mismatched sections.

Jeck explains how he creates this work and what he is influenced by:

> My work takes a long time to make. I build a hollow human body by adding strips of clay on top of each other an inch at a time. I start on the ground, with the feet, and work up, slowly defining the body hour by hour, day after day. Each time I work on this body, which will eventually have a face, pupils and an implied persona, I have a different, unique combination of encounters with the human object influencing me – a previous student critique, a BBC radio broadcast, the Brahms 2nd piano concerto, the recollection of a stranger's gait, my latest, seemingly brilliant epiphany on art, my sons' latest perplexing questions, etc. Throughout this process and in the finished pieces, I am certain that the implied persona that has emerged through months of this is defined by it, as I am that it will eventually become a fragmented piece of insignificant, dusty junk. Or maybe not.

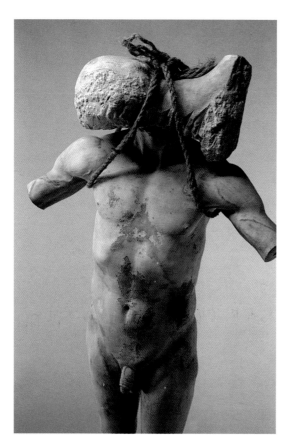

Rule. 1997. Clay, mixed media; 193cm × 58cm × 36cm.

Maybe not ... because Jeck's sculpture is appreciated throughout the United States, where he has exhibited widely, as well as winning many awards and grants. He also lectures and gives workshops extensively. He was born in 1963 and grew up in Fort Lauderdale, Florida. At first he embarked on studying music as a trumpet major at Tennessee Tech University from 1981 to 1983,

he is currently an associate professor and the Chair of the Ceramics Program. He lives in Seattle with his wife Delia and sons Henry and William.

Jeck's work makes us aware of the past, present and possible future. With every piece the artist is embarking on a journey of self-discovery, painstakingly reinventing himself each time, talking about different parts of his nature and its relationship to his experience of the life around him and time going by. Laura Lieberman said, rather aptly, in an interview in *American Ceramics*, 'Jeck's apparitional pieces explore and exploit the subtle differentiation between the human form and the sculptural object.' He himself says of his work, 'It's heroic male statuary. I'm offering a replacement for the idealized male hero with an introspective, self-examining male countenance. I don't want to make the work about me, but through me, and using me.'

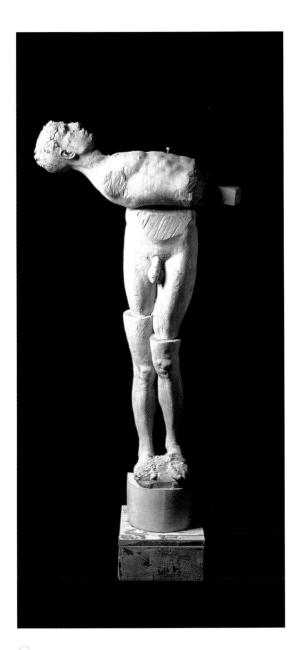

Spunk. *1996. Ceramic and mixed media; 65cm × 30cm × 13cm. Mark Van S.*

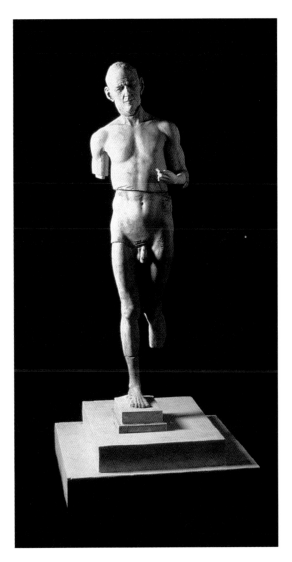

Stopping Man. *1994. Ceramic and mixed media; 82cm × 36cm × 38cm. Mark Van S.*

but then, in 1983, a meeting with Professor Tom Rippon, a mentor and friend, and a visit to an art college, turned him to working with clay. This was, to begin with, at the Appalachian Center for Arts and Crafts in Smithville, Tennessee, where he received his BFA in 1986. Thereafter he attended the School of the Art Institute of Chicago in 1987 and completed his MFA in 1989. Since then Jeck has taught at both the New York State College of Ceramics at Alfred University and at the University of Washington, where

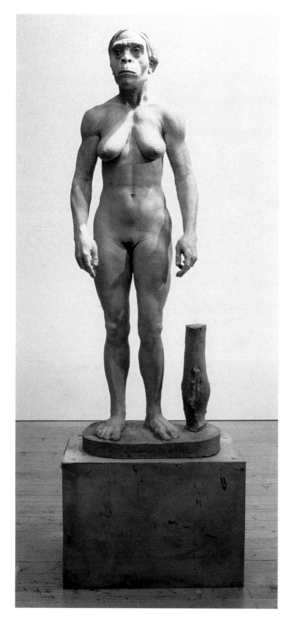

Weeping Belief. *1999. Clay, concrete, steel; 70in × 25in × 13in. Courtesy of The William Traver Gallery, Seattle*

Gill Bliss's human forms are courageous and full of spirit. They have a wonderful springy tautness to them; an exciting stretch that brings the body rearing upwards into a dancing position. This stance and style speaks much about the essence and universality of the female form. When I first saw one of her torsos I was stunned by their great beauty. She draws so many riches into her work: body textures, areas of light and shade, energy and expressive content. Patterns flicker over body-forms in dapples and zebra markings or cracklure, adding extra movement to the stretch.

They are at once both ancient and modern. They could be chanced upon in the Etruscan section of the museum, yet their movement sets them in a place somewhere in contemporary dance, with music in the background. (It is only when you discover that the artist was once an acrobat herself that this begins to make sense.) They are complete forms and, as with the belief that if you were to roll a Michelangelo sculpture down a hill and bits fell off, the remaining parts would still look complete; this applies too to

Gill Bliss
[England/Wales]

In my clay sculptures I use fragmented forms, such as female torsos and hands, to portray aspects of the human condition. By using parts of the body I hope to focus the eye more directly on the important areas of movement, gesture and expression, honing the image down to its essential elements. The torsos are all shapes and sizes; some lean and supple, others heavy and fleshy. My interest is not in finding the 'perfect' female body, but in exploring the diversity and subtlety of shape and emotion that ordinary women experience in their lives.

Female Form. *Porcelain paper clay, fired to 1,240°C, crackle glaze and black stain; 12in.*

Gill Bliss's work, where you could break bits off yet both the fragments and the parent sculpture would not appear to have lost any of the essence of the original work. Bliss manages in her technique to use in full the freedom that paper clay can bring to creating a sculpture in clay. It has helped her impart strength, variety, lightness and weight exactly where and when she wants it.

She is a real professional. Everything she makes is of interest. She also expresses herself with clarity and intelligence, describing her work, the influences upon her and her technique thus:

'I was born in Brighton. My family moved around when I was young and I did not stay anywhere for more than three or four years. Having lived in Cardiff for twenty-five years, I have more roots there than anywhere else. As a teenager I did not have any idea what I wanted to do, and ended up on a teacher training course, which I did not have much enthusiasm for. By chance some friends took me to John Maltby's workshop. This was when John was making domestic ware and had just moved into a new house and workshop in Devon. I was absolutely bowled over by it all – having a workshop and earning a living by selling what you produced; making things that people would want to buy and use; working with clay and throwing on the wheel. I was just another passing visitor to John, but for me it was a turning point and I was determined that I was going to become a potter. I studied on a foundation course at Weston-super-Mare, and then the BA Honours in Ceramics at Cardiff College of Art. (1975–78). I then set up my own workshop in Cardiff, making thrown domestic ware in porcelain, which I sold through craft shops, craft fairs and exhibitions.

'By 1994 I was feeling that my work had become stale, and I no longer had the enthusiasm for spending long periods of time making. I was very lucky to get a place on the MA Ceramics course in Cardiff just at a time when I needed to refresh my ideas and outlook. The two years spent there were incredible. They allowed me to gain confidence with new ways of working, and since then I have been making figurative sculpture. My attitude to work also changed. I now realize I need to spend time out of my workshop – going to performances of dance and theatre, taking time to draw, research in the library and go to exhibitions. All these

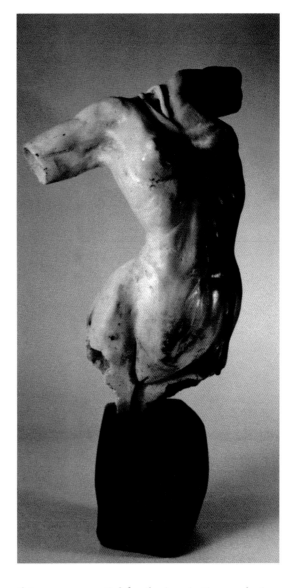

emale Form with Plinth. *Porcelain paper clay, fired to 1,100°C, smoked and waxed; 12in high.*

things are essential for the inspiration and stimulus that feeds into my work, something that was lacking in my life when I spent day after day at the wheel.

'Just at this time, the sculptor Louise Bourgeois came to prominence in this country. I saw an exhibition of her work at the Tate Gallery, the Oriel, Cardiff and a television programme about her. I was greatly impressed by the life and work of this sculptor who did not gain recognition for her work until she was in her seventies.

'*The Arch of Hysteria* is a fragmented figure – although all the limbs are present, there is no head. This creates a figure that is universal, a symbol for humanity rather than an individual human character. I realized that putting heads on my own figures drew the attention of onlookers to the face, and it was from this that I

*F*emale Form.
Porcelain paper clay,
fired to 1,100°C,
smoked and waxed;
20in.

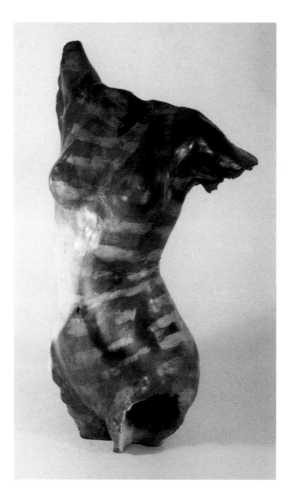

*F*emale Form.
Porcelain paper clay,
fired to 1,100°C,
smoked and waxed;
20in.

this and other sculptures by Louise Bourgeois I understood that it is important to give the onlooker space to interpret the work according to his or her individual experiences. Indeed, this interpretation may change for both the viewer and the sculptor over a period of time.

'Louise Bourgeois works in a wide range of materials and has created whole rooms or "cells" as well as individual sculptures. I do not expect most people to see any connection between her work that fills out large gallery spaces and mine that fits happily into a domestic scale. However, the memories of seeing this tiny woman with such an indomitable and eccentric character on the television and the work she has produced in exhibitions will always be an inspiration to me.

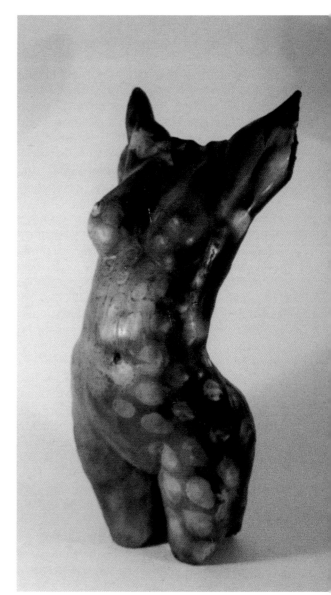

started to omit any areas that I did not feel were essential. I felt a connection with this sculpture that went beyond looking at the shape and liking the form. I was intrigued and fascinated by it. At the time, people were often saying that my work was disturbing. In a way, seeing Louise Bourgeois sculptures gave me a confidence; you could say it gave me permission to make the sort of work that would not be liked by everyone. Sometimes people will tell me they like the thin women, but not the fat ones; they think some of the torsos are funny, but others are too menacing. The important thing for me is to make all of these forms, to create all of these reactions.

'Another factor that I found in *The Arch of Hysteria* was its ambiguity of meaning. Is the body racked in pain or arched in ecstasy? At this time, I was struggling with trying to say too much in my work, wanting to make sure the onlooker would know exactly what each piece was about. This creates more of an illustration than a sculpture. It leaves nothing for the viewer to explore, question or be intrigued by. From

'I use a paper clay body for all my work, by adding paper pulp to a porcelain or stoneware slip. The addition of paper gives me more freedom when constructing and firing. I am able to rework the figures at any stage, when the clay is damp, dry and even after biscuit firing, and there are certainly fewer problems of cracking and warping. I have also found that I can dry out pieces tremendously quickly, finishing their making on one day and putting them in the kiln on a low heat the next. I use a combination of building techniques – coiling, pinching, slabbing and hollowing solid forms. I like to work with clay in a way that is not totally controlled and predictable. The subtle creases, stretches, folds that appear as the clay is worked give it a life and vitality that is impossible to create by direct modelling or carving. For this reason I tend to work quickly, with several pieces on the go at one time, working the clay until it is almost collapsing, before allowing it to rest and stiffen a little. At any stage I may break pieces off or add an extra section; push the form from inside; fold the clay back on itself to give a change of direction. It is a constant process of assessing the possibilities of the emerging shape to find a completeness and balance in the form. All the pieces are biscuit-fired to 1,100°C in a top-loading electric kiln. Some are then glazed and fired to 1,240°C and black ink rubbed into the crackle. Others are sanded until very smooth, smoke-fired in a dustbin of sawdust, waxed and polished. I block out areas of pattern by painting on a resist slip and the smoke creates its own

*I*NFLUENCE
Louise Bourgeois, The Arch of Hysteria. *Polished bronze; cast in 1995; 33in × 40in × 23in. Courtesy of Cheim & Read, New York*
 Bourgeois was born in Paris in 1911 and has lived in New York since 1938. She has produced an extraordinary body of work in sculpture, drawing and prints. However, it was not until 1982, with a major show at the Museum of Modern Art in New York, that her standing was acknowledged. Her subject matter is drawn from her insights into her own disturbed childhood and later from her role as wife and mother. Her work, at times imbued with a predatory sense of danger, is often overtly sexual and psychosexual tension is ever present. In this work the figure is ambiguously racked in pain or arched in ecstacy.

areas of lighter and darker shading over this. The crackle of the glazed pieces and the colour of the smoked clay are influenced and dependent on the individual nature of each form: the curves and hollows of the shape, the thickness of the clay, the temperature of the firings and so on. Both types of finishing, therefore, have an element of unpredictability; something one can learn to use, but never totally control. My intention with the finishing of all work is to add something to the form that is not just a decoration of the surface. Both the smoked firing and crackle glaze are traditional ceramic techniques that give a timeless, ancient quality to the work, a connection to past traditions. Of course, we are used to seeing fragmented figures that are actually broken statues in museums and books about ancient art or history. Although the forms I use have associations with past ages and cultures, I want my figures to bring this imagery into the present day. Each form is complete in itself and contains the whole of what is being portrayed – although each piece is a fragmented figure, it is not lacking something that has broken off.'

Christie Brown [England]

My interest in the body is either as a means of discovery of our own identity and sense of self, or as an exploration of the unknowable and uncontrollable Other. My clay figures are part of my own cast of characters, a personal iconography concerned with the universal themes of attachment and loss, drawing on the body as a site of meaning.

Christie Brown has grown in international stature, winning awards, exhibiting widely and sitting on prestigious committees. She was born in Yorkshire, took a general arts BA at Manchester University, and followed this by a diploma at the Harrow College of Art (where she was tutored by, among others, Mo Jupp). Then she studied at the Sir John Cass College of Art. At the moment she is an Associate Lecturer in Ceramics at the Harrow campus of the University of Westminster. She works and lives in London. At Harrow Christie Brown discovered that life drawing became more important to her, and also gave more pleasure than pottery. Then, in the early 1980s, she found herself moving towards sculptural work. Even today, there is the presence of her life drawing in her sculpture. She says that she tries 'to capture a movement or sensation recorded in the original drawings and preserve it in the final figure.' For a while, the figures were drawn on to clay slabs direct, but gradually Brown's work grew more three-dimensional. Today she makes sophisticated pieces which combine fantasy and reality, the figurative and the abstract. And she is always looking for more content, always questioning and trying to find answers, so that you know that she will always have something new and important to say.

All her figures are honed to the essential, resulting in a powerful presence and quiet authority which are most clearly felt when enough space has been left around them. Surface quality, too, is kept to a minimum, usually

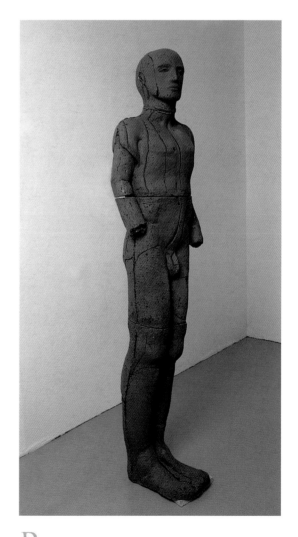

Prometheus's Helper. *1998–99. Brick clay, steel; 111cm × 39cm × 31cm.*

coming about during the several stages of the making process. Threadlike seams might appear where one clay plate has been pushed against its neighbour in the mould, making meandering, delicate traceries. Or there are lines like operation scars, where the pieces have been glued together or stacked one section above the other in the final assembly. Often these receive a brushing with vitreous slip to show that they are intentional.

These carapace markings not only map out the journey of their creation, but symbolize the fragility of the body and also, symbolically, of the content beneath. One area may display a drift of sand where it has pressed through to the surface, another may be highlighted by the artist with further areas of slip that, by their singularity, give impact where it is needed. Even the side seams, where the pieces from the mould have been pressed together, have been left like selvages on tailor's cloth. These mysterious edges echo the strong lines from her life drawing. 'I really like the effect,' she says, 'it's one of those things where the medium takes over, doesn't it? Where fate takes over and you think, oh that's nice, because clay can do that and it has a voice of its own, which is part of its lure.'

The materials Brown uses – a grogged T Material for the white figures and reclaimed, unfired brick seconds for the red – also keep their original colouring and texture. Thus the figure's skin gains neutrality from matt monotones, a skin of all-over, archaic nakedness. Brown makes her original models from coiled clay for the larger figures, while smaller pieces are carved from polystyrene. Both are then cast to make the plaster parent moulds. Into these large formers are pressed the great slabs of clay.

> Pressing the clay in the inner shape is like blotting paper [she describes], the plaster sucks up the moisture from the soft clay and makes it hard … I really enjoy the moulds because there seems to be much more variety than I would have expected. The way you lay clay in the mould, what happens when you lift it out all have an influence on the final form … a rolled slab of clay is a fluid; moving, alive, difficult to tame.

Once lifted out, the clay 'skin' has acquired its own stretched surface. Brown's recent press-moulded figures have the two halves joined while the clay is still in the mould, and no pressing or modelling with foam is done as in

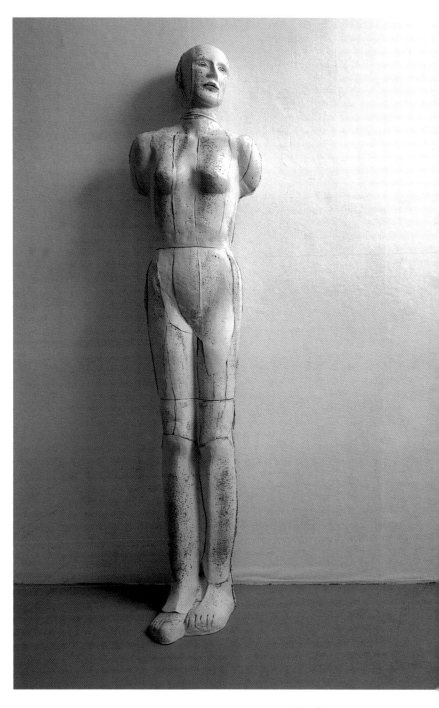

the earlier flat figures. Fronts and backs are squeezed together, and some finishing and tidying of the edges is carried out. Then the heads are added on to to the body, giving them their identity. These joins, too, can be highlighted with vitreous slip, then fired from 1,140°C to 1,180°C. For exhibiting, the smaller figures are glued together to make them stable, while larger figures have their hollow sections held together with an armature. Once assembled, these figures make you aware that dream spirits

*W*hite Galatea. *1998–99. Ceramic; 171cm × 40cm × 34cm.*

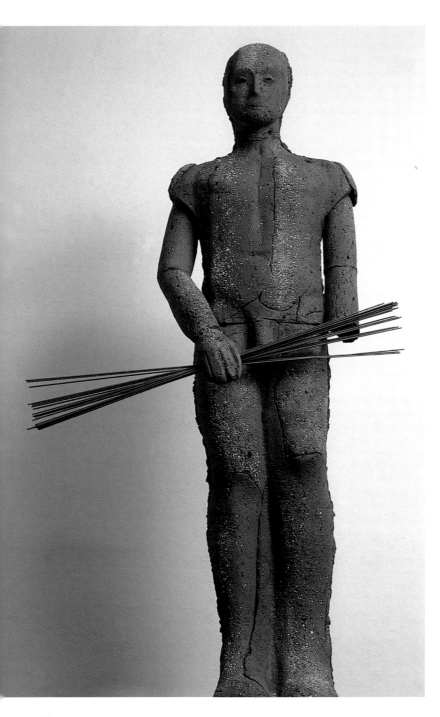

and defining and deserve to be published.)
Most of the ideas come from her own self, but
the artist gathers inspiration from many
sources.

> These are not usually connected with ceram-
> ics, but range from archaic and classical Greek
> sculpture, Renaissance art, ancient Egyptian
> and early Chinese sculpture through to con-
> temporary photography and animation, Sur-
> realism, and a large number of contemporary
> fine artists … Antony Gormley, Stephen De
> Staebler, Carmen Dionyse, Louise Bourgeois
> and Magdalena Abakanowicz are some; and
> especially the work of Portuguese artist Ana
> Maria Pacheco.

Christie Brown says of her:

> Around the end of the1980s I began to engage
> more with this world of ideas. In seeking
> broader references I was struck by an exhibi-
> tion of work by the sculptor Ana Maria
> Pacheco which I saw at the Cornerhouse in
> Manchester in 1989. She worked with one
> theme for several years and made a variety of
> work drawing on this theme, so that as well as
> a group of sculptures that all connected (for
> example, the large group entitled *Man and His
> Sheep*) a range of smaller pieces, etchings and
> paintings illustrated her process of reflection
> and engagement with the central idea. This
> show gave me, in a sense, permission to work
> on an idea for some time, to develop a series
> of related pieces and to consider making work
> that was not of a single, table-sized scale.

Brown's latest work *Fragments of Narrative*, is a
group of figures shown in the old Wapping
Hydraulic Power Station. They are beautiful
with the quiet space of this disused industrial
building around them. Her work needs this
type of space in order to make its presence felt;
its power would be stifled in a crowded area.
Here the pared-down figures make intriguing
and subtle statements in a kind of modern
archaeology. Often legs – and arms, if they have
arms – are fused to the body, giving each figure
a static presence. They hold to the ground obe-
diently, as if waiting quietly to be singled out to
step forward. But they cannot move, except spir-
itually. They remind me of the ka spirits from
an Egyptian tomb which you know could easily
transverse a tomb wall if they wanted. A ka is
our spiritual self – the other self that we look

Red Pygmalion.
1998–99. Brick clay;
170cm × 43cm ×
36cm.

have inhabited the hollow interiors of what the
artist calls her 'Cast of Characters'. Christie
Brown tells us that 'a lot of imagination has
gone into them from my dream world – so they
are figures of my own mind rather than my own
body.'

The artist also keeps working notebooks and
uses ideas from these that mirror her mind and
act as an aid and reflection in the making
process or whenever she needs to question her
reasons for making art. (These are perceptive

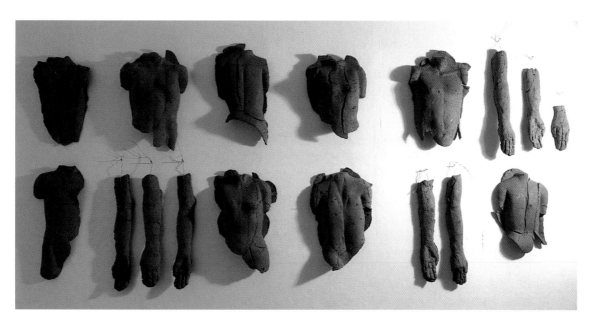

Resource – Clay. 1998–99. *Brick clay; detail, 135cm × 260cm.*

for and first greet once we have died, and which lives off things left in the tomb for the afterlife.

The smaller figures with names such as *Prometheus's Helper* look the opposite of creators, fertility goddesses or earth mothers, more like protectors, essentially helpful and healing. These are made by using brand-new moulds. However, the wonderful 'resource clay' or 'spare parts' have been re-created themselves, since they are all cast from the moulds of previous creations. They have been given a new lease of life – a kind of artist's resurrection. When these are pressed out they leave frayed edges that remind one of chocolate cast in tin moulds left untrimmed, or maybe delicate pieces of worn shell that you might find on a beach, rather lost from the parent shell and separately eroding.

'My figures', the artist says, 'make people project their own feelings and ideas upon them. I enjoy the connection – even if it's not what I intended.' Her recent work

'represents a move away from earlier decorative pieces towards an examination of archaic uses of the figure and an exploration of figurative concerns in cultures which attached importance to the body as a sign of origin and departure. I am drawn to the idea of clay as a metaphor for origin as it is strongly associated with myths of creation and I am beginning to find a connection with aspects of ceramic history in clay figures and artefacts as carriers of deep meaning in archaic burial and funeral rites all over the world. The references which inform my more recent work come mainly from these sources,

expressions of fundamental needs connected with rites of passage in human life. The distinctive quality of clay and its versatile capacity to receive an imprint, coupled with my process of casting and press-moulding, make it a suitable material for the complex subject of the body. The near life-size and 4ft-high figures and the installation of clay body parts form part of a group of work entitled *Fragments of Narrative*, mentioned earlier and specially commissioned for a large industrial space which has generated further ideas about scale, memory and the response to a specific site.

INFLUENCE
Ana Maria Pacheco, Man and His Sheep. *Courtesy of Susan Pratt Contemporary, The Gallery, Ightham, Kent*

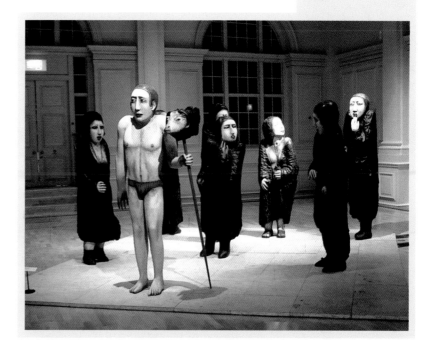

'In developing my relationship with the cast through my library of moulds I also begin to consider plaster as a material in its own right and its long relationship with clay. The traditional idea of a mould is to produce many copies, with associations of cloning and reproduction. This connects with ideas about mimesis and replication, transformation and fragmentation. The mould represents a space waiting to be filled, a manifestation of absence and presence, a representation of the threshold and the liminal.

'The body has been represented in two and three dimensions in a variety of media for thousands of years by human beings seeking to communicate a wide range of social, cultural and aesthetic concepts. For artists who deal primarily with the figure it is both an inspiring and a daunting heritage. Certainly I feel in my own practice as an artist that I have always hovered on the boundaries, but by challenging and engaging with ceramic discourse through the archaic and by seeking beyond this into other psychological discourses, including that of the fine-art world, my practice is becoming more enriched.'

Susan Low-Beer
[Canada]

Making art for me is a journey, an attempt to discover something that resonates. I use the tension of experiences, readings, images and ideas to stimulate my thinking. I then select and fuse what is important to me in an intuitive way until a focus emerges. The search and the accompanying uncertainty create an intrigue, an intensity that leads me on. What emerges is a non-linear composite, a collage-like fusion for others to interpret through their own experiences and associations.

Susan Low-Beer's art reflects the diversity of historic images and collective memory. It slices through time, collects, compresses, stacks, often forces these disparate elements together to reflect the complexity of the present and the fragility of our future: 'The viewer must bring something separate to the work,' she says, 'The piece must be ambiguous enough that the viewer can bring his own life experiences to the interpretation of the sculpture. In my earlier work the titles of the pieces became another component, compounding and deepening the network of meaning.'

Low-Beer exhibits mainly in her own country, Canada, as well as in the USA and Japan. She was born in Montreal, completed her BA at Mount Allison University, New Brunswick and her MA at the Cranbrook Academy of Fine Arts in Michigan. Her major at Cranbrook was Painting; her minor was Sculpture and Ceramics. After marrying and moving to northern California in 1968, she began to explore clay sculpture. When in the early 1970s the family moved to Pennsylvania she began to work almost exclusively in that medium. With the arrival of two sons, family responsibilities began to take up more of her time and she found that working three-dimensionally seemed to make interruptions more tolerable. Since 1980 the family have lived in Toronto.

Low-Beer works in series and three of them are shown here. First are the totemic pieces, *Still Dances*, which represent a composite history of women from the Cycladic nude to the archaic fertility figure, to the Romanesque nun and mother and child, to current media images of the feminine. Each image within the totem symbolizes the female persona through history. Together they suggest a narrative about the female experience. The second series, *Mutable Selves*, consists of fragments of figures suspended in the negative cut-outs of rusted steel. These seem to hover in space and time and to echo themes presented in the first series. Her recent work is less defined as a series and presents us with simplified figures, some in opposition, some juxtaposed; here gesture becomes central. As she says: 'In life the gesture is spontaneous, ephemeral. I am interested in trying to capture the essence of a gesture, its emotional impact. The simple gesture, such as a hand across an eyeless face, suggests underlying emotions. Small, quirky details are reminders of past experiences. They lead the viewer deep into the psyche.'

A philosophy that seems to be relevant to Low-Beer's approach is reflected in this statement by Emily Carr (in *Growing Pains*, OUP Toronto, 1946):

I don't think in the creative process anyone quite knows. They have a vague idea – a beckoning, an inkling of some truth – it is only in the process that it comes to any clarity. Sometimes, indeed often, we work on a theme with an unformed idea, and when it has passed through the process, its final result is something we could never have predicted when we

commenced … of course, there must be the urge, the indefinable longing to get something into terms of plastic presentation, but results are nearly always unpredictable.

In Low-Beer's words:

I am interested in the complexity of human emotions. The energy between two forms can change a mood or feeling. Parts of a figure may be read in one way, yet just by placing something differently, the meaning can change dramatically. In my most recent series figures are created from the same mould. When grouped together in different ways these changing relationships have a gesture that has different implications and meaning dependent on the perspective and perceptions of the viewer. For example, when figures face each other, the underlying narrative is one of involvement, an attempt at contact. The same two figures pulling away result in a completely different dynamic. The choices made by the same set of figures differ vastly, all affected by context and choice of orientation.

Most of her work, both sculpture and painting, has been concerned with the figure. Her inspiration is often triggered by the historic and contemporary images that surround her. Influences

Still Dances 3. *1992. Clay, encaustic with steel stand; 75in × 9in × 11in. Helena Wilson*

Still Dances 9. *1992. Clay encaustic with steel stand; 66in × 13in × 18in. Helena Wilson*

Short Light, Long Dark. *1995. Clay and steel sheet; 3 parts each 6ft × 4ft. Cheryl O'Brian*

may come from anywhere, including the media, the natural and the man-made environment, art and art reproductions. Once an image has meaning for her it may reappear in many of her pieces. Among the images to inspire her the Cycladic nude dating from about 2,000BC and found in the Greek islands stands out:

> When I saw these small, Cycladic figures, I was astonished by their beauty. From the perspective of an artist living in the twenty-first century, they seemed so modern, so current, so relevant to the way we see the world. The poignancy of the gesture, arms folded quietly across chest, touched me. I found the strange proportions and the simplicity of the form beautiful. The sculptures are so still and self-contained, so mysterious. Made of stone and found in their graves, no one knows what they symbolized to the Greek people at that time. Their stillness and their closed gestures became personal symbols to me. I started using parts of the Cycladic nude in my sculpture, combining it with images taken from newspapers and magazines. I created a series of nine sculptures called Still Dances. Together the pieces form a narrative suggestive of the female experience. Individually the pieces repeat and recombine various images. As with each tree in a forest, each sculpture stands on its own while gather-

ing strength and complexity from the group. The viewer cannot physically alter the relationships as the parts do not move. The sections are stacked off-kilter, permanently unaligned. Each sculpture is not a complete narrative and the experiences to which each refers are not those of a particular person. But as a unit, the sculptures work in a cumulative way to form and relate an experience.

The Cycladic nude stayed in my work as 'shadows' in the series called *Mutable Selves*. What I attempted to do was to set up a dialogue between contrasting materials and their spatial polarities and to juxtapose historical connections with contemporary images. The negative of the cut-out areas may be read in several ways: as an invisible image through which one is able to glimpse beyond, as the trace of a human presence now vanished, as the shadowy outline of a figure that has left its mark. In each case a continuity is evoked between past and present, between memory and the 'here and now'.

For Low-Beer, the idea may be important but the materials may draw out the inspiration: 'I think for a work to be successful it needs to be well crafted. One needs to consider the balance between the sensibility of the larger idea and the craft of making.'

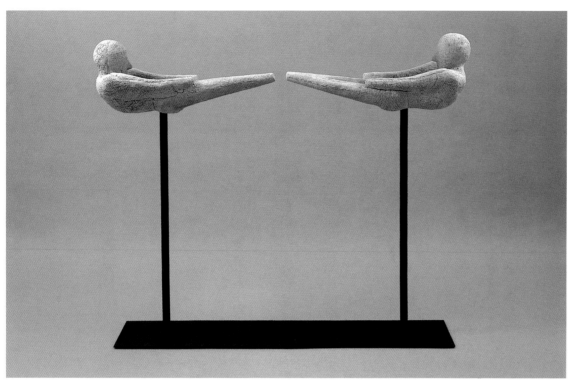

*Pool. 1999.
Paperclay and stains; 2
parts each 9½in × 9in ×
3in, with stand
combined 45in × 54in
× 10in. Simon Glass*

One of the essential ingredients of working in any creative process is familiarity with the medium. She is most comfortable with clay, 'For me, the clay has to become almost invisible to capture the essence of what I want to communicate.' Her early sculptures were glazed. As the colour relationships became more important and the surfaces more complex, glazing became a frustration to her. So when she decided to change her approach and to work figuratively, she began to experiment with encaustic (dry pigment mixed with molten beeswax): 'I found that working in this way I could eliminate the uncertainties of glazes while enjoying the new freedom and flexibility that came with painting the surface direct. The texture of the wax blended well with that of the clay and the medium allowed me to capture the richness and directness of colour in a way so often found in painting.' At present Low-Beer works with stains and terra sigillata and has begun to experiment with paper clay. She finds that it has particular properties that work well with moulds. 'My ideas have changed as my work has evolved. I have used my own experience as a catalyst. Connections are not always visible when I am immersed in the act of doing. The process of making often brings out a need to know more, and a curiosity about what would happen if … thus do I continue.'

*INFLUENCE
An early cycladic figure
from Grave A at the
cemetry at
Dokathismata on the
island of Amoreos.
Marble, 3200–2300BC;
approx 11in × 3in.
Courtesy of National
Archeological Museum,
Athens*

7 The Struggle Towards Peace of Mind and Peace for Mankind

This chapter is essentially about sculptors whose work is driven by difficulties in their own lives which are often reflected in universal problems. This is repair work, as it attempts to alleviate suffering by promoting spiritually up-lifting pieces with which we can all identify.

Carmen Dionyse and *Sabine Heller* make sculpture that is the result of an ongoing struggle since, as Sabine Heller puts it, 'it is a long road, since I must search and recognize something that I can neither explain nor describe, only feel'; Carmen Dionyse says, 'the will is to survive'. *Gudrun Klix*'s work is also the result of anxiety about survival, both for herself and the planet. She builds new connections which are to forge a sense of 'continuity and layering'. *Gabriele Schnitzenbaumer* and *Varda Yatom* use whatever tools are available. With Gabriele Schnitzenbaumer these are powerful tools to overcome childhood trauma and celebrate and honour the ones who struggled through; while Varda Yatom finds a strong language that will help her to create and re-create. It is a forceful shout, because, as she explains, her 'continual questioning and disturbing thoughts about man and his nature give me no peace'.

Gabriele Schnitzenbaumer [Germany]

My sculptures build a bridge across the past to the future, a thoroughfare for feelings, thoughts, ideas, needs, longings and desires.

Gabriele Schnitzenbaumer is an important and gifted artist from Germany. She held the position of University Professor at the Ludwig-Maximilians University in Munich from 1982 to 1992. Then as now, she manages to exhibit her paintings and sculpture every year, and her time is divided between Munich, New York and the Seychelles. But it was her childhood experiences that have been the great force and the influence behind her whole work. She was born in 1938 in Augsburg, where she witnessed the bleak chaos of the latter part of the war and the clearing up afterwards. In the midst of it all, Schnitzenbaumer as a young child with her mother and grandmother was there, 'salvaging amongst the ruins and charcoaled corpses' for what they could find to exist on. It is against these memories that she has created her human forms in clay as a scrapbook. She has built around her an army of helpers, warriors, friends and victims which she endows with the most potent weapon of all to make them bearable for both her and us – wit.

These most exquisitely sculpted clay personalities display characteristics from the toy-like and tender to the menacing and grotesque. And they exert a powerful effect upon whoever comes into their presence. For with the ingenuity of a true sculptor, the artist has drawn into her work and reinstated various artefacts and discarded items from her own past and from the history of the life around her. These 'salvaged' objects have been assembled and elevated in a way that makes one sense that an extraordinary new history is about to begin. A set of old castors form a row of buttons – or medals? – down a tunic front; ancient sash window weights dangle from shoulders; an old metal keyhole forms an adequate pubic triangle; or a torso made from an obsolete switchboard is accompanied by its electric flex, wound tightly around the neck as a choker. Everything is perfectly made and beautifully finished in this world that is being created. Nothing new from the ironmongers has been purchased to be added, everything is recycled; *objets trouvés* from the studio, farmyard or home. Most touching has been the incorporation of Schnitzenbaumer's own used

Die Hochhackige. *1988. Clay, iron; 254cm. Manuel Schnell*

paint brushes to form a headpiece or hair, or the old broom that perhaps has swept her studio floor, but now becomes a face with the addition of runes for features. And most telling are her creations' hands: nearly all have wide, spread-out palms, waiting and wanting to embrace you with love; yet others have no hands at all and have never been allowed the chance. Some are tied painfully to saw blades that might be sharp and untrustworthy, or they are the victims' hands, actually tied down and therefore useless.

In the finished population multiple associations are triggered off. Their imaginative titles, mostly representing our past history or ideas, are derived from the culture of the whole world. There are the noble warriors borrowed from mythology, the magnificent Amazon fighters, the witch doctor and the shaman. Godlike deities have tribal characteristics from African or Mayan culture. Other pieces bear the names of such friends as Lieselotte Weiss or Aaron Louis Lewitan, while exotic chimaeras from her own creation have titles such as *Broom Angel*, or represent powerful female presences such as *Sisters of the Bold Ones*. And there are those emotive titles which come from a nightmare world, with names such as *Eraserella* and *Blind Angels*, among many others.

Conceit. *1998. Clay, saws; 96cm × 36cm × 14cm. Manuel Schnell*

The clay part of the artist's pieces is made from a tough, brick-like body fired once to 1,000°C in an electric kiln, but thereafter the painter in her takes over. Up to ten transparent layers with an outdoor wall paint are carefully applied to build up a resonance of colour over the clay surface, which itself has been sensitively scratched and scarred. Thus the clay surface acquires a patinated history of its own which blends seamlessly with that of the rusted metal or weathered wood that it accompanies. Not only do they look right together but they are right. The layers and layers of paint form a 'protection'; the people are personifications of herself: as salvager, as victim, and the weapons – saw blades, agricultural forks, sickles and brooms – though now blunted or worn with use could, with a little magic, resume their power or bring back the memory of their sharpness. Schnitzenbaumer's pieces are like the gargoyles on the outside of a church. They can leer at dark forces and scare them away, thus protecting those inside. But they serve, too, as a warning to those inside not to lapse into the ways of evil themselves. They can also make you laugh with their grotesquerie.

Before I met Gabriele and she gave me the following testament I was finding it difficult to make complete sense of her wonderful work. So she relates for the first time in print:

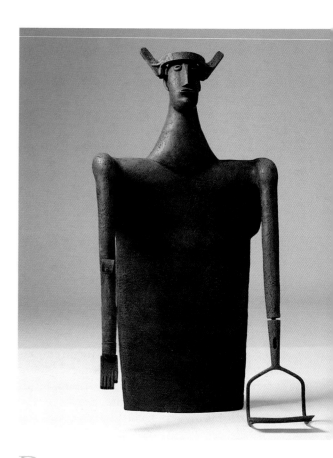

Der Schwarze Fürst. *1998. Clay, iron; 92cm × 52cm × 27cm. Manuel Schnell*

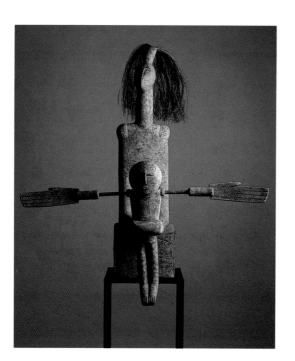

Madonna. *1992. Clay, wire; 90cm × 60cm × 91cm. Manuel Schnell*

It is through building this bridge that I rediscover the women who created a legacy from the ruins of the war, my mothers and grandmothers, and fathers too; men who left full of promise only to return as cripples. It was the mothers who reigned supreme among the devastation. With dignity and imagination they created order and a new sense of burgeoning identity from the bleak chaos that surrounded them. With strength and pride they put to good use any morsel they could salvage amongst the ruins and charcoaled corpses. I was with them. A child even today I am rebuilding together with them by giving birth to angels, guardians, Amazons and heroes in the shape of sculptures that embody and honour my ancestors, my queen-mothers-of-the-ruins, crutch fathers and mummy-siblings. This continuous process of rediscovery from the profoundly personal to the universal is what drives me to offer my inspiration as my gift and statement to the world; my dedication to women of wars.

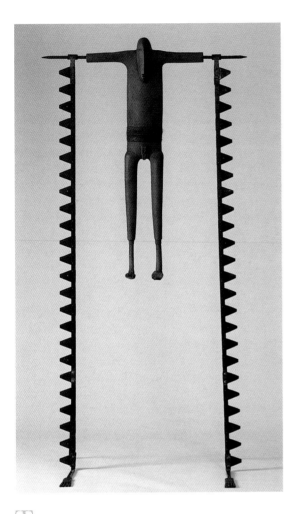

The Condemned Amazon. *1998. Clay, iron, wood; 197cm × 97cm × 79cm. Manuel Schnell*

And so it is to the rebuilding after war, and especially to the women who carried it out, that Schnitzenbaumer dedicates her life's work. A sense of humour will carry her and her memories over. Her bridge to the future is built with wit, and her power is to outwit. We give her Caro's *Bridge for Lovers* at the Introduction for her influence picture, rather than that chaotic picture from her childhood.

Gudrun Klix [Australia]

I use the figure and other forms as a language to refer to issues, feelings and thoughts that are important to me. Of prime concern is our relationship with nature, how we interact with the environment, how we impact upon it, our origins in it, and our alienation from it. I am interested in the effect this

has on us psychologically and spiritually, the implications it has for future generations and ultimately the survival of our species.

Gudrun Klix's work looks into ties and alienation, displacement and the need to get back to what is real. To that extent her work is explorative and she has chosen both mythology and the newly-forged links with wherever she has moved to as themes for her sculpture. Her own displacement means that she continually searches for new ways to grow new roots. Her long-necked figures are stretching up from the ground, crying out like Demeter from the earth or listening from Chthonia's underworld – but it is a universal message. The artist's 'cries' are not just for herself, but for the whole human race to break from the way we are going and to reconsider, then to reconnect with universal values which have been denied or spoiled. To this extent Klix's sculptures deal with dislocation and give out a strong message by whatever means and techniques she thinks fit. This artist has been able to create objectively from the point of view of an outsider looking in, and she has a great interest in the Aborigines' philosophy and has seen that their way is right. She wants us to share their values.

Today Klix is Senior Lecturer in Ceramics at the University of Sydney. She seems to have found new roots and a good country to live in. She talks here of her displacement and how she came to be working in Australia:

'I was born in Germany at the end of World War II in what is now Poland. My father's family had lived in the region as far back as can be traced, that is, at least since the sixteenth century. My mother came from northern Germany. Our family was evicted when the area was occupied by the Russians and subsequently resettled by the Poles. After five years in temporary accommodation in West Germany, we emigrated to the USA, living first on the East Coast, subsequently settling in the Pacific Northwest. Later I emigrated to Australia when I was offered a position at a university in Tasmania. My own family history is not untypical of that of millions of Europeans throughout the centuries, a history that dispersed us far from where our cultural roots lie. Whenever people make such major moves, be they forced or voluntary, a cord is cut that can never be re-established.

'To a large extent my interest in clay and nature has its roots in these dislocations. In the

Pacific Northwest, we lived in the country very close to the Cascade mountains, and I spent much of my free time skiing and hiking. Later, wherever I moved to, I had this great urge to walk the land, to make contact somehow, in order to establish a link to it. I mention this because these experiences have had an impact on my work and provide the basis for the themes.

'I did not begin in ceramics until after completing a Master's degree in German Literature, although I had always been interested in art and had taken numerous art classes as an undergraduate. My career in ceramics really began on the day I signed up for a primitive pottery workshop in British Columbia. For ten days we made pots, dug our own clay and constructed a wood-fired kiln out of self-made bricks. The kiln was stacked up out of still wet bricks and fired and got so hot that it dripped blobs of molten brick all over the pots. I was hooked. After that, I quit my job as a language teacher to make pottery. I learned to throw, built a kiln and made functonal pots for four years. Then I went to graduate school and, while there, developed an interest in sculpture and installation. It was an exciting time as we were exposed to numerous visiting artists coming from New York and we all tried out new ways of working. During this time my mind was opened to the notion of working with concepts as the basis for work.

'Influences on my work have been varied and include sculptors and painters, but I became aware of Stephen De Staebler's work in the mid 1970s, while still a graduate student. It resonated with me then and I have never lost interest in it. At that time I had begun using rocks in my work and his figures intrigued me because they were totally embedded in earth and rocks, being completely integrated with it. They appear to go back through time, to some distant, unknown past, yet are completely current and contemporary. They are at one with the land they inhabit, yet they are skeletal in nature and at times appear but a fossil from some distant time. They remind me of that sense of continuity and layering I had when visiting the Aboriginal sites in northern Australia. They interest me, I suppose, because they speak of many of the same issues that concern me in my work.

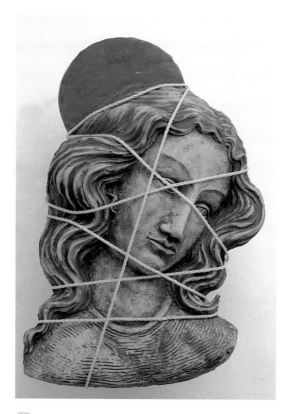

Persephone Bound. *1991; 51cm × 33cm × 10cm.*

Promethea Bound. *1991. Low-fired ceramic wall piece, under-glazes, rope; 50cm × 33cm × 95cm.*

'Over the years I have explored these issues from different points of view. In 1981, after migrating to Australia, when I first became intrigued by the Australian landscape and its Aboriginal peoples, what struck me was this sense of the original inhabitants belonging to and being part of the land. While visiting the Northern Territory and seeing the rock art which is found over vast areas of sandstone country, some of which dates back 30,000 years, I experienced a very strong sense of this continuity and layering of generations through time. I have come to think of this as a vertical axis that connects people to place through time. Westerners seem to have lost this connection due to mass migrations and displacement from our place of origin. From this results a sense of alienation. The phenomenon appears to be widespread and is the cause of much psychic suffering.

'At this time I also developed interest in mythology, both Aboriginal and Western. Mythology invariably deals with stories of origin. And, through ritual, traditional people periodically re-enact the creation of the cosmos

*I*NFLUENCE
Stephen De Staebler,
Leg with Green Path.
1996–98. Fired clay;
29½in × 13in × 13in.

Demeter's Lament. *1992. Low-fired ceramic with terra sigillata and copper wash; 96.5cm × 60cm × 40cm.*

and consequently feel connected to its rhythms. Fully initiated Australian Aborigines, for instance, are obligated to regularly perform rituals that assure the continuation of their world. Through these rituals they partake in the process of creation. This provides their life with purpose and meaning and connects them to their origins and the land.

'Many of my figurative works date from the time after I had visited Aboriginal sites and began researching mythology, including the big heads (*Demeter's Lament, Chthonia Listening,* as well as the bound goddess pieces). For me the working of clay is ultimately about the relationship between myself and the earth. I like the material to speak of its origins in the earth and look for ways to express this. Techniques for me are a means to an end, and over the years I have worked with numerous techniques, from coil building and slab techniques to slip casting and press moulding. For surfaces I use whatever

seems to suit the work and what will bring it to expression, including slips, underglazes, terra sigillatas, glazes of various sorts, low-fire salt, black fire and, currently, patinated bronze coatings. I don't always work with the human figure, but it periodically appears in my work. This is because my work is not concerned with the figure as such but rather with issues that affect us as we interact with a fragile and vulnerable planet.'

Varda Yatom [Israel]

I try to create a language that can present as truthfully as possible the questions and conflicts and situations that bother me … a language that can bridge the distance between the rational and the irrational, between the visible and the invisible, between order and disorder, between the aesthetic and the non-aesthetic, between the process and the finished product … a language that can reach between the limits that differentiate things, ideas and experiences, to define them distinctly, to delineate them sharply and to imbue them with force.

Equilibrium. *1996. Earthenware, gum, metal; each 60–70cm × 45cm × 50cm, part of an installation. Avraham Hai*

In coming to the extraordinary sculpture of Vada Yatom we are at once touched by the force of her profoundly personal work. As visual witnesses to her complex forms we are compelled, through her expressive images, to attempt to understand and to explore the thoughts and feelings that arise and propel us further into infinite enigmas of the human condition. Her unanswerable questions become our own and we are left to wander in her world of images and are made to feel uncomfortable by them. These composed pieces, sometimes in groups and sometimes solitary, are expressive of many internal struggles; some of which we may articulate as ambivalences, painful contradictions, indignities, unanswerable questions, fears.

Hers are heart-rending figures in desperate plight, conveyed through huddling, squatting, the curled up, the heaving of burdens. Her sad creatures in foetal positions appear to be waiting to be born (but into what kind of world?). Her *Transition* figures could either be sinking down into the grave or in thrall to some heavily political oppression and trying in vain to rise from under it. Her bound and squatting figures, although grouped together, are isolated. Some have heads which are gas masks, some try to carry others, many are helpless. The means of escape are often there, but the ways out are also death traps: her clay boats have holes in them, her torsos have no heads to think for themselves, their burdens are filled with useless impedimenta.

Yatom's sculptures are always irreverently juxtaposed. Her clay-built images may be constructed from parts of the human form integrated with found and familiar everyday objects such as shoes, boots, boats, knapsacks, sheep and even swimming pools, and all are imprinted with the anguish and the substance of her inquiry which seems endless. To make them, Yatom uses a ready-made grogged clay and works partly by coiling, partly from plaster and sand moulds, and partly from slabs. The individual components are joined at the leather-hard stage. Colouring oxides, stains and barium glazes may be added to the pieces both before and after a bisque firing. Usually these are washed down to expose areas of the clay beneath. The body surfaces are densely matt and dry. Human warmth and blood seem to be nowhere in evidence. The surface appears squeezed dry, desiccated into an insect husk. And all her clay images have minimum colorants – dry purples, cracked blacks, desert sand colours from archaeological digs, dried mummy shades. There is an urgency that comes from the unfinished shapes and dynamic movement in the material that does not seem to find a resting place or an easy conclusion. And it is through the power of her focus, of bringing into

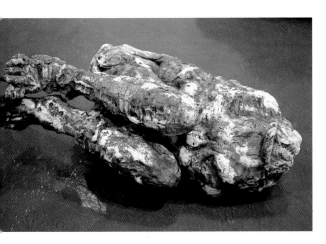

Embryos. *1993–95. Earthenware, barium glaze; 45.5cm × 70cm × 40cm, part of an installation.*

awareness through these forms and images of her own internal and eternal dialogue, that the work holds for us a well of possibilities.

This artist has earned a steady climb towards international recognition. Her work crosses into all cultures and dissolves all boundaries. Living as she does at the edge and in the vortex of intense historic conflicts, her sources are political, social, psychological and archaeological. Her own life manifests these cross-roads.

'I was born in Holon, Israel, second in the family of four daughters. My parents arrived in Palestine before the Second World War; most of our family left behind were killed by the Nazis in the Holocaust. When I turned eighteen years old and had finished high school, I moved to Kibbutz Sasa. It was there that I, a member of a youth group, devoted and dedicated myself to creating a working and living Zionist community. I served in the Army and I have lived and worked here, in Sasa, ever since. It is a commune of 200 members at this time and often with a daily population of 600 people. In addition to the members there are the children living here and then those coming daily to attend our schools from neighbouring towns and villages, young adults who may be soldiers or volunteer workers, and then there are visitors and guests. We are in the north of Israel in Galilee on a mountain near the Lebanese border. I have lived here with my family, my husband and five sons for thirty-six years.

'Most important to me in the beginning years of my life as a commune member was to be an educator, not to be confused with "teacher". The substance of this work was grounded in the ideology of the community. It was to be available 24 hours a day for children, guiding them in the way of life of this particular

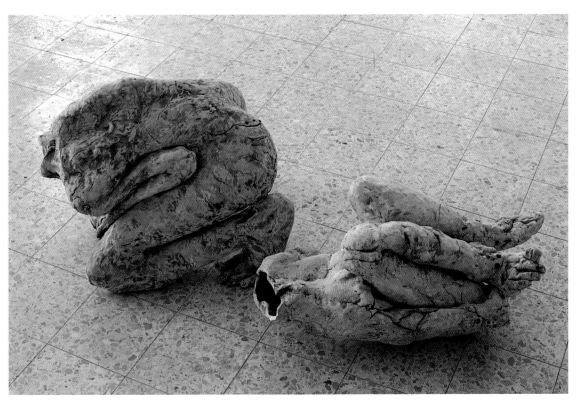

The Diver *and* Embryo. *1992–93; diver: 50cm × 55cm × 40cm; embryo: 50cm × 70cm × 40cm. Howard Smithline*

Transition. *1967.*
Earthenware, part of
an installation; 50cm
× 120cm × 20cm.
Avraham Hai

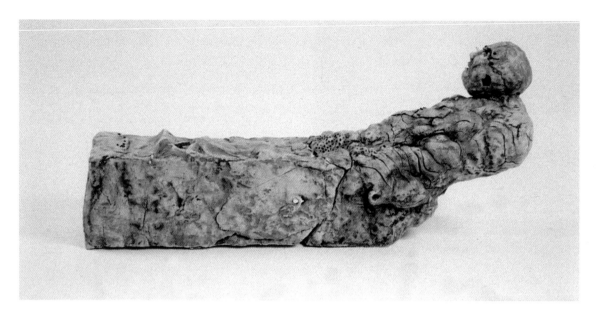

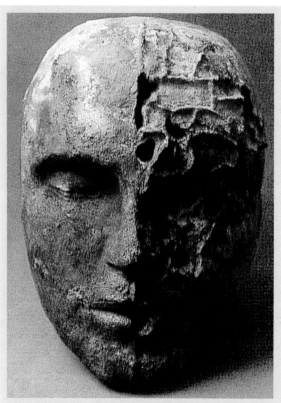
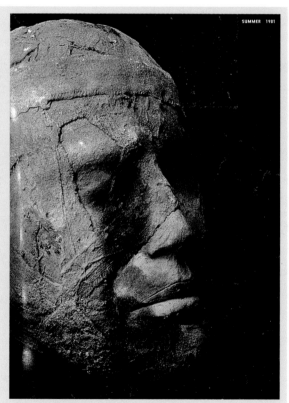

INFLUENCE

Daniel Rhodes, Two Heads. 1981. Stoneware; 18in.

Rhodes (1911–89) was educated at Alfred University and taught there for many years, as well as writing several books on ceramics. He said in 1981: 'I find it very difficult to just force my will on a piece of clay and make "something" out of it. In fact, the whole business of making "art" has become impossibly difficult; a problem without solution. So I try to tap into my own feelings as much as possible and avoid too much conceptualizing. It works better if I don't pursue any objectives too directly but rather key into what is going on with the process under way. When things go well, I seem to be finding things rather than making them. They become not so much conscious creations as evidence of a whole web of things, actions, materials, hunches, the voice of tools and the workings of the fire.' (Ceramics Monthly)

kibbutz including all aspects of living. This inspired work and Zionist ideology of the kibbutz consumed my mind and my life. What evolved over the years for me was the conflict between this devotion and the growing passion that drove me to make sculpture.

'I was sent early on by the kibbutz to Oranim Seminar and to Haifa University where I earned a degree and brought my skills as an art teacher back to the kibbutz. However, by 1987, this conflict grew stronger and I found myself at Alfred University, in New York, for two years, in the graduate department of Ceramic Sculpture. At last I experienced, for the first time, the possibility of focusing without distraction; here I found new ways of working and using unknown materials.

'Among the people who influenced my way of seeing and thinking was my teacher Tony Hepburn, the drawings of Giacometti, the sculptures of Brancusi – and I love *The Head* by Daniel Rhodes. Also, Henry Moore's sculpture taught me about mass, energy and texture. I also admire, because of their dialogue with their materials, Joseph Beuys, Eva Hesse, Tony Cragg, Robert Long, David Nash and the paintings of Georges Baselitz. Sources of inspiration for my work have come from the gathering of archaeological shards, so important in our lives here in Israel as we continue to discover layers of history. I am both a part of that ancient history and at the same time fascinated by how these shards are pieced together re-creating that history.

'Like the language that man creates and re-creates, we are made of diverse elements. As the Bible says: from dust (the earth) you came and to dust you will return. Man's material being is of this earth and of the clay in the earth. One of the mysteries and then the question that repeats itself in my mind, in my work, is how and when material transcends itself and can take on luminous meaning, moving from the banal to the spiritual.'

Sabine Heller
[Germany]

I seek to find a form for the pain, joy, loneliness, love, longing, fear which I feel inside myself. It is a long road, since I must search and recognize something that I can neither explain nor describe, only feel.

Sibenole Figur. *1999. Brick clay; 130cm × 150cm. Bernd Kuhnert*

Sabine Heller is a very gifted German artist who has invented and developed a particular method of work which uses unfired, damp, commercial ceramic construction blocks, though, as she herself says, 'A lot of words to describe something very simple and everyday. Many houses in Germany are built with such fired blocks. They have numerous air compartments, either round or square, going from top to bottom. These serve normally as insulation and weight reduction and also add stability.'

In fact, Heller's work has acquired a weightiness about it from these sturdy blocks which automatically endow her sculpture with a kind of architectural strength that could make them serve equally well as carved caryatids supporting the corner posts of great buildings. They are large pieces which emit a patient 'waiting' as they confront you. They behave rather like sentinels or guardians of a building – the awareness of the squareness of the blocks often remaining intact, as in the toes on *Sibenole Figur*. You might also see them holding up the central beams in a wooden Dogon dwelling, because they look as if they have been carved from the kind of rough, tough wood that could carry weight and not collapse. And when we find that Heller was apprenticed to a master carpenter from 1972 to 1974 we realize that the techniques of wood carving

*A*sleep at Noon. *1994. Four figures in terracotta; 200cm × 77cm × 177cm and 210cm. Bernd Kuhnert*

seem to have influenced her style of clay work. Her pieces have a static, daunting presence, and they throw out an atmosphere of the eternal – one that has implications of ancient civilizations – dark ages, totem poles, boundary figures – such is their feeling of density and permanence. Most are imbued with an inner angst that seems to burst through the crevasses of the rough surface, which itself may be accentuated with colouring to heighten the emotion. When you encounter one of Heller's pieces the force is quite strong enough; when you encounter a line or group of them they can almost be overwhelming. They have a tremendous intimate vulnerability that speaks loudly of our inner condition.

Born in 1956, Sabine Heller completed her schooling in 1976, then studied at the Art School in Berlin-Weissensee, graduating in 1981. Since that time she had been quietly managing her own studio in Sieversdorf (a small town east of Berlin), when, by chance, she suddenly stumbled upon the medium which changed the direction of her work. The artist came by her new method at a ceramic symposium in Römhild in 1987. She describes how 'Karl Fulle, a well-known German ceramicist, surprised us by bringing in large piles of these building blocks, gently urging us to experiment with them. Without Karl's push it probably would never have occurred to me to consider using such blocks for my figures. But from then on, however, I would use nothing else.'

The artist has, quite naturally, chosen these building blocks as her most important source

*K*opf O. T. *1999. Brick clay; 35cm. Bernd Kuhnert*

of influence because they have indeed been the greatest inspiration in her career so far. She has found, too, that these blocks hold other important qualities that have become central to her sculpture. She tells us why:

In their damp, unfired state I can build large figures just by piling the blocks one on top of the other without worrying about stability. They can be easily cut and added to at will. I leave no hollow space in the middle of the piece, so they hold the moisture extremely well. Time is therefore not a problem and I can work on a piece as long as I wish. Before the figures are fired they are taken apart, block by block. These are then fired in a reducing atmosphere by open fire, either wood or gas. I prefer the former but it is not always possible. I use slips and oxides for colour. The temperature depends on the type of material used but it is generally around 1,100°C. After firing the blocks are put back together with cement in the traditional masonry manner. No longer do I have to worry about the thickness of the clay walls or the size of the figure. And since the pieces are fired individually, there is also no problem getting them into the kiln.

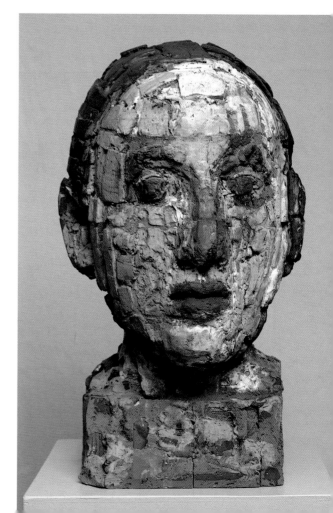

This extraordinary kind of deconstruction that occurs in Heller's work is a wonderful practical solution to filling a kiln or moving a sculpture once it has been fired. And the reconstruction turns her into a builder rather like the Egyptians forming their pyramids with each stone having a number and location on it in red ochre giving directions where exactly it was to go. The reduction firing reveals, too, a dark inner substance that adds to its density. And the inherent air compartments in the blocks conceal secrets and cavities like those in the centre of a pyramid, which serve to contain the artist's inner thoughts and feelings, as she describes:

'The air compartments are of greatest importance to my work, since they give the blocks an inner structure. When I cut away parts of the blocks, segments of these vertical compartments become visible. Since it is not possible to foresee their exact position, especially those at the centre of the piece, there is always an element of chance and even surprise involved, which I welcome. These spaces then become part of the outer skin, making the surface rough and uneven. This is perhaps the most characteristic element of my work. At the beginning I was careful to control how much of this "inner structure" I allowed to be seen. Now I let it lead me, using it as much as possible.

'The centre of my artistic interest is the human body. Perhaps one reason for this preoccupation is that I don't like to plan my pieces beforehand. I prefer to observe and feel, seeking the core and perhaps finding something that is not visible at the outset. I often use a model, a person who sits or stands quietly opposite me and whom I can study. Generally they are persons close to me, making it possible to observe them over a long period of time, not only during the short hours as a model. When I create a head, I usually have a definite person in mind. The goal is not to "copy life" but to bring out the special, singular qualities of the individual: the large eyes of my daughter, for example, set far apart; her beautiful white skin; the special line of her forehead; the green light which shines through the trees on to her face. These moments inspire me and lead me to the form I am seeking. Thus I can use green colour on the white face or red can glow through the white surface, as coals under the ashes. Through colour I can accentuate certain parts, which the form cannot. In many cases I need a second figure to complement the first. Not until both are

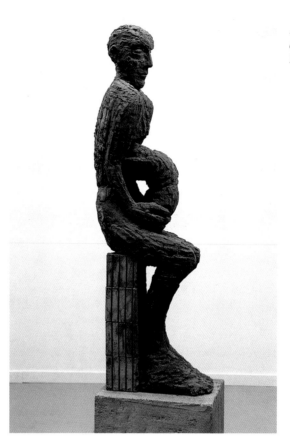

Angst. *1993. Brick clay; 120cm. Bernd Kuhnert*

finished do I have a feeling of completion. This is especially true when I deal with the woman–child theme, which is predominant in my work. I use the word "woman" instead of "mother" for a reason. I feel the theme is narrowed too much when called "Mother–Child". There would be just as much justification to speak of a "Man–Child" relationship.

'My *Woman–Child* groups have their origin within myself. Being a woman, my approach is admittedly one-sided but it is the way I must work. Generally the older figure either kneels or sits, while the child stands. This brings them closer together and makes the form more compact. They are to be simultaneously both large and small. The woman seldom protects the child with her arms, even when they are afraid. Both show their own fear. To show closeness there must be distance between them, although they are often cut from one block. Gestures have no place in my work. The space surrounding the group must create the relationship between the two figures and it is consequently as important as the figures themselves. The most important goal of my work is to endow my figures with a soul.'

Carmen Dionyse [Belgium]

What really counts is being human, that is, life and death, and the great myths of mankind in between. The mastery of technique brings about an original symbiosis of matter (clay), spirit and culture. The talent was present at birth, and the will is to survive.

For the newcomer to her work, Carmen Dionyse's human forms in clay look at first glance pretty, calm, beautiful. They are modelled with extreme care and sensitivity and have a purity about them. They appear to have been drawn up from the earth, either bodiless or on long, neck-like structures. They are formed from many different sorts of grogged clay: earthenware (red, white or black), stoneware and mixtures of stoneware with earthenware or a soft porcelain. But it is as if the artist has involved every element except water in their making. Their skin is dry and bark-like, have a cracklure of crusty, husk-like fissures – more like the surface of the earth than human tissue. They seem to have bubbled up from a volcanic area like a blister, then set, fossilized into stasis. Their surfaces are usually matt and are glazed with granulated, often crystallized components: lead or barium carbonate, whiting, lithium, chromium lead. Then fired to mature between 1,280°C and 900°C in an electric kiln.

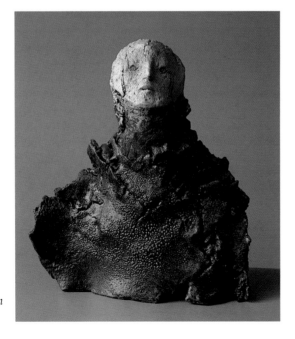

Beholder. 1996–99; 32cm × 15cm × 29cm. William Wauters

But if you approach more closely and observe more deeply, you are met with a strange, highly personal work that seems to be shouting out – but the mouths are mostly closed and only a mere breath of air could penetrate through. And the eyes … the artist has made openings in the shape of eyes, but instead of looking at you they gaze right through you. More usually they are closed and introspective. They have a weird reticence about them, a sinking into the self. The colours, too, are of a volcanic nature, very brittle, ash-like, fragile colours, like some transitory rainbow or those metallic, fleeting changes of oil reflected in a puddle. Is her work to do with transformation? There are titles like *Metamorphosis* and *Daphne*, and Carmen Dionyse knows Ovid's *Metamorphoses* well.

Their expressions are fascinating. They are definitely not asleep, but they could be in some kind of dream trance. The many prophets, seers and sibyls Dionyse has sculpted have their mouths closed or they come obscured by a veil of glaze or are covered over with patches of clay, and you know that you could watch forever, waiting for them to speak their oracle or describe their vision. But there is something more disturbing still. There is a quietness, a singularity, an unwillingness about them, as though not only are they unable to speak but they do not even want to. Only a few of her pieces smile, such as *Maiden Mask*, *Summer Nymph* and *Eos*; but the smiles are inward, tentative, unrealized and her *Sunset Glow* speaks of the setting sun not the rising one. Is her work about vulnerability and disappointment? The forms, too, are always potential. Noses, cheeks and breasts are only in bud, pressing out from underneath. And the way they are made – the working is all done from the interior. Each piece is slab-built and embossed, pinched and pushed from the inside out. Are they filled with fleeting memories? Perhaps they guard against the ravages of past or future fate?

The colouring, too, suddenly looks like poppy colours, opium-induced; drugged colours. Their fleshy substance is thin, reminding you of leaves that have been left in a pond so that only the skeletal veining remains. The clay skin barely covers their craniums. Some are like head masks, some skull-like. Are they about death, acting as symbols of our mortality? Their mouths are sealed like the mouths of a tomb. Many are named, *Blue Skull*, *Crackled Skull*, *Skull Mask*, or have chthonic titles: *Hades*, *Osiris*,

Orpheus, Eurydice. Carmen has studied the magical and mythical, death rites and cults from everywhere. She collects masks and skulls.

Suddenly you see what it is. Their cries are internal. Whatever it is, is trapped inside. All her pieces are hollow. They act as containers for something. They are definitely not empty. Immediately they become threatening. Something is shut inside, something we all fear. An unhappy spirit is locked up like a mummy in a tomb? Like a terrible spider trapped beneath an upturned vessel. They make us feel uncomfortable because we are unable to broach them or feel part of them. They shut us out of their self-absorbed centres of loneliness and suffering.

Look for a final time in a different way and they are centres of internal energy, swathed in clay, but with something ultimately quiet within. They never look eroded by time or weathered on the outside. They have layers of resistance, glazed over and over again, multi-fired in the kiln. They are sheathed in the noble colours: sheens of gold, silver, ruby, purple – colours that can retaliate. They are precious reliquaries and there is probably light within, shining like a centralized beacon. Carmen is religious. Many of her pieces have Bible themes of devout and holy followers. Some have titles such as *Lazarus* and *Resurrection*. If Carmen believes in the afterlife, then there has to be an inner state, a numinous, ever-glowing centre. Then you realize that their greatness is that they encompass all of these things: they are about human existence, living as well as dying, and about the metamorphosis through life towards death, and after death, the resurrection. They are never questioning nor inquisitive, it is we who have to ask questions of them. They are about her.

Dionyse was born in 1921 in Ghent. But from the start she was a very unhappy child 'because', she says, 'from the moment I was born my mother declared that she did not want me. This leaves wounds in a child's soul.' The reasons are long and complex, but they explain a great deal about the content of her work and the lifelong search to release and heal herself from the pain in every piece she creates. She is building up protection against the world. She found herself being brought up in a house surrounded by books (the family firm were book distributors); it was from these that she explored mythology. 'It was where', she relates, 'as a lonely child I discovered the world for myself and I felt fulfilment in creating my own

secret universe.' But it was the persecuted figures from mythology, particularly the women – those who were punished without deserving it – that touched her. 'I am on the side of the weak', she insists, 'and not of the heroes – in the general case, heroes do everything by force.'

And there were other ways to fill this universe. From an early age Dionyse engrossed herself in 'drawing, cutting, carving and glueing, collecting artefacts, bones and natural objects.' Later, at the Royal Academy of Fine Arts in Ghent, she took courses in 'drawing, painting, sketching, etching and applied arts – and ceramics with first-class Honours.' At last, this artist had found a way to begin to heal the pain by meeting it headlong. 'The encounter with ceramics', she explains, 'was a liberating epiphany. I discovered that I neither had to follow the prescribed ways nor to emulate my predecessors. I proved to be able to create freely, in

Terra. 1994; 220cm × 40cm. William Wauters

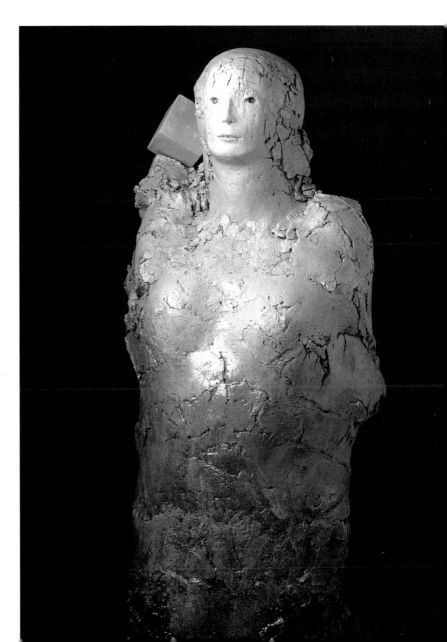

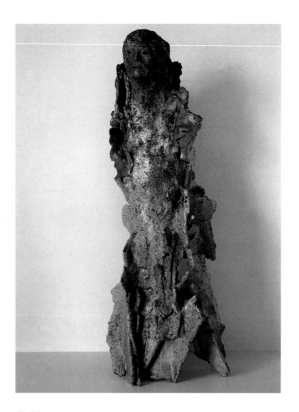

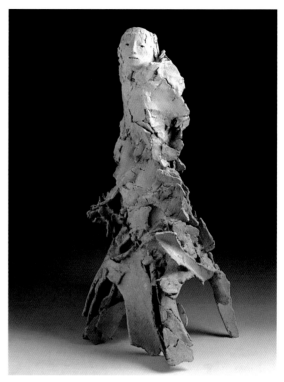

Holy Man. *1999; 63cm × 26cm × 21cm.*
Bollaert and Moortgat

Wind. *1997; 88cm × 45cm × 33cm. Bollaert*
and Moortgat

my own way, within my own world.' This is also the advice that she would give to other artists, that 'the artist should avoid working in function of others. Of course, a commissioned work requires a dialogue with the patron, but following your own impulse, while mastering the technique, is what counts.'

In 1996 Dionyse took on the challenge of entering an exhibition called 'Movement'. Suddenly Dionyse's figure left their entrapment. Body parts – or attire – were added, built from semi-dry slabs, joined and welded with slips. She had allowed the outside to enter in, or the inside had been let out. However, these body parts look as though they are made from pieces of fractured snowflake and need to melt a little more to move. You feel that the 'movement' is only just beginning and that some of these figure are still tottering a little. I still prefer the enclosed pieces, but symbolically Carmen is liberated and that is the important thing. What is important, too, is that she finds herself today in the honoured and revered position of having influenced many artists during the course of the second half of the twentieth century. Her work is still extraordinarily individual (the only other

artist whose clay work hers vaguely resembles is Paul Gauguin).

But what about Carmen Dionyse today? She still lives in Ghent, but sadly without her husband and partner, the painter Fons De Vogelaere, who died suddenly in 1998. She will be eighty when this book is published and says, 'I try to survive, working very hard, but in my work there is solitariness more than ever, and waiting for…?' It is certainly a privilege to be allowed to enter her private world, which she is willing to share.

> My sculptures are my children [she has said] and in creating my figures I intend to interpret my experience of life, to search for a sense of security, to avoid being hurt, to find happiness in solitude, to understand more fully the many signs that life offers. In this sense my work is my universe. My universe, which is both intimate and worldly, is also underpinned by mythological and religious meanings. I cherish my amazement that the purpose of a work of art is understood, even without any explanation: is it the eyes, or is it the silence that emanates from them?

⑧ The Poets

The artists in this chapter fall into three groups of three. All produce monumental work to draw the spectator into a poetic awareness of space and mass, of spirit and form. Most believe in – or hope for – a certainty, an everlasting explanation for life. Both *Claire Curneen* and Carmen Dionyse make pieces that, as Claire Curneen puts it, 'serve as a vessel for the physical and spiritual being'. *John Maltby* explores the mystery of life, and his work is, he says, 'a constant reinterpretation of my surroundings'. *Xavier Toubes*, too, searches for meanings that explain reality. All distil content to express poetic ideas about the human condition.

The next three sculptors are concerned with structures in space, particularly in the landscape (and could include Stephen De Staebler and Antony Gormley, for example). *Imre Schrammel* encloses space with poetic sensitivity, while continually bumping against what he terms 'the miracle of the constructing-from-the-inside principal' and thus achieves a spiritual/physical equilibrium with the surrounding environment. *Mo Jupp*'s sculptures, too, merge into the landscape, adding pinpoints of form and colour. *Gwen Heeney* does the opposite; she invades space with her images of exuberance that make bold markers in the landscape.

The final three sculptors play with abstract gestures of poetic engineering which are compact and full of compressed energy. *Anthony Caro*'s statements are grounded in mythology, *Charles Bound*'s in philosophy and *Sándor Kecskeméti*'s in his own style of sacral wizardry.

The Spiritual Poets

Claire Curneen [Ireland/Wales]

My work with the figure is grounded in the exploration of the human condition, focusing on aspects of the religious and the ceremonial. With semi-autobiographical references, the figure serves as a vessel for the physical and the spiritual being.

Claire Curneen's figures are made from a pearly matt porcelain. You notice immediately the expressive hands, which are elongated and often tautly stretched. They carry a great deal of the sculpture's emotion as does the stance of the figures, which is rather oblong in shape, making us unsure whether the representation is of a man or a woman, and thus speaking for both sexes. The fact that the figures are devoid of hair makes them appear even more naked – almost newly-born – and the porcelain whiteness adds to this effect, as well as contributing a spiritual luminosity.

When seen singly they appear alone and exceptionally vulnerable – even helpless, looking at you from appealing, rather shy and self-conscious faces. When several are seen together an altogether different atmosphere is generated. Between them the figures build a strong current of enclosing group identity. Their similarity adds a quality of graceful complicity. They are usually lined up side by side as if posing for a school photograph or like envoys sent out from our planet to another world. Because the lower parts of the body are larger than the heads and the 'breasts' on the thorax area are pushed

Tools of the Trade.
1999. Porcelain; 58cm
× 31cm × 17cm.

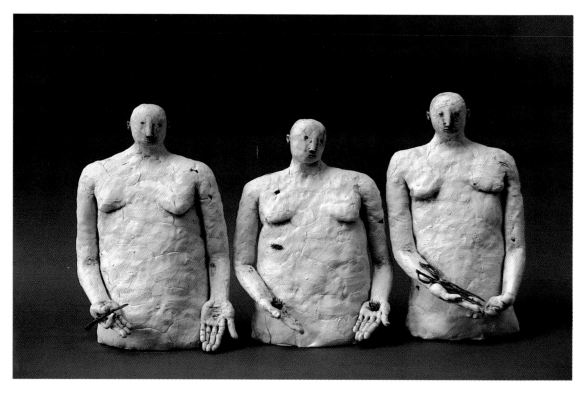

higher and seem smaller in proportion, you get a kind of reversal of the effect created by figures placed high up on ceiling cornices in stately homes, where the top parts are made deliberately larger so as to appear in proportion. As we look at Curneen's figures the attenuated tops go into perspective away from us, giving them a heavenwards stretch. But the feet are firmly fixed earthwards, and the elongated larger-than-life hands symbolize what we can do on earth with our lives in justification of our existence. Newer work has the addition of small, sharp protruberances which Curneen calls 'prickles'. These 'serve as a reminder of the physical nature of the body'. They are clothed in a dark, honey-coloured glaze which makes the figures much heavier and less sensitive in shape than the earlier work, and I find them more strange and disturbing than moving.

Claire Curneen is a young sculptor who is a natural at working with clay. She adds fine, skin-like layers which build up patches of sensitivity that, intentionally or not, resemble veins and sinews. The patches could easily be static, but are not: they have freshness and fluidity – something you cannot be taught but which is inherent in her style. Claire, herself, likes what Amanda Fielding says about her and the work – 'Claire Curneen's preoccupation with human existence, alienation and transience of life is starkly expressed with elements of autobiography, narcissism and obsession.' Of herself she says:

> My figures give a hint, or a suggestion of a story or a happening. Their nakedness is essential as any form of outward social appearance would be a distraction from the essence. I work with porcelain, constructing the figure from thin slivers of clay. Gaps appear in the form, enhancing their fragility, allowing the viewer a glimpse of the dark interior. The significant focus points are the head and the hands, the latter sometimes containing prickles. I want

Tools of the Trade. *Detail.*

the hands to suggest different things. These, plus the head and the feet, are the areas where most of my time is consumed, modelling with dentist's tools.

My figures are hand-built using Potclays HF porcelain, and from a hand-size piece of this I begin with the base, hollowing it out and building a cross wall inside the base so that it does not collapse and will support the figure. The feet are added to the base, the modelling is left until the whole figure is constructed. From the feet upwards I construct the body from my thin clay slivers which are pinched together without any slip. No structure or supports are needed on the interior, but long pieces of wood (about 30cm) are used outside the body almost like scaffolding to support the figure when making it and to prevent its falling over. The completed piece is put into the kiln damp, because there is less chance of the figure's snapping at the ankles, the area which is most vulnerable before it has been fired. The ankles are the narrowest part of the figure and carry most of the weight, so when it is put into the kiln it must lean against the kiln wall – another support.

The piece is fired to 1,000°C, and then washes of stains are applied to the head, hands and feet, with clear glaze applied in tiny areas. The piece is then refired to 1,200°C, again leaning the piece against the kiln wall.

Curneen's kiln and studio are in Wales, where she is now settled and lives, having completed her art training there with a Master's degree in Ceramics at the Cardiff Institute of Higher Education. But she was born, in 1968, in Tralee, County Kerry in Ireland. From 1986 she studied ceramics at the Crawford College of Art and Design, then did a postgraduate Diploma in Applied Arts at the University of Ulster in Belfast. Although she has now left Ireland, Curneen was brought up in a strong Catholic environment where the church was central to daily life. Therefore it is not out of context that she has chosen *The Baptism of Christ* as her influence picture. This is pinned to the artist's studio wall where it is a constant reminder of what it implies, and it is her touchstone to the content of her work. She says of it:

> Every few months I make a trip to London and stand in front of the painting *The Baptism of Christ* by Piero della Francesca in the National Gallery. It is a moment of great excitement.

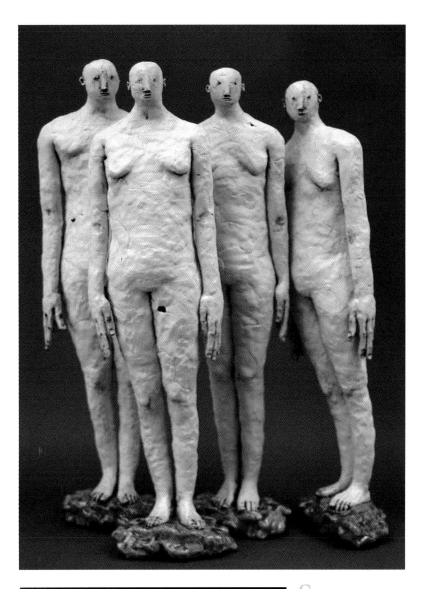

Standing Figures. *1999. Porcelain; 63cm × 15cm × 12cm.*

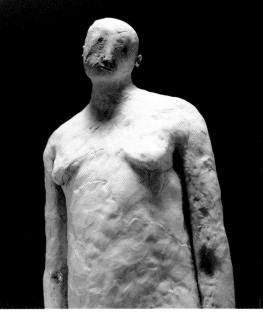

Standing Figure. *2000. Porcelain; detail, 63cm × 15cm × 12cm.*

The space I occupy when viewing the painting is usually, on a good day, in the centre of the gallery and facing the centre of the painting, the Christ figure. This positioning of my body is very satisfying and allows me to understand the perspective of the painting. I wander through the painting with ease and observe the monumental event. With each visit I find new worlds to explore. At the moment I am curious about the activity behind the baptism, the figure disrobing revealing his undergarment. I want to know what he is doing, taking off or putting on his garments? Marilyn Aaronberg Lavin, a student of Renaissance culture, states in her book *Piero della Francesca* (Thames & Hudson, 1992, p.64), 'His static pose is rather meaningfully ambiguous.' He is 'a perfect human specimen, permanently held in time and space, he is a representative of mankind, perpetually prepared to be born into divine life.' The main focus of the painting is Christ himself. I am drawn to his slightly flushed face, his strong body and white porcelain skin. He is very human. His body weight shifts on to his right leg, conveying a sense of ease, maybe in preparation for the sacrifice that lies ahead. The three angels to the left of the painting are not so at ease.

They communicate through hand gesture rather than direct eye contact. One gestures in the direction of Christ, almost hushing everyone to be silent, another engages the spectator with his very serious eyes, informing us of the monumental scale of the event. Two of them clasp each other's hands, suggesting their concern. John the Baptist carefully attends Christ. His ungainly stance almost contradicts his control and accuracy in pouring the water over Christ's head. The gentle trickle of water is mirrored by Christ's hands and his barely touching fingertips. The painting begins and ends here. The drama is charged with atmosphere and at the same time the world seems to stand still.

John Maltby [England]

The particular 'Englishness of English Art' is a very distinctive quality found profoundly in its arts; I have tried to return to this ever-nurturing natural inspiration, to sea and sky, rocks, churches, birds and flowers. These subjects, close and familiar to me, are a leitmotif running through our creative tradition; our experience of them shapes our thoughts and attitudes and they are always present in our work, sometimes more clearly stated than at other times, but always inextricably integral with the objects that we make.

John Maltby's figures in clay are like little spells. They work because they are familiar to us, created in a personal language that we can all understand. They speak direct to our hearts. His angels bring faith and comfort – and a touch of glory. His work comes uncluttered and with a child's ease and purity of style. They have a charm about them like the kings and queens of that early carved chess set from Lewes in the British Museum. We feel that we have been brought up with his subject matter as part of our English heritage. It is what you might find nearby: local, parochial. He mostly exhibits his work nearby: in the United Kingdom, Germany and the rest of Europe. And of their content? Like religious icons, they have the same power to touch us spiritually. They belong to the whole church tradition of early stone carvings, though Maltby says that it is 'their contemporary relevance with a link to the past which is most important'. Their high kiln-firing gives them a stone-like permanence so that they appear to

*I*NFLUENCE
Piero della Francesca,
The Baptism of
Christ. *C. 1460.*
Courtesy of The
National Gallery,
London

have been around for a long time. Their natural-looking patination allows them to live easily side by side with wood, stone and iron; and with their ecclesiastical connotations they would not look out of place in a church today. The compositions are small-scale; often like little gatherings or nativity scenes you might find in a niche inside a Norman church. Their compact neatness reminds you, too, of a model for a theatre set, though Maltby's artistic language is rather more suitable for one of the mystery plays, than for the London West End. There is mystery to his dramas, but there are no secrets that cannot be shared. They seem part of our past, yet they have a contemporary relevance which we can easily recognize and relate to.

Maltby's technique also makes his work accessible to everyone, because it is warm and friendly, even domestic. He gets soft, biscuity tones, firing to 1,200°C (all the artist's work is reduced in a propane kiln which gives them that particular toasted buff appearance). This is also 'high enough to make a strong object which can be practically handled and packed and posted, etc.', the artist says. 'This relatively high firing temperature also means that colours are limited in range, but we live in a country of

mists and soft colours', he reminds us. Bright reds, however, can be applied in an extra firing at a lower temperature (750°C).

It is not easy to make something that is a cross between what a child might produce and a stone-carved effigy in a Norman church and get it right. This naiveté is difficult to achieve, but the artist succeeds. This is because he approaches his pieces in the right frame of mind: he makes his sculpture with love, care and a consideration for the material. Simplification is Maltby's basic calligraphy and style. 'My methods of making are as close to the absolutely basic as I can dare to make them', he states. In other words, it is direct and unfussed. No glaze is used, for example, as it makes form complex, but colours are introduced with coloured clays, which are painted on. And his influences? 'My hero is Paul Klee ... but apart from him, I have tried to use the English tradition of painting and sculpture as a springboard for my work', he says, 'and as a ceramic metaphor for my life ... The continual renewal of vitality in my work is dependent not on repetition but on a constant reinterpretation of my surroundings.'

John Maltby was born on the east coast of England and now lives on the south-west

Figures and a Ruin. *1999. Reduced stoneware 260mm × 180mm.*

Mozart's House. *1999. Reduced stoneware; 250mm × 170mm.*

King and Queen: Tomb. *1998. Reduced stoneware; 260mm × 260mm.*

peninsula. He received his art training from the Leicester College of Art (1994–96), and from 1958 to 1959 at Goldsmiths College in London. From 1962 to 1964 he worked with David Leach (which was where he met Bernard Leach whom he found 'magnetic'). He also taught for a little while. But in 1996 he became ill with a heart complaint that needed surgery. Afterwards he turned to making small objects and sculpture. He could no longer wedge the clay and so took the material direct from the bag. This new sculptural work had, as he put it:

'Some of that familiarity and dexterity that I considered so important in my ceramics, but they had an immediacy of reference and a new variety of idea which was more *intense* than previously. It was now the flexibility of the mind that mattered: what you put in is always very different from what you get out. Nowadays, the work I make depends primarily on the idea, upon some of those fluid skills learned originally in the workshop, and of a reasonable efficiency. Looking back I suppose the challenge is no less now that it was nearly forty years ago.

'When I was a student I was happy to be able to make things: I was excited by the stylistic influences of those around me. I had easy access

to museums and to all manner of illustrations of traditional and contemporary art. I suppose both Picasso and Henry Moore were my most influential teachers: all of life is to be found in Picasso, and Moore taught a formal creativity (inspired by the natural world) of great dignity and Englishness. I knew what I wanted to do as my life's work: I wanted to be some kind of artist and to live by the work that I was to make. I was drawn towards "craft" largely as a result of meeting Bernard Leach, who, at St Ives in Cornwall, ran a small pottery making functional ware which had much of his own stamp on it (both in the design of the pots and the spirit of the workshop) and also some pots which were personal and unique to his somewhat eccentric character. He showed me work by Hamada and Kenzan and I was intoxicated by both. Bernard Leach's philosophy, though largely based on his experiences in Japan, had yet a strong resonance for me in my own desires to survive solely by my work, yet to create an ambience in which flexibility and originality might not be stifled.

'I worked in such an environment for some years. Like Bernard Leach, I made functional (that is, repetitive) pieces and also individual work; my economic existence depended on such a balance. But ultimately I found that

A̸ncient Knight. *1998. Reduced stoneware; 300mm × 120mm.*

"repetitive" work (though the act of repetition can liberate a distinctive kind of relaxed beauty) was eventually to prove monotonous and boring. (We may admire the beauty of a Korean farmer's sixteenth-century tea bowl, but would a twentieth-century, educated, somewhat sophisticated potter wish to emulate his lifestyle?)

'I became convinced that most ceramics *should* be about function and that craft (which was originally driven by use) and that contemporary art (which is largely motivated by expression of self) should be inevitably dissimilar. There is much beauty in craft: it can be wonderfully uplifting and it is this which originally drew me towards it, but it is ultimately limited in expressive potential by this tie to function; it cannot comfortably – and nor should it try – to be a vehicle for emotions regarding those issues of life for which we have art – painting, music, poetry, sculpture, dance – art that appeals to the more immediate senses and which can make us laugh and sing and cry. The present role of the artist is to try to pinpoint and then give substance to the mystery which is ourselves. To do this, it would be stupidly arrogant not to build on those great traditions of our culture which we inevitably inherit, yet it must be teased out

*I*NFLUENCE
Brian Ilsley, Wooden Construction.

John Maltby says: 'I'm not sure, but I believe I remember his saying that it was of a man swimming (floating?) in St Ives Bay, when a seagull settles on his chest.' (It could be the story of Alcyone and Ceyx of Greek mythology: Ceyx perished in a shipwreck. Alcyone saw his body and threw herself over the cliff edge in despair, but she was changed into a bird which skimmed over the water to sit on her beloved's chest; John Maltby says that Ilsley is very down-to-earth, so it is probably the former. JW)

in a meaningful and yet intuitive way which is pertinent to our contemporary world. The sculptures that I now make try to be concerned with this human condition; of course, the craft skills that I have acquired in the workshop are part of these objects, often their techniques are deceptively simple (which is as I would like it) but their "life" and their validity seem to reside in the way that they comment on the contemporary situation that is me.'

Xavier Toubes [Spain/USA]

For me to be an artist is a way to know how to be in the world.

Xavier Toubes – or Francisco Javier Toubes Vilariño, to give him his full name – was born in Corunna in Spain in 1947. He worked in an international bank in Spain and London until 1974. His big change of career came when he was at Goldsmiths College, part of the University of London, from 1974 to 1977 and afterwards went on to work in the Winchcombe Pottery in Gloucester. Then he returned to

Spain to spend a year at the Seminario de Estudios Ceramicos de Sargadelos. Between 1980 and 1983 Toubes was in New York and came away with a Master of Fine Arts degree from Alfred University.

This artist is a great enabler. He lectures widely and has taught at the University of North Carolina at Chapel Hill for ten years. At the moment he teaches at the School of Art Institute of Chicago. But perhaps his most important involvement has been to help in setting up the European Ceramics Work Centre in 's Hertogenbosch in the Netherlands, where he was the Artistic Director from its opening in 1991 until 1999. There hardly seems to have been time for him to do his own work, but this is so fused with his own existence that it has been an on-going procedure which he weaves in with his daily life as its events unfold from day to day. And it is a highly personal art that he finds at the end of the string; a Minotaur of work which has won him many prizes and awards.

Toubes makes clay heads using the particular material that suits him at the time. He creates in constant improvization on different pieces. His inspiration is the present. As he works, he progresses with what is inside his own head and its response to emotions and feelings. He works

Exquisite Nomads. 45cm × 42cm × 65cm each.

The artist's work is charged with much piled-up energy and he has a poet's compression of thought and form. In these sculpted heads the mouths are in perpetual oratory, talking of life and experience. The eyes are located high in the forehead, as if in a direct link with the mind and looking straight out from it. His heads look, feel and think and speak. Their outer surfaces are pitted with texture from the modelling done by a kind of pinch/coil method. Sometimes they are clothed in rich areas of colour or emblazoned in gold or silver lustre. Their form is organic and they use their own necks as their stands. At other times the artist makes pure, abstract statements pinched out of porcelain and almost drained of any colour. These are comments on the state of being and are in the shape of containers, figures or fragments. The scale of the artist's work is ambiguous – they could work as well both huge and tiny and sometimes the area between one feature and the next seems immense. Toubes says of his work:

> There are themes that I repeat, like the heads that often are dedications. When I make them it never occurs to me to think about tradition or the past. For me they are very much for

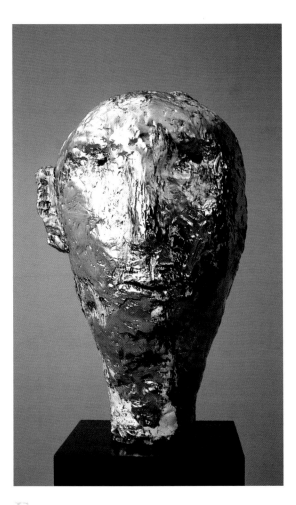

Enamorados de la Luna. *60cm × 57cm × 98cm.*

towards finding everlasting solutions, while destroying, changing and re-creating on the way. He describes this process thus:

> I work on a number of pieces at the same time, finishing a few in this way while others are broken or disappear gradually in the studio. Some pieces reappear later in other works with a new meaning. Often I fire the same piece a number of times or sandblast it to obtain more complex surfaces or transform the piece in such a way as to open new possibilities to continue the investigation. I work alone in the studio, better in the morning, quick, nervous, intense with attention even to errors and the unexpected. While working in the studio I don't trust too much what I 'know' and notes and sketches often are intermingled with words, long lists of words, that like a poem give precision to the task.

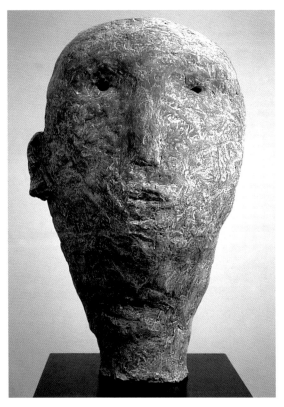

Namorados da Lua *(In Love with the Moon). 53cm × 50cm × 85cm.*

Lozas. *1999; 80in ×
35in × 76in.*

today; as a matter of fact, they begin as a
response to a particular event in 1983. They
are also proposals to investigate the possibility
to express complex and direct feelings today,
finding ways to bring emotion and engage-
ment to sculpture. The heads contain in them-
selves as much as they are containers that have
a physical as well as a mental interior. They are
looking, waiting with intention like anony-
mous poets. There is another series of works
that refer to the body and to the landscape
that frequently become the same thing. The
landscape is not only what my eyes see but
also the structures invisible to the eye, the
'fields' that the scientists tell me are funda-
mental in comprehending reality. The same
with the body. The interest is in what the eye
sees, also what is concealed, what I can imag-
ine. I want to make things with physical and
mental space that in spite of everything can
last.

Architects in the Landscape

Imre Schrammel [Hungary]

*He who forms a human out of clay puts into shape
the essence of life made of a living material – clay –
with the means of a poet.*

It is a privilege being able to invite such an
important and revered artist into the book.
Probably more than any other sculptor Imre
Schrammel believes in the inherent power of
the material of clay and in the responsibility of
creation or 'putting into shape the essence', as

he terms it. He is a man well-versed in magic and miracles, as his work shows. It is so physical that you can almost feel him clawing the clay out of the earth unrefined and squeezing it into fleshy shape with all the warmth and pathos of human existence. The markings of sensitivity where the sculptor has pressed and altered and coerced the clay into the image he wants are visible. In the finished piece is its beginning. The raw modelling needs nothing extra to enhance his original purpose.

Imre Schrammel sends us some philosophical thoughts:

'Man! Dust thou art and into dust shalt thou return.' Those who carefully examine this quotation from the Bible will surely see that there is a deep and mysterious relationship between the human body and clay. Science has only confirmed the Creation-belief expressed by mythology and specified and proved the structural identity of the macro- and the microworld. Today a ceramicist should know not only the past of his material – covered by the mist of mythology – but also the structure, quality and function of it; further he must know about the beginning of life.

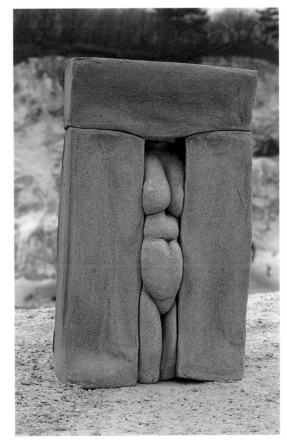

Gate. *Stoneware,
fired to 1,260°C;
1998; 48cm × 23cm ×
14cm.*

Schrammel was born in Szombathely in 1933. He studied at the Hungarian Academy of Applied Arts, graduating in 1957 from the Department of Ceramics. Then he went on to study and assist at Miklós Borsos's master classes. In 1958 he became the leader at the faculty of porcelain designers and in 1993 Rector at the Hungarian Academy of Arts. If you get the feeling that Schrammel could sculpt anything, you would be right. As well as the figures in clay shown here, he has made great murals up to 80sq.m in size. He can also design exquisite porcelain figurines (*see* page 2).

In 1997 Schrammel was commissioned to design a series of porcelain carnival figurines by the Herend Porcelain Manufactory. If his 'naked clay' sculpture is the miracle, then his costumed and sparklingly-coloured and refined porcelain figures are the magic. The contrast between these styles of work is extraordinary. In the porcelain work each figure, hand-painted in the gorgeous costumes of carnival, has undergone several firings, reaching as high as 1,380°C to 1,400°C.

During his visit to the Venice carnival, the artist was overcome by the breathtaking costumes as well as the mystery that these dis-

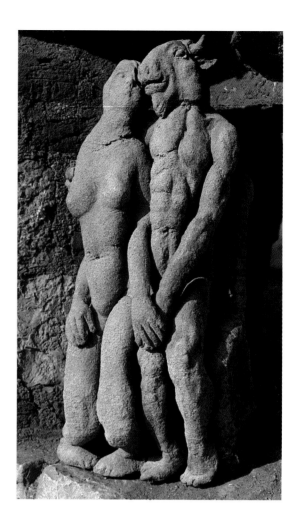

Minotaur and His Lover. *Raku, fired to 1,200°C; 1992; 42cm × 25cm × 17cm.*

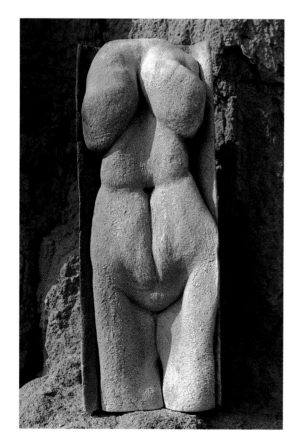

Small Torso. *Raku, fired to 1,200°C; 1997; 40cm × 20cm.*

guised – whether they 'concealed a man or a woman, a fresh young face or a wrinkled old one'. Schrammel felt the desire to realize them in porcelain or 'white gold' which shines, he describes, 'like a precious stone presenting the world in a different, deceptively dazzling light … I was drawn to evoke in this noble material the waking dream of Venice's magic.' The resulting figurines cannot be bettered, especially because the artist calls upon the aid of magic in their realization:

> Every mortal man desires that his wildest dreams may once come true, with the aid of supernatural forces. This urge lies concealed inside all magic, which is why the sorcerer, the repository of great secrets, is a figure found in every culture. He is the one who assumes the mantle of the universe and intercedes between Heaven and Earth. This figure, who also appears at carnivals, is symbolized by the Magician. And the proud lady, with her high, medieval headdress and amply-pleated mantle, is partner to the Magician.

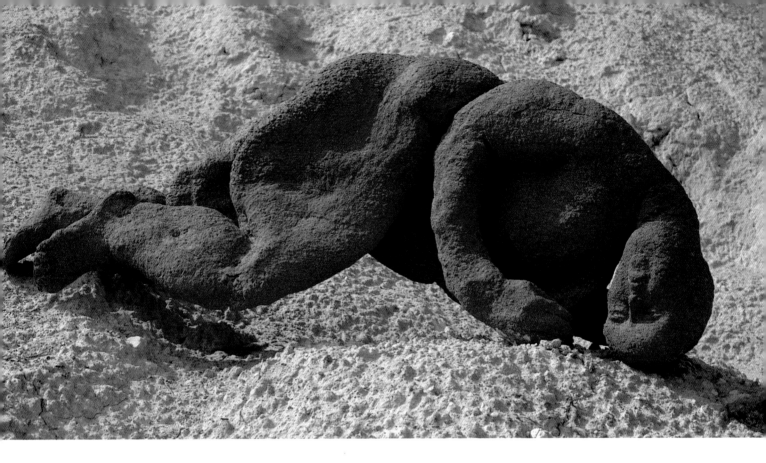

INFLUENCE
Chartres Cathedral, Portal.

Schrammel has been a guest lecturer all over the world, his work is widely known and in the collections of many museums. But what inspires this artist? He says: 'Gothic sculptures made the biggest impression on me, especially the figures on the portal of Chartres Cathedral. The spirituality of the sculptures, the material chosen and the architectural environment are for me in a remarkable unity of style.' This influence shows strongly in the artist's own work, where the settings and the architraves around several pieces that he has created, such as *Gate*, make the viewer totally aware of different surfaces and interacting spaces, and also of the architecture of a piece from both its outside and its inside. The artist describes this similarity:

> The ceramicist thinks in the same way as an architect, he encloses space within walls. The body of a living being is a structure of cavities, separated from the outer world by a skin surface. If a ceramicist takes any living creature as a model, he almost immediately bumps against the miracle of the constructing-from-the-inside principle. Such a sculpture constructed from the inside changes shape according to forces as living beings do. In addition, it adjusts itself to the environment, just as the environment adjusts to living beings. This mutual formal interaction can be the starting principle for a new partnership between artist and architect.

Pompeii Series IV: 1998. Without Hope. Terracotta, fired to 1,260°C; 19cm × 48cm × 14cm.

■ *159* ■

In both his own-sculpted human dramas (like *Pompeii*) and mythical dramas (*The Minotaur and His Lover*), Imre Schrammel follows some of the earliest mysteries of making with his beliefs and also with his life-enhancing and accommodating style. His sculpture shows us that we often have to go back in order to advance.

Gwen Heeney [England/Wales]

My work is of human scale, constructed out of a familiar material – vernacular brick, which has resonances of the home and the domestic environment. The interaction of the public with the work, and more recently with certain aspects of the making process, fosters a sense of ownership and helps to develop respect for and understanding of the work. Additionally, the source of the imagery is taken from popular Celtic mythology and has a powerful narrative potential. In short, the work operates on a variety of levels fulfilling my need for personal expression whilst at the same time allowing me to appeal to a wider public through its symbolic imagery.

These massive works of Gwen Heeney's, particularly the most recent ones, are like the ancient carved faces of the type you might discover while hacking your way through dense jungle. The facial features are closed secrets of lost and hidden civilizations; the forms look like a composite of both carved stone and the jungle vine that has grown to become part of the sacred image. Heeney's sculptures are both courageous and adventurous – particularly when you know that they do indeed involve a long and arduous commitment and that their outdoor nature has meant not working in jungle temperatures, but often in sub-zero ones in Wales. 'My last commission, the *Branwen Storytelling Arena*', the artist relates, 'required me to cover 14 tons of wet brick with layers of woollen blanket to protect it against frost.'

Gwen Heeney is thoroughly appreciated in Wales, where her sculptures take up spaces of mystery and enjoyment for her audience. But she was born in Liverpool in 1952 where she was brought up with her two sisters. She moved to Wales in 1976. Between 1971 and 1974 she read for her BA at Bristol, after which she ran a ceramic studio for thirteen years in Powys. Here she put in some practice that would prepare her for her future large-scale work: she threw and

Bid Ben Bid Bont. *1999. Brick clay; 30ft long. Marco Kuhl*
 The artist working on her piece; I love the way she holds such a small modelling tool to work on so large a work.

modelled anything and everything for the garden. Later, in 1987–89, she worked for her MA at the Royal College of Art.

Heeney relates her work from that time and describes how she makes her monumental figures in clay from what she terms 'the creative brick':

'For the last ten years I have been working and liaising closely with many brick factories throughout Great Britain. This influence, together with the time I spent at the Royal College of Art, have both inspired significantly my current concerns with the site-specific 'functional' work that I make. At the RCA, Eduardo Paolozzi and David Hamilton encouraged me to explore the possibilities of employing ceramic media in a public art context. In this way I could develop the interaction of audience and sculpture, as well as making opportunities for people to be engaged with and participate in a creative process. The experience in the brick factories contributed significantly to my current concerns and practice and has meant that the work I create is firmly rooted in centuries of acquired knowledge, experience and tradition. This security has provided a sound basis for experimentation and innovation, a situation that is normally not possible for an artist who has a small and modestly equipped studio.

'Many of the commissions I undertake are total collaborations between artist, landscape architect, gardeners, craftspeople, engineers and the industry. What I have learned is that, even if you have teams of people working with you, the only thing that really makes it happen is you – you must be the driving force behind it, gathering up others and spurring them on, and inspiring confidence and energy.

'The carving process I employ generates an intuitive response to the material. The process is one of patiently revealing the form within, giving time for reflection – intellect is lost for a while. My method of construction is to pile up large blocks of wet clay; I decide upon a structure and brick-lay the blocks to a size a little larger than I need. Then, with a sharp gardening spade, I rough out the shape. I use nothing to keep the blocks in place except suction (the blocks are covered with machine oil as they have come direct from the extruder on the production line). I then start to carve with a large loop tool which cuts through the brick at an alarming rate. Once I have a rough shape I begin to carve with smaller, sharper tools. The final stage can be painstakingly long depending upon the finish I require. At this stage the work has the appearance of an exquisitely carved, velvet-like piece of sculpture. It will never again be seen like this. The next stage is to immediately

Nehalennia. 1994.
Brick clay; 11ft long.
Three stages of
making: Heeney
modelling the sculpture;
Mandy Christmas
posing. Marco Khul

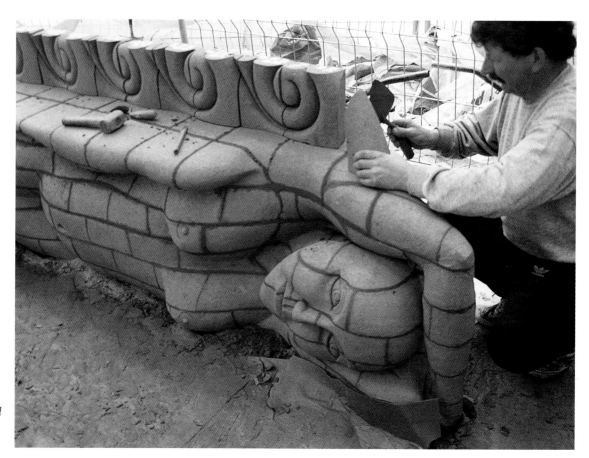

Nehalennia.
Three stages of
making: Idwal Inksen,
master stonemason and
bricklayer assembling
the fired bricks.

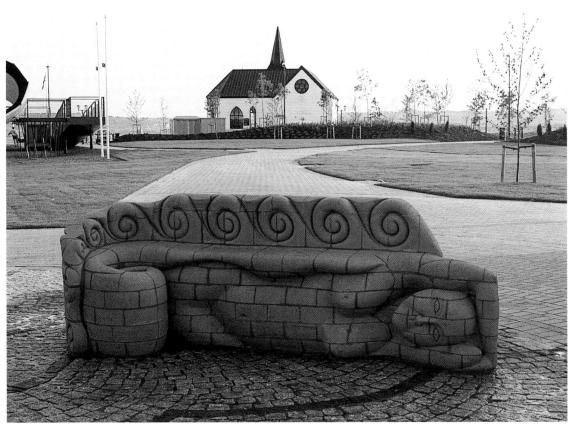

start to dismantle the work. As it dries, the lines between the blocks begin to appear and they are easily dislodged. The work is broken down into thousands of pieces and one is enveloped in chaos. Every layer has to be numbered and lettered – nothing must be lost. There is something about destroying the perfect image which is important to me. The work will never be seen in its original pristine state because the nature of bricklaying dictates its broken lines. Somehow this is an important part of the journey or performance.

'In 1994 I was successful in an open competition to produce a series of nine benches along the waterfront in Britannia Park. Shown here is the initial modelling for *Nehalennia*, and later on (after a firing at between 1,140° and 1,160°C), the master stonemason and bricklayer Idwal Inksen of the Dennis Ruabon Tile Company, bricklaying the fired sections into place. Finally, the piece is shown *in situ* in Cardiff Bay. For my inspiration for *Nehalennia* I used Dylan Thomas's poem 'The Ballad of the Long-legged Bait'.

'I mainly use mythological ideas for the content of my work. Mythological narratives are invariably constructed around eternal and com-

plex questions of social identity and meaning. They are thus ideally suited for tackling contemporary issues related to, for example, gender roles and the nature of the modern family with its associated problems of structure and function. Much of my work articulates such tensions and attempts to resolve a conflict of emotions. As my young son matures I am increasingly conscious that my work in some way tacitly reflects this development and my relationship to him.

'In *Bid Ben Bid Bont*, 1999, Llanfyllin, Wales, both sides of the two-headed Janus vie for dominance whilst pulling at a rope, a symbolic umbilical cord. I aim to create a visual tension within the work. In *Taliesin*, 1996–97, a sculpture bench for Llanfair, Caerelnion, Powys, a baby balancing on its head is engulfed by a giant, menacing hen, whilst a vicious dog prepares to pounce from the other side. The stories are a constant source of such imagery and encourage an anthropomorphic realization that in turn provides an opportunity for a broad range of interpretations. The symbols are multivalent.

'Recently I have participated in a number of international symposia. The work created during

events such as "The Yellow Brick Road" have provided the opportunity to explore a personal language free of the inevitable restrictions of public commissions. The intense creative atmosphere working with artists from different cultures and traditions brought about wholly unexpected conclusions, enabling me to develop work using a familiar methodology and extend its possibilities. This will certainly have implications for the future development of my site-specific, public commissioned works – as will recent technological advances in Japan and Europe, which have considerably expanded the possibilities for innovative architectural ceramic materials in the future. These have resulted in minimal firing temperatures and paper-thin cladding tiles measuring metres across.'

Mo Jupp [England]

I start with a title. That becomes a function. I try to make a piece that attempts to talk about that title. I like to think I make functional pieces. I honestly see no difference between a teapot and a Howard Hodgkin painting. A teapot can be critically taken apart; so can a painting. They both have a function. My main aim is to make a piece that functions artistically; as well as a good teapot.

Mo Jupp's work is poetic, graceful and celebratory. He seems to have been born with a fluent language of clay. He uses it to veer between the abstract and the figurative, both of which uphold a distinctly powerful evocation of life. He has that enviable natural talent which seems to allow him to fold and form his clay like a poet into tender expressions of essence and simplicity. He has both a strong sense of form and a strong sense of space and is an optimist with a great sense of humour. But his work is autobiographical and, as such, everything he creates is born of a constant self-questioning and personal renewal.

Mo Jupp was born in 1938 and brought up in London. He trained at the Camberwell College of Art, where he took his NDD and after that an ARCA at the Royal College of Art between 1964 and 1967. Since then he has done nothing but work hard, both at 'making' and earning a good part of his income from teaching. All his students love him; in fact, as one of his mature students has written, 'Mo Jupp has presented more exhibitions during his career than most could hope for, whilst still

Black Venus. *1995. Stoneware clay; 150cm × 50cm; private collection. Courtesy of Peter's Barn Gallery, Midhurst, Sussex. Photo: Greg Preston*

devoting a tremendous amount of time to his students. He teaches with enthusiasm, and Juppish humour and an energy surpassed by none of his young pupils.'

Jupp has tremendous respect for the clay, and it is almost as if he allows the blanket of material to take up the form through encouragment rather than by the imposition of his will upon it. 'Nowadays, everything I make is slab built', he says, 'My favourite tool is my Opinel knife.' Jupp admits that he likes best 'putting down a beautiful edge; I've worked in plaster, bronze, wood, but they don't work for me … I enjoy clay. I understand its timing.'

The artist's work is also an exploration of the hollow form. The rounded, tubular form that he uses is one of Nature's strongest[1], one which can flex in a wind; one which offers in its diam-

eter all-round equality of strength. Jupp says: 'I was drawn to clay in order to make hollow objects that would last forever (not pots) – things that portrayed my personal desires.' During the 1990s Jupp began to create hollow, slender, ceramic rod-forms. These stretch upwards, thrusting skywards through the landscape. They are Brancusi-like in both simplicity and dynamism and tribal in their patterning of stacked pieces. In *Turning Form*, made in 1997, this effective colouring is the result of alternating stoneware and earthenware firings. These shapes could have sprung from the earth like exotic, erotic toadstools. They are pole-like and masculine but have fragile female breasts sprouting from them, flower-like, somewhere high up. It is as if both male and female have

Grey Form. *1996. Stoneware clay; 54cm × 30cm. Courtesy of Peter's Barn Gallery, Midhurst, Sussex. Photo: Greg Preston*

Turning Form. *1997. Red earthenware; 197cm × 7cm. Courtesy of Peter's Barn Gallery, Midhurst, Sussex. Photo: Greg Preston*

been brought together into some kind of glorious sexual relationship *en plein air*.

But most of the artist's prolific output has been devoted to portraying the female form, on which he has been concentrating almost entirely since 1989. This he celebrates with a rather relaxed attitude; resting on the upward curve, the tilt of the torso, the centring on earth, and a gentle but firm wrapping around with collaged pieces of clay in a rich and mystical style that is both refreshing and sensible. He folds his clay around space to create exquisite, primal outlines of attenuated female form, which turn out looking ancient and modern (as the shark – which looks like the most modern of nature's streamlined inventions – turns out to be one of the earliest creatures in the sea).

[1]D'Arcy Thompson, *On Growth and Form* (Cambridge University Press).

W aiting Form.
1997. Earthenware;
30cm × 14cm. Norman
Hollands

The Abstract Poets

Sándor Kecskeméti [Hungary]

Sticking a finger in soft clay means asking a question. The answer always follows when you take the finger back. It comes down to when and how to stick your finger in the soft clay.

Mo Jupp says that he has no inspiration as such except what is around him and is natural-looking or what is inside him and is auto-biographical. He admires Egyptian and Indian art, both of which are of obvious influence, as is Alberto Giacometti. He is also inspired by Antony Gormley's work, and his favourite painters are Egon Schiele and Euan Uglow.

Jupp has often been called provocative in his choice of subject matter, and some people have found his more erotic work outrageous (in 1973 he presented a series of porcelain temples containing gold or silver genitalia adorned with cane or white feathers). But he is single-minded and goes his own way. A few years ago he said, 'My work is often misunderstood, but that is often because people do not look closely enough. It seems that as a male I am obliged to make male-biased objects. This is very often not the case.' He does understand the sexuality of women. I believe that his *Grey Form* – with its graceful charm and gentle patination of texture and colour – can stand as the epitome of erotic femininity. And remember the woman who, on seeing his work, remarked to the artist, 'Your pieces make me feel good to be a woman.' It comes as no surprise that, when asked in an interview for *Ceramic Review*, 'What are the ideal conditions under which you like to work?', he answered, 'Surrounded by beautiful women – not necessarily young ones.' Mo Jupp's work is easy to love, and he is always up to something that will be accompanied by a chuckle. 'At present', he told me, 'I am sculpting women with attitude – or, to be more precise, I am three-dimensionializing my favourite paintings.'

Sándor Kecskeméti is stonemason, architect, builder, teacher and poet. He is a man who loves to communicate with others, extending friendship of the kind that is so typical of Hungary. In his sculpture Kecskeméti is an ingenious juggler of form, space and the distribution of weight. He has that rare gift of allowing both vertical and horizontal shapes equal value and importance – usually one is dominant in someone's work. He is also a master of distortion, making off-balance balance, of creating a soft geometry. His texture and patination meld with his pieces as if they had grown along with their making. They confirm his work to be at one with the landscape of earth and man.

Some of the artist's shapes have the simplicity of a sugar lump, fitting snugly into dolmen supports which hold them high off the ground. Others are warm, interlocking or linking forms with names such as *Family* and *Love*. These pieces have a *gemütlich*, Brancusi-like quality. Or there are powerful, more compact pieces, carrying simple titles such as *Wedge*, *Gate*, *Figure* or even *Sculpture* – nothing fancy, but all very punchy and strong like the sculptures themselves. And they have the same gift of being entirely suitable wherever they are placed, sitting comfortably in their surrounding in sympathetic assimilation; Kecskeméti's work is a powerhouse of impact. It has earned its maker a great reputation. Kecskeméti is a member of the International Academy of Ceramics. He has won too many accolades and prizes to list. He has work on show in all the places where he is known; but he should be even better known. At present he is Professor and Master Teacher at the International Ceramics Studio in Kecskemét and he lives and works in both Germany and Hungary where he is thoroughly appreciated.

He was born in 1947 in Gyula, Hungary. There he studied under Árpád Csekovsky at the

he Last Supper. *1992. Clay, fired at 1,100°C;
24cm × 14cm × 15cm. Kálmán Vass*

Budapest Academy of Applied Arts, acquiring a good background knowledge of ceramics and glazes. Since graduating in 1972 Kecskeméti has been a freelance artist who has turned from potter to the rolling, twisting, folding and stretching of a ceramic sculptor. He has made work for theatre and film as well as filling both landscape and lawn with monumental forms. All his pieces are monumental; even the smallest maquettes which line every shelf of his studio walls could, if magnified, be as demonstrative as a 50ft-high menhir. The artist states simply, 'I always think big.'

Kecskeméti works in stone and bronze as well as clay, but clay is appropriate to his work in that it fits well his language of chunk, wedge, stack and cushion. But, he says, 'Materials are needed to help the ideas and thoughts of the artists become materialistic. Different thoughts require different materials. An important rule in art: everything is allowed.' This freedom and variety runs like a vein of marble throughout Kecskeméti's work. Jigsaw-puzzle shapes fit, balance or slot one into another, in a way that is both playful and sexy as well as timeless – like the standing stones. He works in series around a technique or theme. First he makes a maquette and searches for forms with sketches in pencil or ink and wash. He makes stronger and

stronger developments of an idea, defining with conviction, 'whiting out', for example, any irrelevance, reaching always for a distillation of statement until everything becomes clear.

The artist says that he can neither name one piece of art nor a specific era that has had an influence on his work. 'I believe in the continuity of art', he explains, 'See how we have turned from the twentieth century into the twenty-first. Artists have to be able to think back, and first they have to know what happened before, because the present is built on it. I believe that artists are trying to give true answers to the question of life – individually, according to their abilities.'

To begin with, Kecskeméti's own sculpture was involved with crumpled forms or cubes which he used like building blocks to create broken-wall effects. These mirrored the Hungarian regime of political frustration and social fragmentation; and they were to do with a geometry of tensions: tumbling down, architectural instabilities, constructions with pieces missing. And for his patination, the artist used a method of his own creation (which he called 'external reduction') to give his work a more painterly surface. This involved using a welding pistol like a blow lamp.

I stumbled upon the external reduction technique [he says], or, more precisely, it stumbled upon me. The technique itself simply fascinated me, but then I wanted to impart meaning to colour as well. Yet I let chance do the job instead of me, for fire can never ruin my work. I am also attracted to the kind of living

igur. *1998.
Porcelain, fired at
1,350°C; 17cm ×
12cm × 7cm. Kálmán
Vass*

167

*Figur. 1997.
Porcelain, fired at
1,350°C; 18cm × 4cm
× 4cm. Kálmán Vass*

dynamic way. A kind of spiritual stamp, rather like a pharaoh's seal: a sacral figurative scene on an already figurative form. Gert Meijerink, in a catalogue of the artist's work, describes how this came about:

> Continuously searching for universal solutions, the artist does not shy away from the fragmentarist experiment if he should chance on it. When I met him, he was experimenting with the possibility of a tin mould found in the streets; it portrays a reverse image of the Last Supper – a minuscule, three-dimensional version of the famous Leonardo da Vinci fresco. He impresses them – often more than once – on the still fresh skin of new sculptures.

Today, Kecskeméti's work has acquired that undefinable quality of 'thisness' which is filled with humanity and love. Each piece acts like a kind of magnet drawing into itself qualities that come from its maker's own magnetic field: maturity of vision, wisdom and a delightful humour. The final accolade is that Sándor Kecskeméti's work, once made, looks as if it has always existed.

relationship which presumes that I don't simply shut the door of the kiln and wait, but influence the course of the burning itself.

Since then the artist has continually played with new methods. His recent series in porcelain appears to be carved from solid blocks of clay. Each brings with it all the pristine purity of the material to make single, distilled statements, usually with some kind of contrast to make the content vibrant. Each has an anthropomorphic structure, generally with feet, then torso, and topped by some kind of head or crowning shape which is as strong as the feet and which, if the piece were to be turned upside down, would hold the same weight and contact with the ground or sky as it does the right way up; that is, it has a controlled, spatial existence. The variety in texture comes by allowing the nobility of porcelain with its smooth, white, creamy surface to be contrasted with a deliberately sanded or gently coloured area. And the artist draws markings or bores holes through the surface with decisive, simple, connecting lines, which alter its significance.

Since the late 1980s Kecskeméti has incorporated an interesting leitmotif in much of his work: a depiction of the Last Supper, printed rather than drawn on to the surface of his abstract figurative compositions. By introducing the Renaissance into his work the artist has involved a figurative idiom in a direct and

*Abendmahl (The
Last Supper). 1991.
Stoneware reduction,
fired at 1,100°C; 10cm
× 10cm × 15cm.
Kálmán Vass*

Charles Bound
[USA/Africa/England]

Work is the philosophy, being able to work, so in time you may understand what that work is, its provincial and sometimes greater context and meaning.

The workings of this artist are bold statements, tightly formed but freely handled, so that when you know that Charles Bound has his studio on a farm in Yorkshire, where he is close to things that matter, the rough texture and vitrified rocky appearance begin to make sense – for their ruggedness connects them direct to the earth. It is a great pleasure to have found this artist for the book. I was introduced to his work by Tony Birks-Hay at the Alpha Gallery in Sherborne and saw that its forthright strength and unfettered sensibility was dominant.

Charles Bound has a true, natural affinity with his material. He has had a life in three countries, and from each has collected a poignant influence for his work. He was born in 1939 in New York City. At the age of 28 he left for Africa with its wide open spaces. 'Eventu-

ally', the artist says, 'I arrived in Europe, middle-aged, took up with clay – all else having gone adrift. Missed that art college thing, its extendings and limitings.'

Bound tells us about his artistic journey, the influences upon him and his technique:

'That work is the philosophy may sound privileged, pretentious (I can hear it being said), where work inclines to be something you do directly for someone else, taking away that part of your life, just grinding you down. This is part of it, certainly, but a part wanting to exclude what we generally separate out and call play, that process of the body and mind's imagination always extending the task at hand, messing about.

'On the farm where I am privileged to work, my own and occasionally the farm's, there is a three-year-old who now and then during her busy life wanders in and works with me. At the moment we agree what I am making is houses, and she willingly draws, carves windows and doors, adds people. Other times we just prepare clay together or she works on her own uses of the stuff. Of course, she is a pure artist, a magi-

Always chaos glides to order. *1998. Clay; 43cm × 28cm × 26cm. Winpenny Photography, Otley, West Yorkshire*

For it that it be. *1997. Clay, wood; 61cm × 33cm × 30cm. Winpenny Photography, Otley, West Yorkshire*

Our arrangements here. 1997. Clay, steel; 39cm × 29cm × 22cm. Winpenny Photography, Otley, West Yorkshire

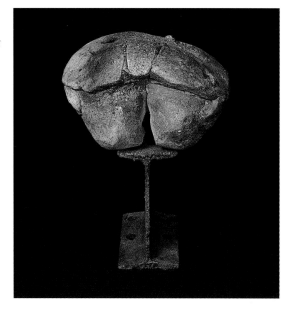

cian at the art of becoming herself and a great teacher of these things. What she is doing is working. Together we keep accumulating skills, ways of seeing things, now and then with much delight, what we have done being more than we had imagined. It is an ordinary human thing, this kind of activity, this work, some understanding coming now and then when for a moment you think of such things or someone asks. So my aim is to work, keep trucking, see how the going is, where one might arrive, and then again depart.

'As for technique – always work beyond yourself. This doesn't mean, as some think, give way to chance, ignore skill, accumulate experience; it means accept that at any time there's more there even if you don't work it out. I have found that when I back away from pushing, directly try to repeat something that seems to have succeeded, everything goes dead. I imagine that it is because what I am then doing is totally favouring existent skill, a certain dominance of materials, whatever you may call it. Yet, knowing, I often do this because something has drawn me I want to get at again and so I start to copy, afterwards wondering what my blindness was, why sucker myself again. Given this, many of the best things I make come from collapse, bits retrieved then off the floor suggesting where I wasn't looking; come from turning things upside down, cutting apart, reassembling in frustration at the intractability of it all, the clay occasionally then saying, "See, now, this is the way I'd rather be", a lump suggesting what hadn't been thought about, beginning to be seen.

In the ordered mind. 1998. Clay; 40cm × 29cm × 27cm. Winpenny Photography, Otley, West Yorkshire

'That I work on a farm helps. There's stuff around to remind how extraordinary are disintegrations and reconfigurations: rusting bits seemedly ignored in a field, cut and welded, painted plough blades, mirrors once used again, mud on tracks drying and cracking, trampled by sheep. These are "gifts". Clay, even as bought refined, has as well in its states of ooze, bend, break, becoming stone again. My way of working is to try to latch on to such things, be as interesting as their casual intensity. I figure if I have enough bits full of information around something will happen. Need one say this is not a way the farm at large can work.

'The work is fired in a wood-fuelled, tunnel kiln now. This being the crucial tool (flame, time) has much to do with results that feed back into the process of seeing and making. The nature of the kiln, as the qualities of clay, much determines how I continue with things. One might ask, as an afterthought, what someone basically seen as a potter, ambiguous as that is, is doing making figures? Well, it just turns out that way sometimes. And why not? Tell me great pots don't sit there like Buddhas such that you would be certain, if you only look at the right tangent, they are vital in the way of a vibrant live thing about to dance. As for what influences me – anything by Stephen De Staebler, who, in an overly self-conscious time, can

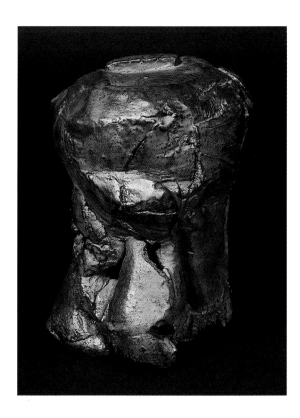

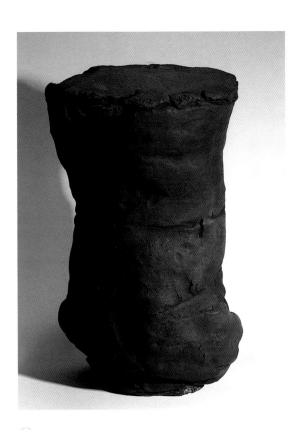

erian. *1997. Dark slip and wood, fired to 1,280°C; 45cm × 28cm. Alphabet & Image Ltd*

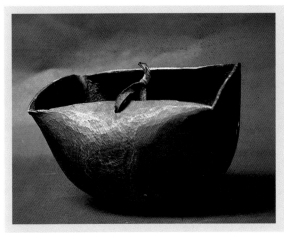

*I*NFLUENCE
*Anonymous woman,
Wooden bowl from
northern Kenya.*

Anthony Caro
[England]

Things suggest other things, which is the beginning. The feeling has to be right. You try to get on to the right wavelength of the sculpture. I want the sculpture to be a real entity rather than completely separated from our world – a one-to-one thing – to speak directly to us … I don't feel now that I have to establish that figurative sculpture has to look like a person. The battle to make an abstract sculpture is over and we can do something more literal if we want to.

work as if a pure force of nature on clay while being complexly human. I also have an object which has influenced me – which has a story behind it: twenty-six years ago, a bowl was forced on me in northern Kenya by a woman who needed money during a regular brutal drought. I didn't want it for all the complex contradictions Europeans experience in such a situation, and anyway I was working hard to travel light in all ways. She insisted. This bowl has been with me ever since. It sat around on the floor for years in Kenya, ignored among the cats, the frogs and insects that wandered in at night. When we came to Europe it came along, something we had, continued to be ignored except that on particular damp days the scent of it would catch me back. And so I began to pay attention to it, its graces, elegance, perhaps in isolation only for the longing that can overcome one about Africa. This bowl (its curves, hand-worn patina, the way it sits, seems so easy in itself) is that woman. She has been tracking me with her gift, the idea of herself, ever since. And I can say, in one way or another, everything I do tries to talk about her, with her.'

Abstract, welded steel sculpture is, in fact, what one normally associates with Anthony Caro. But he has always created figures in clay; he won two silver medals and a bronze for such work at the Royal Academy of Art, where he trained. And it is clearly evident in every sculpture he has made – whether of metal, wood, stone or clay; and whether used singly or in combination – that Caro developed early a wise understanding and appreciation of the nature of each material. Unwilling to accept any received wisdom, Caro still prefers to experiment, to test for himself what each material can say to him personally. And there is nothing precious about his attitude. Caro will be 77 when this book is published and he is still in the thick of things. 'I am always out to challenge myself. I like to do things that are difficult. I keep pushing ahead.'

Caro's father wanted him to be a stockbroker and go into the City. When he eventually realized that his son was adamant about being a sculptor, he went along with it, but gave him one piece of advice: 'If you're going to do it, do the thing properly.' Caro took his father's advice. First he enrolled on a five-years' course

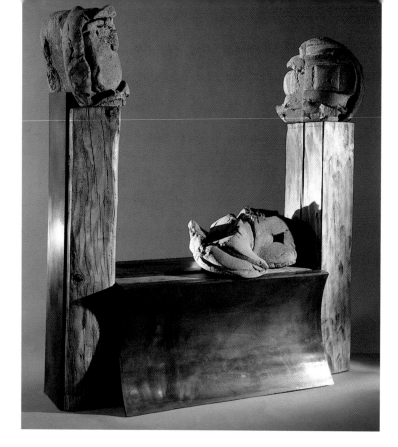

The Trojan War: the
Body of Patroclos.
*1993–94. Ceramic,
oak and steel; 152.5cm
× 140cm × 59cm.
David Buckland*

at the Royal Academy Schools, an important period of his life for two reasons: first, it was there that he met his future wife, the painter Sheila Girling; secondly, he had a different teacher every term which exposed him to a variety of ideas and approaches. But the place was very traditional and it was teaching him more about painting than sculpture. 'Halfway through the course', he says, 'I got cheesed off.' So, choosing the best sculptor of the age, Henry Moore, the young Caro went to ask him whether he could be his apprentice. 'Well, you might have telephoned me first – but come in and have some tea', said the master.

Caro began to work for Henry Moore in 1950 and stayed for about eight years. He found him a very warm man, and one who taught him what it was like to be a serious sculptor and what a real sculpture studio should look like. He also criticized Caro's drawings from the Academy Schools and taught him how a sculptor draws. Caro was introduced to modernism and distortion, and there, too, he was influenced by Picasso and his 'Angry Animals'. 'But', he said, 'I couldn't make the figurative sculpture real enough – it was still a model.' So, in 1959, he went off to America. There he felt 'freer and less bound by history'. He embarked on a career of making brightly-painted steel and aluminium sculptures, which were very controversial when they were shown at the Whitechapel Gallery in London in 1963. 'But we were

The Trojan War:
Agamemnon.
*1993–94. Ceramic,
jarrah wood and steel;
178cm × 63.5cm ×
32cm. David Buckland*

behind the painters,' Caro says, 'they had done this already.'

Caro came back to working with clay again in America in 1976, when Margie Hughto brought a group of artists together to literally 'play with clay'. And so began a series of collaborations over the years with several artists: Paul Chaleff, Jim Walsh and Hans Spinner, making clay pieces that were arresting, exciting and fun. Caro enjoys collaborating with others. 'You have your own vision first', he says, 'then you can get involvement, help, opinions from other people.' With these artists he handled different weights and types of clay. And his treatment of it, whether it is stacked, dropped, folded or kneaded, continually surprised with its punchy, instinctive approach. Caro says: 'I quickly discovered that clay exhausts itself if overworked, and the moment I feel the clay "tiring" I will discard it and begin with a fresh slab.'

It is this quality of freshness that always strikes you with a Caro piece. Whenever clay is involved it always looks just worked, then it is miraculously preserved in that state, even after the final firing. There is no need to use a glaze. The surface is enriched naturally inside a wood-firing kiln. Surface colouring is created by the fire, drawing agreeable tones from within the clay body itself; simple but effective. His *Lazy Susan*, made between 1988 and 1989, illustrates this perfectly. It is constructed from thrown

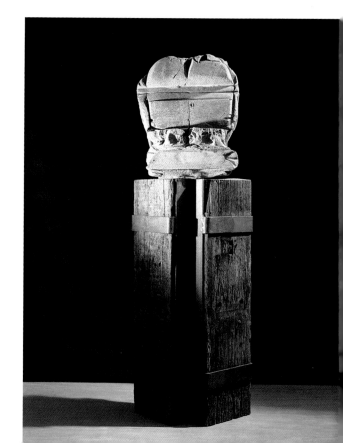

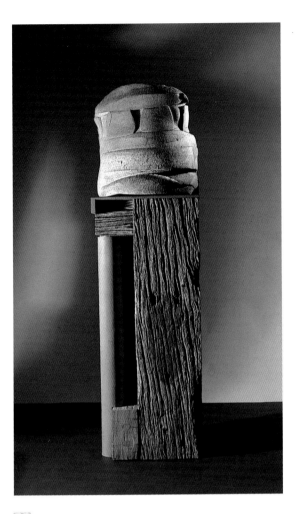

The Trojan War: Menelaus. *1993–94. Ceramic, jarrah wood and steel; 169cm × 49cm × 34cm. David Buckland*

cylinders of stoneware clay, manipulated with the utmost sensitivity – without any fuss or overworking – into a lively and expressive gesture. *Lazy Susan* becomes a simple statement of exactly what clay can do. Caro describes how he became aware of which way clay 'asserted its needs, how it liked to turn in on itself, how it needed to be cradled when it is damp'.

In 1993 Anthony Caro began work on a monumental series entitled *The Trojan War*. This consisted of forty individual pieces which represent the gods and heroes from Homer's *Iliad*. Again they are direct, unadorned statements, but with a most powerful kick to them; an assemblage of truly heroic proportions which uses a warlike narrative to convey personalities. 'I felt forced into doing something that had a resonance. I wanted to comment on something that was happening in the world. The clay itself reminded me of warriors. I could use mythology to say something about the present.' The clay is worked with intensity. Solid lumps are pummelled, dropped or folded into simple shapes. The metallic components render an armour-like darkness and strength; the rough wood speaks of a warmer, human element; the clay, a soft, flesh-like quality. Thus they symbolize the hard, unyielding characteristics of the gods with the brave vulnerability of those on earth.

Although these gods and heroes were obviously inspired by a visit that Caro made to Greece in 1985, I think they represent a culmination of a lifetime's experience. They bear echoes of when Caro took an engineering

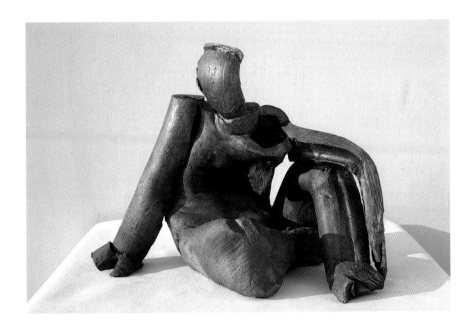

Lazy Susan. *1988–89. Stoneware; 17in × 21in × 16in. Mick Hales*

degree in 1944 at Cambridge, or when he served with the Fleet Air Arm from 1944 to 1946; even from when he took up life drawing once again, working direct from the model at the international Triangle Artists' Workshop in the 1980s, which he founded.

The notion for the *Trojan War* sculptures came originally from various studies in clay, made during his collaboration with Hans Spinner in 1993, at the latter's studio in France. Caro tended to go with his feel for the clay, which he describes as,

> very natural and tactile. If it had been porcelain it would have resulted in a finer, tighter way of working. I worked very loosely, intuitively. I allowed the clay and the lumps – what Hans calls 'the breads' – to take me. We pushed and beat things into the clay until an image began to emerge.

Later, Caro said, 'they began to speak, they became gods and heroes'. These loosely-structured, heavy-volumed pieces could be fired without exploding because Spinner had taught Caro to add up to 60 per cent grog to the clay body. Again Caro chose to leave the clay component unglazed, thus melding sympathetically with the other natural materials.

Three of the Greeks, Agamemnon, Menelaus and Patroclos, are shown here. They evoke both past and present, expressing both ancient and modern passions; they are a fusion of romantic with classical. The massive heads of clay are hauntingly primitive, sometimes frightening,

sometimes having the ability to draw from you the compassion aroused by a Greek chorus. In a way, the completed series looks like a cross between architecture, engineering and abstract figurative sculpture. Caro calls it 'sculpitecture'. He adds:

> I feel freer now than I did thirty years ago. The language of abstraction is so well established that it doesn't have to be defended in the same way. In the past, it seemed that if a sculpture was to be alive, to be 'real', it couldn't look like anything else. I used to worry that my sculptures might remind you of something. Now I don't mind if they do.

Caro was knighted in 1987 and he has won many other honours and awards during his career. Today, he lives happily with his wife in London. And the artist still keeps his finger on the pulse. In 1996 Caro, together with the architect Norman Foster and the engineer Chris Wise won the competition to design the Millennium Bridge – the first completely new bridge to span the Thames since 1894 (*see* page 15). This is a modest, delicate structure linking St Paul's Cathedral to the new Tate Modern Gallery on Bankside, 'a walking bridge', as Caro describes it, 'and rather narrow. People can wander over it and look at London in a new way. Do it in good weather as it's a long way over the Thames. It should be a lover's bridge.' This bridge has started life with a few wobbles. But this makes it perhaps even more of a symbolic bridge over which we can walk across into the future.

Index